# Court Painting in England

Charles I, by Van Dyck
*(Frontispiece, overleaf)*

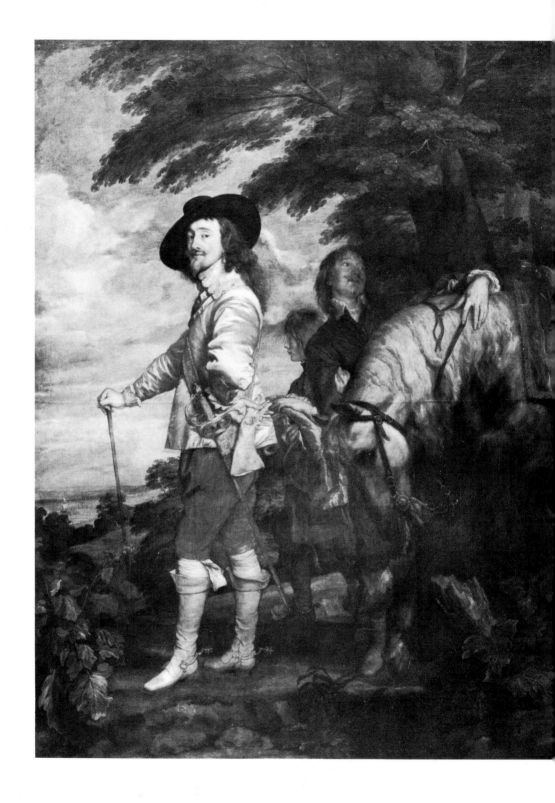

William Gaunt

# COURT PAINTING
# IN ENGLAND
from Tudor to Victorian Times

Constable  London

First published in Great Britain 1980
by Constable and Company Limited
10 Orange Street, London WC2H 7EG
Copyright © 1980 by William Gaunt
Set in Monophoto Ehrhardt 11pt
Printed in Great Britain by
BAS Printers Limited,
Over Wallop, Hampshire

British Library Cataloguing in Publication Data
Gaunt, William
Court painting in England
1 Painting – England – History
2 Painting, Renaissance
3 Painting, Modern – 17th – 18th centuries –
England
1 Title
759.2   ND464

ISBN 0 09 461870 4

# Contents

# Illustrations

Illustrations

Illustrations

Pictures supplied by Mrs Stuart Rose of Illustration Research Service.

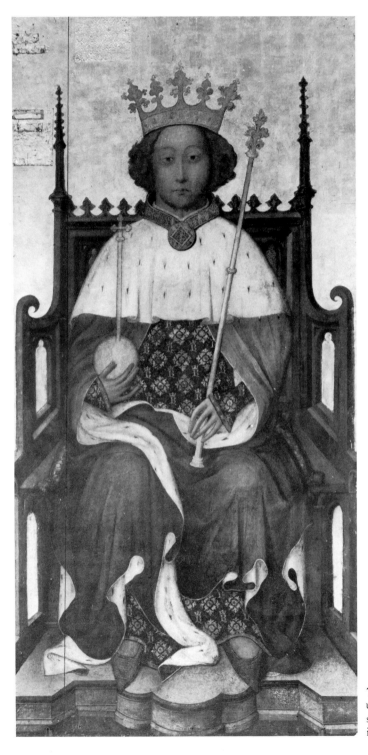

This portrait of Richard II by an unknown artist, though formal, suggests some effort to give individuality

# Introduction

One of the great changes that marked the end of the Middle Ages and the beginning of a new era in Western Europe was the rise of powerful dynasties in Spain, France, Austria and England. It was a marvellously complex family affair. Their courts were the seats of national authority and at the same time the centres of an international network combining and recombining in intricacies of alliance and enmity. Twin instruments of policy were the diplomatic marriage intended to link ruling houses in friendship, and the balance of power that aimed to prevent any one country from becoming dominant, to the danger of others.

In this competitive situation artists gained a special importance. Ruling families needed them to add to the magnificence of outward show that gave visible form to power and prestige. The great artist was a prize in the contests of splendour. To lure Leonardo da Vinci to France was in itself a triumph for the French king, Francis I. To work for emperor, king, queen or prince was a function of many of the most illustrious European masters from the fifteenth to the eighteenth century.

The portrait, as a recognizable individual likeness, was of especial value. Portraits were a constant reminder of the personality of a sovereign and the strength of a dynasty, whether on permanent display in a royal palace or given in token of friendship to friendly foreign powers or to favoured followers in the Court at Home. The Court, in the comprehensive sense of the sovereign's councillors and retinue, was likewise portrayed in a way that reflected status and dignity. The painted likeness served still another purpose—as an item in the negotiations for royal marriage, a proposal for alliance often settled before the contracting parties met in person. The exchange of portraits as a substitute for courtship made it the more desirable that they should be as close in personal resemblance to their subject as the skill of the painter allowed.

I

In England the new era began dramatically with the reign of the Tudors and the advent of a great artist, Hans Holbein the Younger. Portraiture acquired a new life. With the end of medieval faction and the firmer position of the throne, an art of the Court developed in a way until then unknown. The religious outlook of the Middle Ages, while paying respect to kingship as an institution linked with divine authority, was little concerned with individual likeness. The goldsmiths, coppersmiths and master-masons of London who created the effigies of the royal tombs in Westminster Abbey from the thirteenth century onwards invested them with a saintly idealization. The monastic painter and illuminator of manuscripts gave particular attention to events, such as a coronation, that had a symbolic religious value.

The panel known as 'The Wilton Diptych' (opposite) which depicts Richard II presented to the Virgin and Child by his patron saints, is an instance. The youthful aspect of the king has set a problem for historians as the panel appears to have been painted when in fact Richard was bearded and careworn with the troubles of his reign. Whether or not the intention was to present an image of timeless youth, likeness, it would seem, was of less account than the piety of association.

The full-length portrait of Richard II by an anonymous painter, formal though it is, suggests some effort to give individuality. This was a trend that can be traced to a limited extent in the turbulent period that followed his abdication and death. The development of portraiture in the Netherlands, so closely tied to England in many ways, may be faintly reflected in a series of royal portraits up to the time of Henry VII, painted on panel somewhat after the Flemish manner, though no distinct impression of a Court painter appears. The imperfect abilities of the craftsmen thus employed, the probability that they drew on varies sources such as medals, tombs and miniatures to assemble an identikit image in lieu of a picture from life, would account for the generally wooden and unrevealing nature of these works. There may be an authentic glimpse of the outwardly affable and handsome presence of Edward IV in the portrait painted about 1472, when he was thirty, by some unknown Fleming.

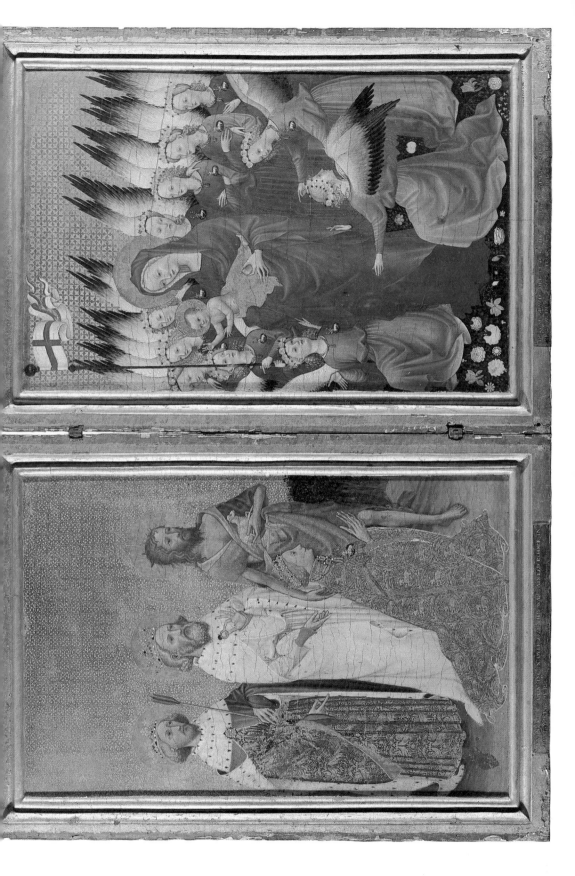

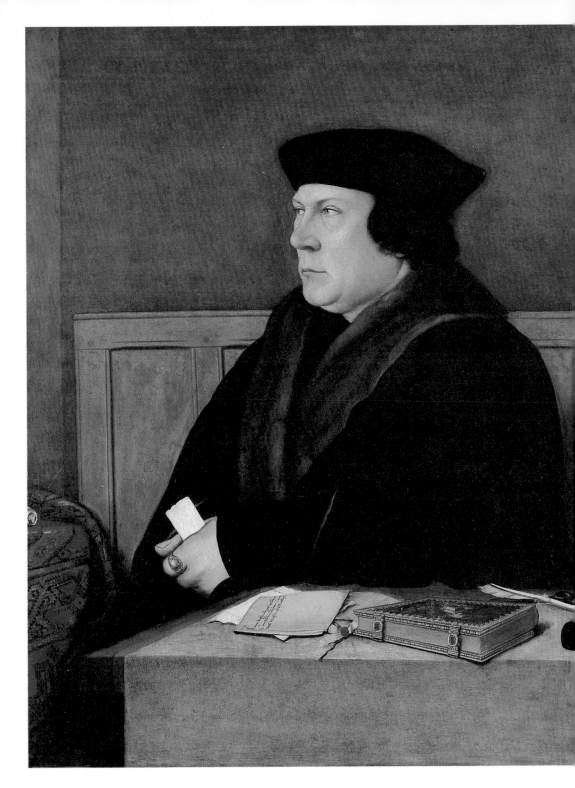

Holbein painted Thomas Cromwell when he was Secretary to Henry VIII, Chancellor of the Exchequer and Master of the Rolls (see page 11)

What may be read in the features of Richard III, as portrayed in a panel by an unknown artist, whether the sinister being who was capable of the murder of his nephews in the Tower, or one much maligned by later propaganda, is a matter of guesswork depending on the bias of the spectator.

There was no decided change in the visual arts after the storms of the Wars of the Roses, the death of Richard III on the field of Bosworth in 1485, and during the reign of the first Tudor. Though the shrewd and practical Henry VII acquired a huge fortune in the course of his twenty-four years of rule, by the fines and forced loans he was able to exact from wealthy subjects now powerless to resist, he had little to spare for luxuries such as painting. Of the many-sided Renaissance that had its origin in Italy, only the new interest in classical learning had so far reached England. Latin and Greek were valued mainly as the equipment of Bible scholarship. The schools and colleges built to further these studies were still medieval in their style of architecture. The splendours of Italian art, the master-works then fresh from the hands of Piero della Francesca, Mantegna, Botticelli, Leonardo, Michelangelo, and Raphael, belonged to another world. A stray from that more brilliant scene, Pietro Torrigiano 'of the citie of florence, graver and paynter', commissioned three years after the King's death to design the tomb and recumbent effigies of Henry VII and his Queen, Elizabeth of York, in Westminster Abbey, demonstrated the extent to which a mature Renaissance outlook made for contrast with the abstract virtues of the native Gothic.

Humanism, as the literary and scholarly aspect of the Renaissance, had a wider influence. In this form it was a freemansonry of the learned. The pursuit of knowledge, expanding with a newly gained critical approach, promoted the free exchange of thought and friendly alliances between scholars in different countries, including England. A signal instance is the cordial and civilized relationship of Sir Thomas More with the Dutch scholar, Desiderius Erasmus; and this, by a web of circumstance, was originally the means of bringing Hans Holbein the Younger to London, and of his eventually there becoming one of the greatest Court painters of all.

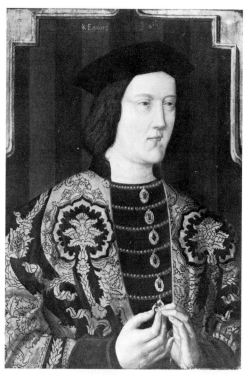

Edward IV, painted in 1472 by an unknown Fleming

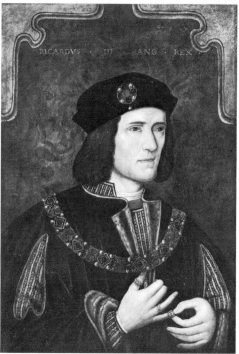

Richard III, by an unknown artist

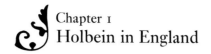

# Chapter 1
# Holbein in England

It was at Erasmus's suggestion and with his help that Holbein paid his first visit to England in 1526. Erasmus was then sixty, the famous author of the satirical *Moriae Encomium*—'In Praise of Folly'—and settled after many wanderings in the German-Swiss city of Basel. As a literary centre, possessing a distinguished university, and free (as a member of the Swiss Confederation) from such restrictions on the liberty of thought as might be met with elsewhere, Basel was congenial to the humanist. He acted as literary adviser to the publisher Johann Froben, and was friendly with the young Holbein who worked for Froben as illustrator and made little drawings to go with the 'Praise of Folly'.

One of an artist family, born at Augsburg in 1497, the son of Hans Holbein the Elder, a painter of religious subjects and portraits, he was in Basel by the age of eighteen together with his brother, Ambrosius, who was an artist of promise cut short by his death in 1519. Hans Holbein became a naturalized Swiss citizen and for some time found employment in a variety of undertakings as designer and painter. He showed a particular aptitude for portraiture and one of his early masterpieces was his portrait of Erasmus in 1523. Several artists had sought to catch his subtly amused expression as he sat at his desk, equipped with the humanist tools of pen, paper and learned volumes; Dürer in his majestic engraving, Quentin Massys in the portrait intended, with that of the Antwerp intellectual Peter Gillis, as a present for Sir Thomas More. Holbein in a work of beautiful simplicity gave the most complete evocation of the man.

By that time Holbein was in financial trouble. The avalanche of the Reformation had been set in motion by Martin Luther's attacks on abuses in the Church. Commissions for altarpieces, mural paintings, and designs for stained glass, that had been a main support of the artist and his family, were no longer forthcoming in

5

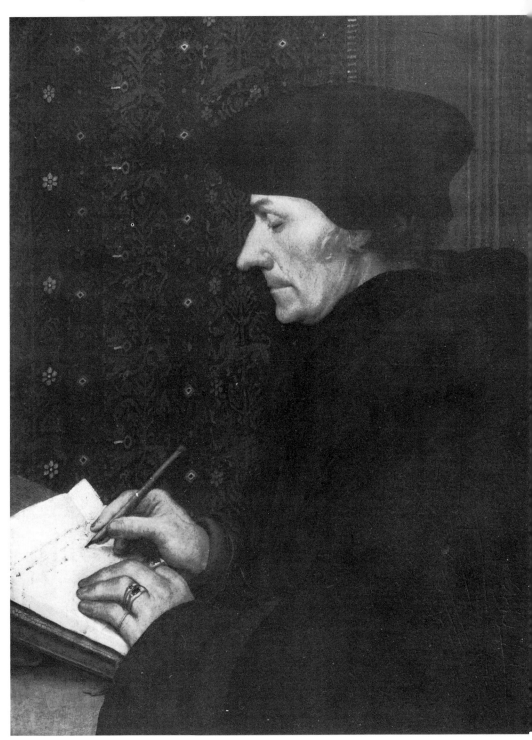

An early masterpiece by Hans Holbein – his beautifully simple yet evocative portrait of Erasmus

this disturbed period. He was, as Erasmus put it in writing to Sir Thomas More on Holbein's behalf, 'without bread'.

Memory of his own hard times made Erasmus sympathetic to the plight of the young married man with two children. He should go to England, Erasmus advised. He himself had been warmly welcomed there; in Oxford had stayed in the house of William Grocyn, eminent in Greek studies, whom he gratefully described as '*patronus et praeceptor*'; at Cambridge had been for two years Lady Margaret Professor of Divinity, the chair founded by Lady Margaret Beaufort, Henry VII's mother. Thomas More, his great friend, whom he had assisted in launching the Latin editions of More's sociological romance, *Utopia*, and with whom he had collaborated in other ways, was in addition a man of power who could wield much influence. Erasmus's letter of introduction resulted in the invitation to Holbein to stay at the house in Chelsea that was More's rural retreat after many years spent in the heart of the City.

Some years were to pass before Holbein could correctly be described as a Court painter. His first visit to England, which lasted for two years, 1526–28, was occupied with portraits of Sir Thomas and his family, and of those dignitaries of the Church to whom he was introduced. Though the group portrait of the large More household has not survived, the ink outline in the Basel Museum gives an intimate idea of its plan. The individual portrait of Sir Thomas suggests the determination and integrity that accompanied his kindliness and humour. Such apostles of the New Learning as the mild, elderly William Warham, Archbishop of Canterbury, and John Fisher, Bishop of Rochester and Chancellor of Cambridge University, were among others Holbein portrayed. Considerably better off as a result of his visit, he returned to Basel in 1532, by then able to buy a house. A more emotional portrait than usual to him was that of his wife and their two children. Her features seem to reflect the anxieties of the times and of their own condition.

Basel, however, could not keep him for long, though he was urged to finish the mural paintings in the Council Hall which he had left incomplete. Once again he set out

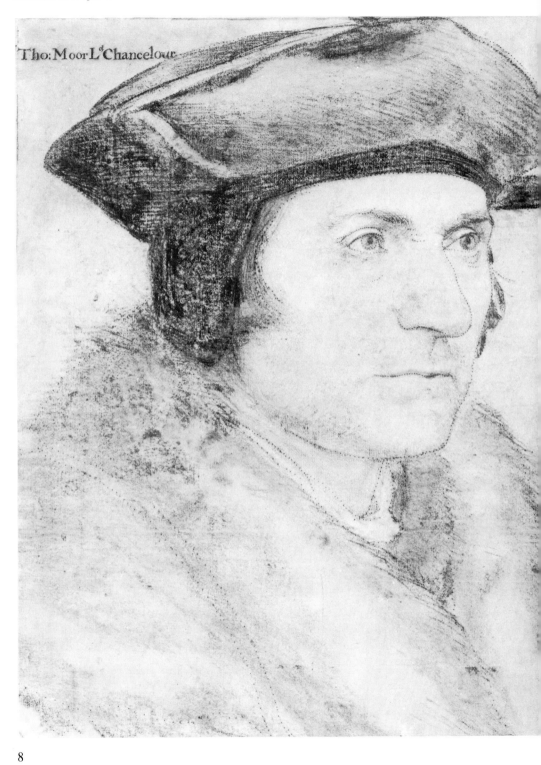

Tho: Moor L.ᵈ Chancelour

Holbein's studies of Sir Thomas More suggest the determination and integrity that accompanied the sitter's kindliness and humour

for England, in 1532, and for some while found employment in painting portraits of the merchants of the Hanseatic German cities who had their hall of business on the riverside at London. This was the anciently-founded Steelyard, so named after the official scales for weighing imported goods. The members imported a large variety of commodities and had a main export in English cloth. They hung on to their special privileges, in spite of insular objection, until towards the end of Elizabeth's reign. They were still flourishing when Holbein painted the merchant George Gyze in carnation-coloured doublet, surrounded by the properties of commerce, quill-pens, seals, cashbox, ledgers, invoices and letters. It became the painter's favourite device to show his mercantile sitters in the act of opening their correspondence.

But a Court connection was soon to come. Much had happened since Holbein went back to Basel in 1528. There was a tense atmosphere consequent on the crisis in the King's marital affairs, his break with the Papacy and his claim to be the supreme head of the Church in England, his short and lethal way with opposition. It was not for a foreign artist—or indeed for anyone else except at great risk—to express an opinion on the explosive situation in which both politics and religion were involved. In 1533 the unfortunate daughter of Ferdinand and Isabella of Spain, Catherine of Aragon, having failed to produce the male heir Henry desired, was dismissed in tears at the age of forty-eight. Her marriage to the King being declared void by Archbishop Cranmer, Catherine went into austere seclusion in the country. It was certainly not for the merchants of the Steelyard to doubt the validity of the King's marriage to Anne Boleyn immediately afterwards; nor did Holbein demur about designing their pageant arch in honour of Anne Boleyn's entry into London as Queen.

His skill in other ways drew him to the Court. The double portrait of the diplomatic envoy to England, Jean de Dinteville, with his friend and fellow-diplomat, Georges de Selve, 'The Ambassadors' of 1533, destined eventually to find its way from de Dinteville's chateau to the National Gallery in London, attracts attention as much by its extraordinary collection of still-life objects as

A more emotional portrait than usual for Holbein is this painting of his wife and children: her face seems to reflect the anxieties of the time

by the portrayal of the two Frenchmen. Speculation in fact has never ceased or been satisfactorily resolved as to the meaning of the miscellany of instruments shown, whether as indicative of the diplomats' interest in science, music and curious things, or simply the artist's ability to paint anything. Was the painting of a skull included at an angle a kind of *vanitas* or *memento mori*, or no more than one of those feats of perspective in which the Renaissance indulged? Whoever saw the picture, at all events, would be likely to find in it the fascination of an enigma that it has continued to hold.

The favour of Thomas Cromwell was of weight, at about the same time. He had taken Cardinal Wolsey's place as the King's principal agent. Wolsey's fancied lukewarmness in the effort to obtain papal sanction for the divorce from Catherine of Aragon had in 1529 brought the charge of treason against him. He had died a broken man on the way to his trial. Cromwell, high in royal esteem from the zeal with which he set himself to destroy papal authority in England and make over monastic properties and wealth to the Crown, had become Chancellor of the Exchequer, the King's Secretary and Master of the Rolls when Holbein painted his portrait. The version in the National Portrait Gallery (facing page 3) does justice to the grim features of the 'Hammer of the Monks'—the document so tightly grasped in his hand might well be some warrant of proscription to bring dismay and ruin to a condemned religious house.

By that time Sir Thomas More was a prisoner in the Tower. Unshakeable in religious conviction, 'the King's good servant, but God's first', he refused to subscribe to the sequence of moves that resulted in the Act of Supremacy, making Henry VIII head of the Church in England. What qualms Holbein felt when his first English patron was beheaded on Tower Hill in 1535 can only be imagined. He was already well established as a painter to the Tudor court and inevitably portrayed those in some way concerned in Thomas More's fate; Thomas Howard, third Duke of Norfolk, with the worried expression to be expected in a friend of More who yet felt bound to concur in his condemnation; Sir Richard Southwell who was sent to More in the Tower on the

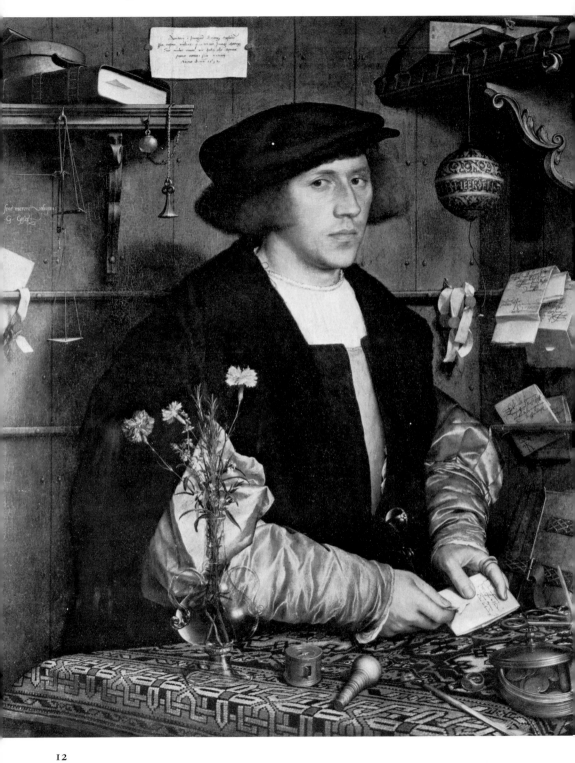

*Left:* Holbein's portrait of the
merchant George Gyze, surrounded by
the properties of commerce

*Above:* 'The Ambassadors' Jean de
Dinteville and Georges de Selve, by
Holbein

mean errand 'to fetche awaye his bookes from him'. Holbein's superb portrait of the King himself, in the version accepted as the work of his own hand (as distinct from the numerous copies) was painted in 1536.

That Henry VIII had any great liking for art is less evident than the taste for luxury in which his inheritance from his millionaire father enabled him to indulge lavishly, and the avidity to add to his material properties by acquisitions such as that of Wolsey's magnificent residence, Hampton Court. In the earlier years of his reign he commissioned the remarkable history pieces glorifying his efforts to give England the status of a great power and illustrating the shifts of his foreign policy. These crowded panoramas by an artist or artists unknown refer to his alliance with the Emperor Maximilian against France; the 'Battle of the Spurs' in which he took part when he invaded France; and finally the alliance with France dictated by the 'balance of power' principle. After

*Above left:* Thomas Howard, third Duke of Norfolk, by Holbein

*Above:* Sixteenth-century copy of Holbein's portrait of Sir Richard Southwell

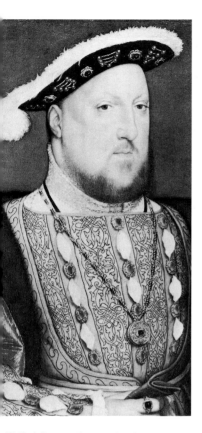

Holbein's superb portrait of Henry VIII, painted in 1536

the departure from Dover, depicted in great detail, came the view of the 'Field of the Cloth of Gold' where Henry and Francis I sought to impress one another with the brilliance of display amid the gilded tents set up at Guisnes near Calais. To the frugal nature of Thomas More, a scene of conspicuous waste was this spectacle of glittering processions, banquets, masques, tournaments and fireworks.

No similar record of historic happenings seems to have been made after 1520, though the King always retained his liking for display. The dynastic image was a matter of permanent concern, the royal portrait of primary importance. He was aware that in Holbein he had at his command an artist of exceptional gifts, by appointment painter to the King from 1538. The story seems credible enough of the sharp rebuke the King gave to a nobleman who complained of having been ejected from Holbein's studio while the artist was at work: 'I can make any number of men of title but I cannot make a Holbein.'

Only Holbein indeed could convey a personality so instantly and formidably recognizable as in his royal portrait. The 'bluff King Hal' is also the Renaissance prince on the model of Machiavelli's *Il Principe*, who would use any means to gain his ends. How suddenly the warmth of affection might turn to a cold and deadly anger could be read in the suspicious eyes, the cruel mouth. Thomas More had remarked to his son-in-law, William Roper, when still high in favour but with a premonitory shiver, '. . . if my head could win him a castle in France it would not fail to go'.

The love of display appears in the sumptuousness of dress and personal ornament, the dual richness of material obtained by the slashings of the doublet filled in with puffs of contrasting texture, the interlaced patterns of gold embroidery, the gold chain, the buttons and rings of precious stones, the fine weave of the pleated, stand-up collar, the plumed hat studded with pearls and rubies. Holbein evidently delighted in the minute pictorial inventory of gorgeous detail as much as the King in its reality.

The greatness of Holbein can be all the better appreciated when his royal portrait is compared with that

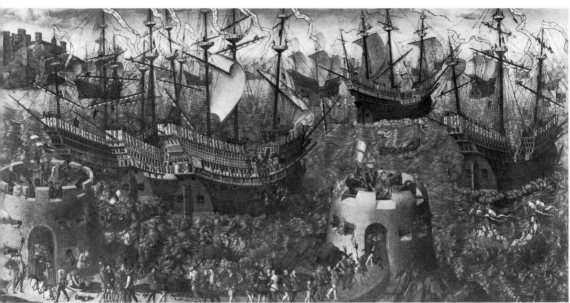

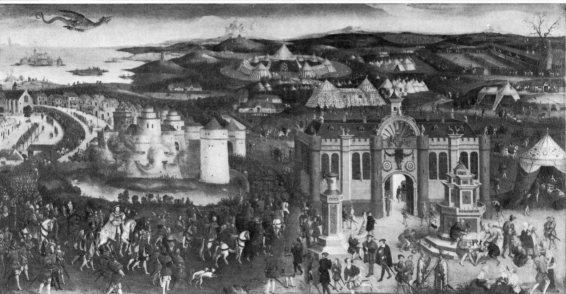

of the Flemish painter Joos van Cleve who produced his version a little earlier. Van Cleve's portrait might be that of any bearded dignitary; Holbein's could be no one but Henry VIII. As distinctive in pose as in facial character, the full-length portrayal of the King gave full value to his exceptional breadth of shoulder and the resolute stance, legs apart, with the suggestion of a colossus bestriding the

*Above:* The Embarkation of Henry VIII at Dover – a history piece by artist or artists unknown

*Below:* The Field of the Cloth of Gold, from the same series of history pieces

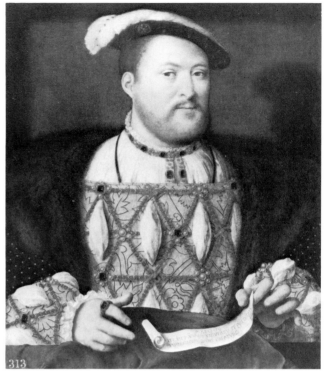

*Above:* King Henry VIII with his father, Henry VII: cartoon by Holbein

*Above right:* Joos van Cleve's portrait of Henry VIII

world. In the welter of suspicion, frustration and violence in which the royal marriages were involved, Holbein seems to pursue his way with all the calm of which the solid, and even phlegmatic, countenance of his self-portraits is an index. He has nothing to tell of Anne Boleyn, Henry's second Queen, save for the decorative flourish of design that heralded her coronation. No subject for a portrait painter, but rather for a dramatist writing in the vein of John Webster's *The Revenger's Tragedy*, was the story of Anne Boleyn's fate after her failure to produce a male heir—the macabre trial with its charges of lust, incest with her brother and adultery with others, at which her own father and uncle sat in judgement, followed in 1536 by her execution with others accused on Tower Green. A drawing of her in black and red chalk by Holbein, that came into the possession of the Earls of Bradford, bears the inscription, ANNA BULLEN DECOLLATA FUIT LONDINI 19 MAY 1536.

It was Holbein's task to paint Henry's third wife, Jane Seymour, whom he precipitately married the day after

17

Anne was beheaded. The portrait of the same year of this daughter of Sir John Seymour, trusted follower of the King, brings before us a plain young woman of twenty-seven attired with all the appurtenances of Tudor fashion, the ropes of jewels, the heavily embroidered gown, the headdress curiously extended and elaborated; with a prim and what might excusably be thought a perhaps apprehensive expression.

Lady Jane Grey, painted by Master John some years before she was made heir to the throne (see page 30)

After Jane died giving birth to a son in the following year, the future Edward VI, another aspect of royal portraiture came to the fore: the likeness that was the first step towards a politically motivated alliance with a foreign family. The Court painter was a necessary go-between when the principals concerned had not even met. A painter in the Imperial service Michael Sittow (or Zittoz), a pupil of Memlinc, known in Spain as 'El Flamenco', had in this role come to England to paint the portrait of Henry VII when, as a widower, he contemplated marriage with Margaret of Savoy, daughter of the Emperor Maximilian. The passable likeness the artist took back was scarcely calculated to stir romantic feeling for the middle-aged King, though this was least of the reasons why the negotiations fell through.

The Protestant alliance Henry VIII wished for, to strengthen his hand against the Catholic powers, directed his attention to the daughter of the Lutheran Duke of Cleves. Holbein was dispatched to the ducal palace to paint her portrait, as evidence of whether she looked a suitable Queen. He may have made her better looking than in fact she was. In the three-quarter length, her features gain in tranquil attraction by contrast with the massive finery of robes and jewels, as ever scrupulously detailed. But the 'Flanders mare', as Henry described her, when seen in reality was disappointing enough for him to have the marriage annulled after six months, by the obsequious Archbishop Cranmer. As the advocate of the match, Thomas Cromwell fell suddenly into disgrace, and only a short while after he had been made Earl of Essex he was beheaded.

Negotiations in another direction, which did not get as far as betrothal, at all events produced a masterpiece: Holbein's portrait of Christina, Duchess of Milan. The

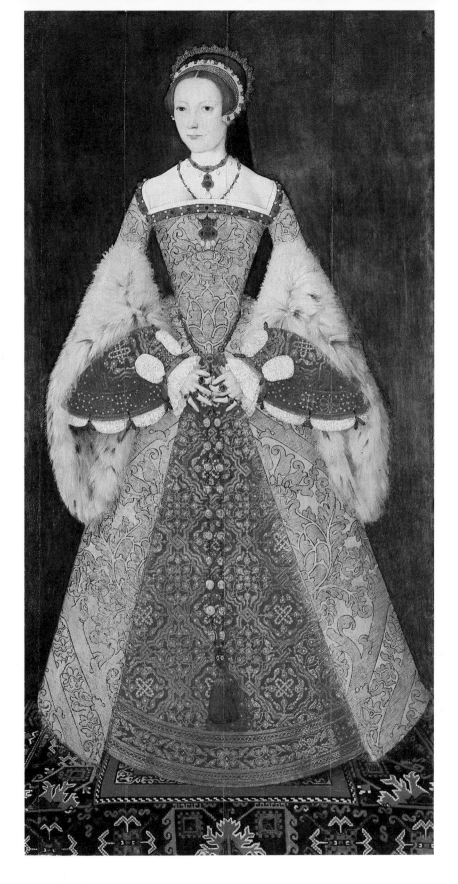

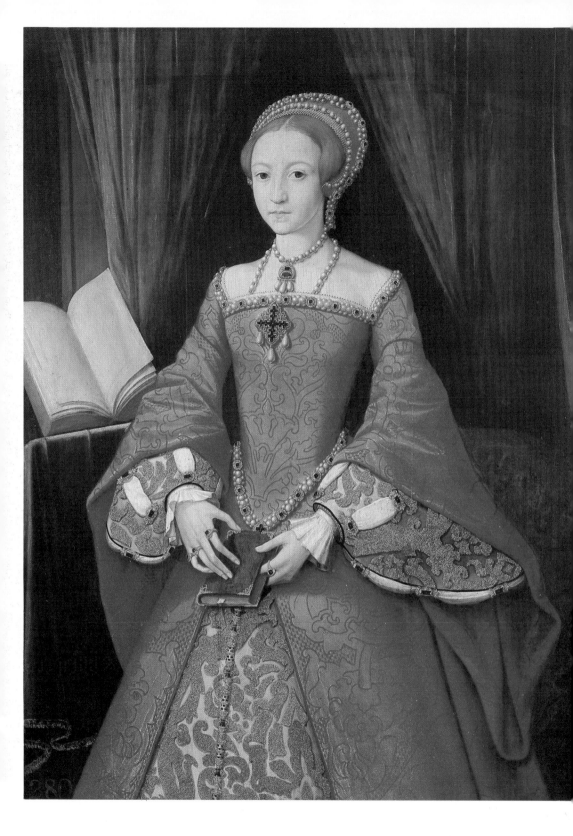

*Left:* Princess (later Queen) Elizabeth, painted when she was thirteen, by an unknown artist (see page 37)

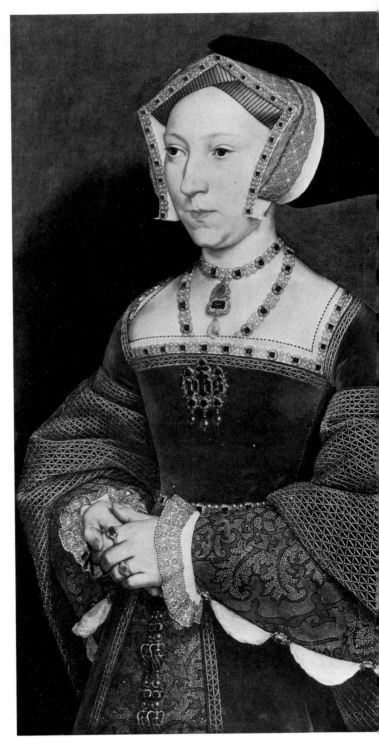

*Right:* Jane Seymour, by Holbein – a prim and apprehensive expression amid the trappings of Tudor finery

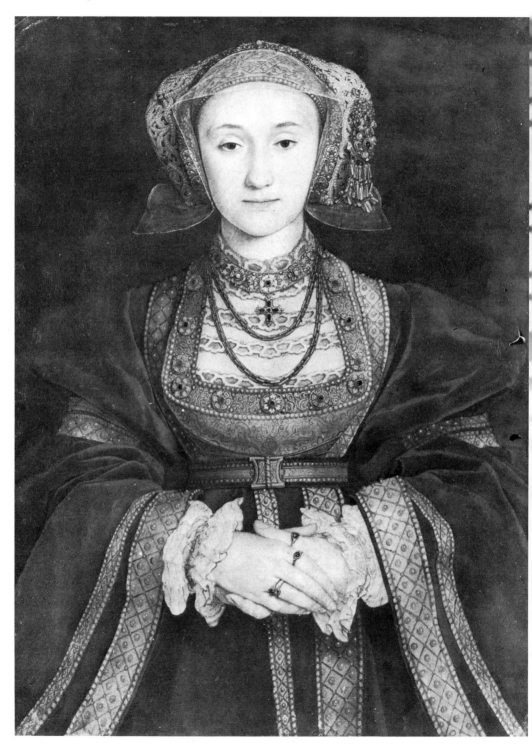

*Left:* This portrait of Anne of Cleves by Holbein may have made the 'Flanders mare' better looking than she really was

*Right:* One of Holbein's masterpieces – his portrait of Christina, Duchess of Milan

daughter of the exiled Christian II of Denmark and
Isabella of Hungary, sister of the Emperor Charles V,
Christina was a girl of sixteen, though already a widow
when the possibility of marriage with Henry VIII was
raised. She had been the child-bride, at the age of twelve,
of Francesco Maria Sforza, Duke of Milan but he had
died a year later. The Hapsburg relationship enabled her
to live in the Netherlands at the Court of the female
Regents, her great-aunt Margaret and after her the
Regent Mary. Holbein went to Brussels in 1538 to paint
Christina's portrait, and in a three-hour sitting at their
only meeting made the sketch for the full-length portrait
in oils that he completed on his return to London. It was
serenely beautiful in design, without the load of ornament
that in other works gives its record of the owner's wealth
and possessions. Nothing distracts the eye from the fresh
and candid countenance, the delicate poise of the hands,
the simplicity of the long robe. Yet the great work of art
did not seal the bargain. Christina married the Duke of
Bar, later Lorraine, the year after Henry made his unhappy
alliance with Anne of Cleaves.

As the officially appointed Court painter, Holbein had
several functions. It fell to him to paint the dynastic group
as well as the single portrait. For the Privy Chamber of
the old Whitehall palace, he depicted on a grand mural
scale the life-size figures of Henry VII and his Queen,
Elizabeth of York; and below them Henry VIII in the
commanding stance that was to be reproduced in many
copies, together with Jane Seymour. When the old
Whitehall Palace burnt down in 1698 the painting was
destroyed, but the seventeenth-century copy earlier made
by the Flemish painter Remigius van Leemput to the
order of Charles II, (still in the royal collection) and the
cartoon, preserved in the National Portrait Gallery,
convey the forceful nature of the composition. The
central sarcophagus round which the figures are grouped
in the copy contrasts in its rigid lines with the Renaissance
opulence of the architectural background. If, as it has
been surmised, the space occupied by the sarcophagus
was in the original a window above the throne flanked by
the royal figures on either side, the effect may have been
still more impressive.

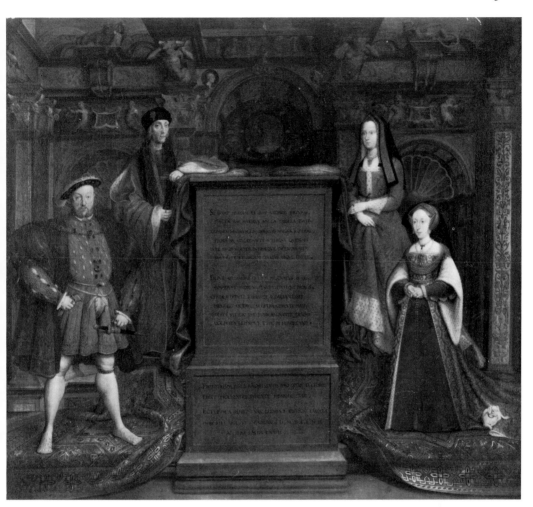

Holbein's dynastic group: a mural for the Privy Chamber of Whitehall Palace, which was destroyed when the palace burnt down in 1698. This copy by Remigius van Leemput survives

In a last composition that Holbein left unfinished, commemorating the presentation of their charter to the Company of Barber-Surgeons, there is an altered conception of the royal presence, no longer realistically seen in fashionable attire but in the remote and symbolic majesty of king enthroned, crowned, wearing the robes and carrying the sword of state. The ancient device of making the ruler larger than his subjects proclaims Henry's dominance amid the assembled barber-surgeons. The formalized image not only recalls a past tradition but foreshadows a changed attitude in the Elizabethan age to come.

Holbein was in completeness a Court painter in his

extensive portrayal of the officials, diplomats, and aristocratic following, male and female, of the Tudor Establishment. The superb drawings in the Royal Library at Windsor, brought to light long after his day and carefully preserved by George II's consort, Caroline of Anspach, had an immediate utility for him in giving the sitter a first idea of the finished work and serving as his guide in the painting executed without the sitter's being present. Apart from this practical value the portrait drawings were masterpieces in themselves. Holbein had inherited his father's faculty for precise observation, first displayed in early silverpoints. In his later use of black and red chalk it is possible he took up the method of his French contemporaries, Jean and François Clouet, carrying further their lucidity of graphic style. In his portrayal, the Tudor lords and ladies come to life in a way that seems to bridge the centuries and bring them—in outward features at least—close to the present day.

The activities of the Court painter did not stop at portraiture. Holbein was commissioned to design objects of many different kinds. Acquaintance with the Renaissance art of northern Italy, dating from a visit to Milan, and the example of Holbein the Elder's father-in-law Hans Burgkmair in the use of Renaissance motifs, had equipped him with a repertoire of ornament which he applied with zest to a variety of purposes. There were suits of armour to be ornately patterned. Grown obsolete in war, they were a decorative feature of the jousts and tournaments that had a revived popularity, paying nostalgic respect to a vanished Age of Chivalry. Vessels of gold and silver; jewellery; the clock commissioned by Sir Arthur Denny as a New Year's gift to the King; a fireplace for the projected royal palace of Bridewell; the ornamental gatehouse that was quaintly distinctive amid the rambling buildings of Whitehall—all came within his scope as a designer.

With the facility he had always shown in graphic illustration (of which the woodcut 'Dance of Death' series is a famous example) he produced the title-page for Miles Coverdale's translation of the Bible, published in 1535 and authorized (to quote the wording of a later edition) by 'oure most redoubted Prynce and soveraygne Lorde,

Kynge Henrye the VIII, supreme heade of this his churche and Realme of England; to be frequented and used in every churche within this his sayd realme . . .' The title-page included the figures of Henry VIII, Archbishop Cranmer, and Thomas Cromwell, at whose instance this first of the 'Great Bibles' was prepared. That the arms of Cromwell were cut out of Holbein's design in the fourth issue of 1540 is a comment on the dire fate he had by then met with.

The tale of Holbein's many-sidedness was completed in his later years by the practice of miniature painting, or 'limning' as it was called. Though the medieval art of manuscript illumination, from which the 'limning' was derived, was by then virtually extinct, its legacy remained in the technique of the small portrait considered as a kind of jewel to wear or to give as a present. Instead of the sober tones of the oil painting, a brilliance of colour to match a framework of gold and enamel was called for. Holbein is said to have been instructed in the art and craft by the Flemish painter Lucas Horenbout, who had long been employed in the King's service. The understanding which Holbein quickly gained of the qualities that made the miniature distinct is to be seen in the rich blue ground, the crisply silhouetted forms, the avoidance of emphasis on light and shade, in his beautiful miniature of the young Mrs Pemberton, *c.* 1540–43.

Attributed to Holbein is the miniature of one more unfortunate Queen, Catherine Howard, niece of the Duke of Norfolk. Married to the King in 1540, she was accused by Cranmer in the following year of pre-nuptial intimacies with her music master, and of other offences resembling those with which Anne Boleyn had been charged. The same fate awaited all those involved. They were executed in 1542. About the same time Holbein painted his self-portrait in miniature, with his habitual calm of expression, unaffected to outward seeming by the fury of events. With the death of Holbein at the comparatively early age of forty-five, in one of those epidemics generically known as the plague, in 1543, a new era of Court painting begins.

Mrs Pemberton by Holbein

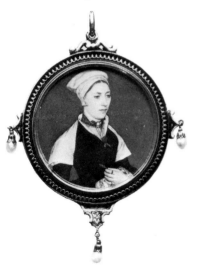

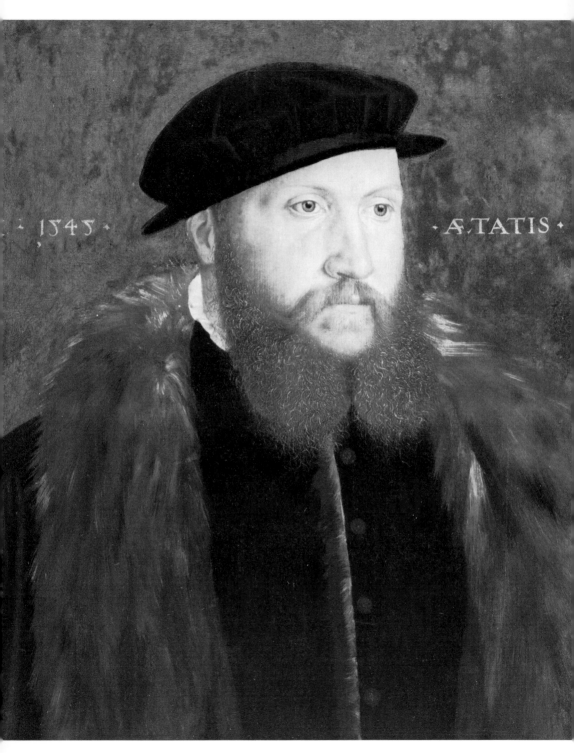

· 1545 ·  ·  ·  Æ·TATIS ·

## Chapter 2
## Tudor Court painters after Holbein

One of the greatest European artists and an observer of Olympian detachment, Holbein stands alone in Tudor England. His genius was so far personal as to leave no tradition. Numerous copies were made of his works in his own time and after. Replicas of the royal portraits especially were called for, their wide distribution being a necessary item of propaganda, but how his studio was run and who were the assistants he must have had, remains unknown. Only one painter can be named as being close enough to Holbein in style to make it possible that he worked with the master, and applied his way of painting and seeing in portraits of his own. This was an Englishman, John Bettes. A single picture is the only certain evidence, the excellent portrait of a bearded man now in the Tate Gallery. Otherwise he is as obscure as a shadowy miniaturist of the same name with whom the dubious attempt has been made to identify him. It is a minor puzzle, though not beyond reasonable explanation, that the inscription on the portrait *faict par Johan Bettes Anglois* should be in French. There can be no doubt however of the Holbeinesque stamp of character of which little trace was otherwise left.

The artist who succeeded Holbein as King's Painter, William (or Guillim) Scrots (or Scrotes), in the alternatives of Tudor spelling, marks a changed direction of effort. Art in Europe had moved past the Renaissance peak into the phase that has come to be known as Mannerism. The term implies an extravagance of style and distortions of various kinds for the sake of emphasis, for example the elongation of the figure to heighten gracefulness of effect that was a sixteenth-century development in Florence. Italian in origin, the Mannerist style quickly spread abroad, was brought to France by the artists Francis I employed, and had its exponents in the Netherlands—Scrots among them.

A Court painter to the Regent of the Netherlands,

Man in a Black Cap by John Bettes

Mary of Hungary, he came into the service of Henry VIII after Holbein's death and was provided with an annual grant of £62 10s. This was continued through the period when Henry's son Edward VI, a delicate boy under the guidance of Protectors, ruled in name. The allowance stopped at the time of Edward's death in 1533, when it is likely the artist left the country. All that is known of him otherwise is what a few paintings suggest of his interest in elaborate accessories and ingenuities of technique. They were least obvious in the full-length portrait of Edward VI, intended to present the image of a possible son-in-law to Henry II of France. The boy Edward stands in pose somewhat pathetically imitative of the massive straddle of his father as pictured by Holbein. Mannerist ingenuity was a main feature of the panel portrait of Edward distorted in a way that needs a special viewpoint to be seen in normal profile. This trick of perspective, used incidentally in Holbein's 'The Ambassadors', was no doubt a fascinating curiosity for visitors to Whitehall — as it now remains for visitors to the National Portrait Gallery. Startlingly unlike the sober approach of an earlier day was the portrait attributed to Scrots, existing in several versions, of Henry Howard, Earl of Surrey. Invention ran riot in the surround of architecture and emblems of classical sculpture. The mannerism of fashion as well as art is reflected in the fantastic ornament of the Earl's attire and the fastidious elegance of his attitude as he leans on a broken column. The elaborate display assorts oddly with the grim realities of the mid-sixteenth century and the unfortunate destiny of Surrey, soldier and poet. Secure as the Tudors might seem, they were nervously aware of the never quite exorcized threat of revolt or usurpation. That he assumed the arms of his ancestor Edward the Confessor, in addition to his own,

The distorted perspective of this panel-portrait of Edward VI by William Scrots still intrigues viewers

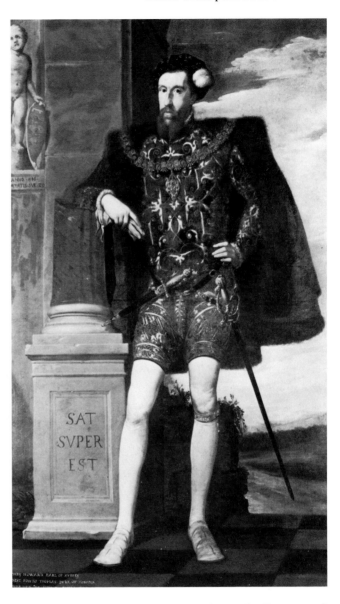

Portrait of Henry Howard, Earl of
Surrey, attributed to William Scrots

made possible the charge of pretension to the Crown, and
decreed his execution in the last year of Henry VIII's
reign.

What became of Scrots after his official allowance
stopped at the time of Edward VI's death in 1553 is not
known. It could be he left England, deterred by the
ominous atmosphere of impending calamities. The
quarrels of religion and the questions of succession with

29

which they were linked provoked fresh and increasingly intense outbursts of violence. The Puritan fury that wrecked churches and destroyed their sculpture and stained glass met an equally violent reaction in favour of the old religion. It is possible that Scrots painted the Catholic princess Mary Tudor, daughter of Catherine of Aragon, in retirement while Edward lived, but as the pensioner of the Protestant regime of which the Protectors Somerset and Northumberland were in turn the overseers, he had little to expect from Mary I as Queen.

The work of one 'Master John', so known from the entries in the official records of expenditure, was another departure from realism towards the formalized image. Attributed to him is the portrait of Lady Jane Grey (facing page 18), probably painted some years before Edward VI was induced to make her heir to the throne and, in doing so against her wishes, signing her eventual death warrant. The picture attracts by an almost doll-like character. 'Master John' might be imagined as a craftsman interested above all things in symmetries of line, in the pattern of sleeves and cheerful touches of bright colour and gold, rather than as making any more serious inquiry into personality. Very different was the art of Anthony More, as he was sometimes known in England, a painter so much associated with various courts as to have an alias for each. Born at Utrecht Anthonis Mor van Dashorst, he was the pupil of an artist of international experience, Jan Scorel. He was admitted to the Antwerp Guild in 1547, travelled in Italy and worked in Antwerp, Lisbon and Madrid where he was known as Antonio Moro, becoming portrait painter to Philip II.

The light and shade of Titian, and the sombre atmosphere of the Hapsburg courts, contributed to his style of portraiture. With this equipment he came to England in 1554 to paint the portrait of the Queen, now committed to marriage with the least acceptable husband she could have chosen, in the view of most of her subjects—Philip II of Spain. Without flattery, unless the appearance of ruthless determination could be regarded in that light as being acceptable to the sitter, she is, as portrayed by More, one of the most memorable of

characters. In the pinched features, the compressed lips, it is easy to discern the intent to reverse what had passed for reforms: to restore the Latin Mass, to suppress the Books of Common Prayer, to re-enact the statute that allowed for the burning of heretics and to destroy all who stood in the way, from Edward VI's Protestant mentor, Northumberland, and the poor 'ten-days queen', Jane Grey, to the many martyrs to religious principle who were burned at the stake. They included Cranmer, hated for his support of the Coverdale Bible.

The presence of More in England was an interruption, just as in a wider sense the five-year reign of Mary interrupted the course of Tudor history. There was no inducement for a servant of the Hapsburg empire to stay on in a country that hated and feared his employers. He was better off, and richly rewarded, in the courts of an international Catholicism in Spain and the Spanish Netherlands, where he had the favour of the dread Duke of Alva. He settled at Antwerp and died there in 1575. For any artist there was little propitious in an England bedevilled by attempted insurrections, savage persecution, religious conflict raised to a new pitch of bitterness. Yet Court portraiture was still a requirement, and the confusions of the time did not stop the inflow of painters from the Netherlands.

One of them was Hans Eworth, about whom and whose work there has been much to engage the speculative interest and detective inquiry of modern scholars. The spelling of his name has added confusion to the little that is known about him. In Tudor orthography he appears in the several guises of Haunce Eworth, John Ewottes, Hans Heward and a score of variations more. His initials have produced a further complication even to the length of tail of the second letter forming the monogram, H.E. There is an observable difference between the E normally shaped in the signature of pictures now attributed to Eworth, and the extended letter that seems to include L in the monogram of others. The eighteenth-century enquirer, George Vertue, who examined many early works with a view to identifying their painters, concluded that all those signed H.E. were by another Fleming in England, Lucas de Heere—which has left a good deal to be sorted out.

It is assumed that Hans Eworth was of Dutch origin, and that he is identical with Jan Eeuworts listed in 1540 as a freeman of the Antwerp Guild of St Luke. He came to England about the time of Mary I's accession and became a denizen in 1550. There are several portraits of the Queen said to be by him. He continued active during the reign of Elizabeth, painting members of her Court though he is not known to have painted Elizabeth herself. Eventually he was employed in the Office of the Revels, a state department instituted by Henry VIII for the organization of the pageants, tournaments and masques the Tudors delighted in. When England came into alliance with France against the menacing power of Spain, it was Eworth's task to design costumes and decor for the ceremonial reception of the French delegates who came to London in 1572 to ratify the agreement.

*Above:* Sir John Luttrell by Hans Eworth

*Right:* Eworth's portrait of Mary Neville, Baroness Dacre

The pictures by, or probably by, Eworth include a number of exceptional quality and character, though showing him receptive to varied influences. The allegory or pictorial metaphor was one of the channels by which a painter might escape from the routine of portraiture and at the same time pay a courtly tribute. A remarkable work by Eworth in this category was the allegorical portrait of Sir John Luttrell, painted in 1550 with an evident allusion to the peace obtained in that year by England's surrender of Boulogne to France. Luttrell, soldier and merchant adventurer who died in 1551 when about to embark on a voyage to Morocco, is seen wading through the stormy seas of war towards the figure of Peace who leans from above to pat his arm. The inset allegorical scene by another hand suggests a friendly collaboration with an artist of the Mannerist French School of Fontainebleau.

Eworth was well aware of Holbein's greatness. In his likeness of Mary Neville, Baroness Dacre, the portrait by her side of her dead husband (hanged for murdering his park keeper) is a perfect Holbein, copied with obvious appreciation and contrasting in its simplicity with the crowded decor in which the Baroness is seen. Eworth's own sense of character is vivid in the double portrait of Frances Brandon, Duchess of Suffolk, mother of Lady Jane Grey, and Adrian Stokes who became her second husband. There is a hint of comedy in the manifest

*Below:* Frances Brandon, Duchess of Suffolk, and Adrian Stokes, by Eworth

difference of years between the mature Duchess and her handsome Master of the Horse, sixteen years her junior. Scandal attached to the marriage, partly because of its haste soon after the Duke of Suffolk had been executed for his complicity in the Wyatt rebellion, and not least because she married beneath her. As Horace Walpole tells the story, Queen Elizabeth exclaimed to Lord Burleigh: 'What! has she married her horse-keeper?' to which he answered: 'Yes, madam, and she says Your Majesty would like to do so too,'—thus crediting the Duchess with a reference to the Queen's fondness for her own Master of the Horse, the handsome Robert Dudley, Earl of Leicester.

Mrs Wakeman by Hans Eworth

Something of the sombreness of Mor's style appears in another masterpiece, the portrait of Mrs Wakeman with its inscription lamenting the passage of her youth. Other works show an increasing use of rigid Mannerist formulas such as may be found in the companion portraits of James Stuart, first Earl of Moray, and Agnes Keith his Countess, which Eworth went to Scotland to paint.

In these, as in other works of the time, the stiff outward semblance was the cover for desperate events and passionate and tragic episodes. The dangerous age in which they lived was to prove fatal to many of Eworth's sitters. Involved in the dark tangle of events round the person of Mary Queen of Scots, Moray was to be assassinated by one of her supporters. The Lord Darnley whom Eworth portrayed as a boy was soon to play his notorious part as her consort, to encompass the murder of her secretary David Rizzio, and at last to be blown up by gunpowder while he slept in Edinburgh. The portraits of Thomas Howard, fourth Duke of Norfolk, and his wife, in all their Court finery in the early years of Elizabeth's reign, once again went before a sorry fate. Norfolk had a part in the conspiracy of the agent Roberto di Ridolfi to overthrow Elizabeth's government. He was arrested when the plot was discovered and executed for treason in 1572. How long Eworth continued in Court employment after 1573, when he was still with the Office of Revels, seems uncertain. By that time Court painting was taking on a new complexion.

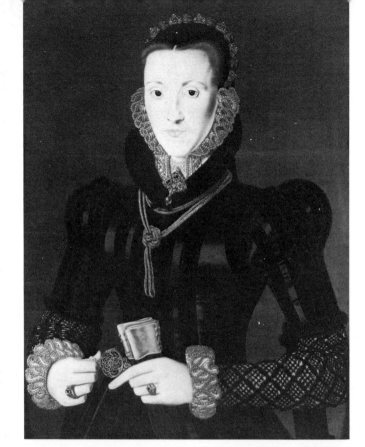

Agnes Keith, Countess of Moray, by
Hans Eworth

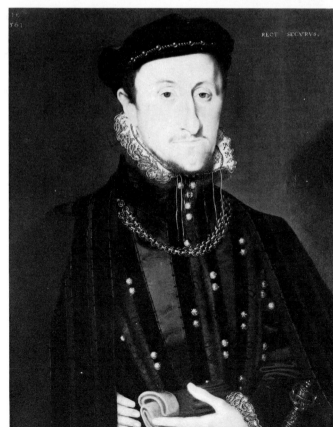

James Stuart, first Earl of Moray, by Hans
Eworth

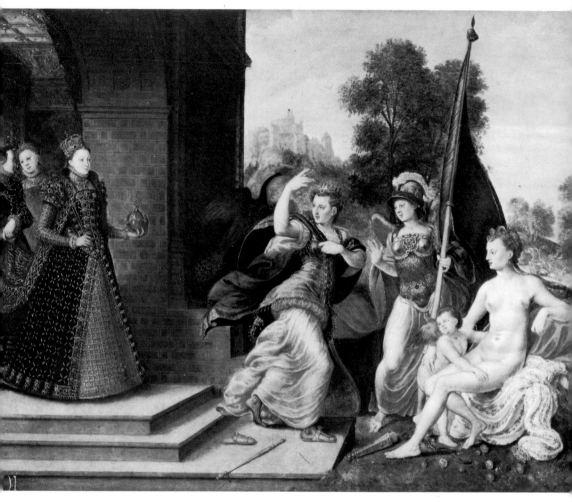

Queen Elizabeth I and the three
goddesses, attributed to either Hans
Eworth or Lucas de Heere

# Chapter 3
## Queen Elizabeth I and the painters

A difference would only be natural between the portrayals of Queen Elizabeth as a girl and those of her mature years—the record of a normal progress from youth to age—but more remarkable than this in her portraits is the change from simplicity to enigma. It can be measured by comparing the likeness presumed to have been painted for Henry VIII in 1546, when she was thirteen (facing page 19), with the unrevealing icons that were to come later. The painter of the first is unknown, but in a competently Flemish style he depicts the daughter of Anne Boleyn as quiet and studious-looking, ornament in her attire as secondary to the plainness of line that emphasizes her youth.

Great is the contrast with the awesome fantasy of the later portraits: the pallid, mask-like features, the extravagance of headdress and ruff, the padded ornateness that seemed to exclude all humanity. In arriving at this result the dictates of the Queen were an operative factor, coinciding with a trend in art that led away from realism. There is nothing to show that at any time she was greatly interested in the work of art as such; or in any way concerned with aspects of art other than the presentation of the royal image. An allegory which was also a piece of pictorial flattery presumed to have been painted for her, was 'Queen Elizabeth and the Three Goddesses'. Richly dressed, wearing her crown and carrying orb and sceptre, the Queen takes the role of Paris in judging the classical beauty competition of Juno, Minerva and Venus. The three goddesses are thrown into confusion by her appearance, thus implying that she outshines them all. The composition—Mannerist in its curious arrangement—though it has been attributed to Eworth, was possibly, as George Vertue surmised from the signature, the work of the Flemish painter, Lucas de Heere, who had a leaning towards poetic fancy. On this assumption it is possible also that rather than commis-

sioning the work she graciously accepted it as a tribute from a visiting foreign artist.

Opposed increasingly as time went on to anything in the nature of a realistic likeness, she was an adverse critic of the light and shade that was its means. The miniaturist Nicholas Hilliard reports the conversation they had on this subject in which she maintained, and he concurred, that shadow should be avoided. Vanity may have had some part in the wish for an unwrinkled smoothness of countenance, though the results have made it hard to know exactly what she looked like. There is only one rendering of her ageing features that seems a plausible resemblance, the unfinished miniature by Isaac Oliver — unfinished, it may be, because too like.

She could scarcely have wished to be portrayed with the 'goggle throat' and other personal shortcomings remarked on by Bishop Goodman in his *Memoirs of the Court of James I*—an unflattering description that verged on caricature. But something more than vanity is needed to explain the avoidance she insisted on of entirely personal characteristics in her portraits. The virginal image that became an established convention had its bearing on both foreign and domestic policy. The balance of power between the great ruling houses of the Hapsburgs under Philip II of Spain and the Valois in France could be tilted either way by matrimony. England was a sought-after addition to the properties of the rivals. The Spanish Ambassador, Mendoza, summed up the Queen's position in saying: 'I see clearly that all will turn upon the husband whom this woman will choose.'

The answer being to avoid commitment to either of equally dangerous alternatives, the image of the 'Virgin Queen' steadfastly maintained was a political safeguard. At home, and in another way, the idea was calculated to win devotion for the Queen by a psychological transference that made her almost a substitute for the religious conception of the Virgin.

Emblems in portraiture could stand for virtue as well as majesty. A learned woman, after a long seclusion under the tutelage and in the company of scholars, well read in the classics, fluent in French and Italian, and not unaffected by the poetic spirit of the times, Elizabeth was

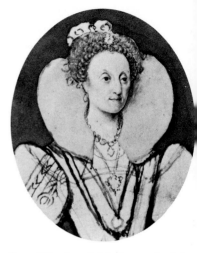

Isaac Oliver's unfinished portrait of the ageing Queen Elizabeth

*Right:* Emblems abound in portraits of Queen Elizabeth: in this one by an unknown artist, the sieve she holds is an emblem of virginity

38

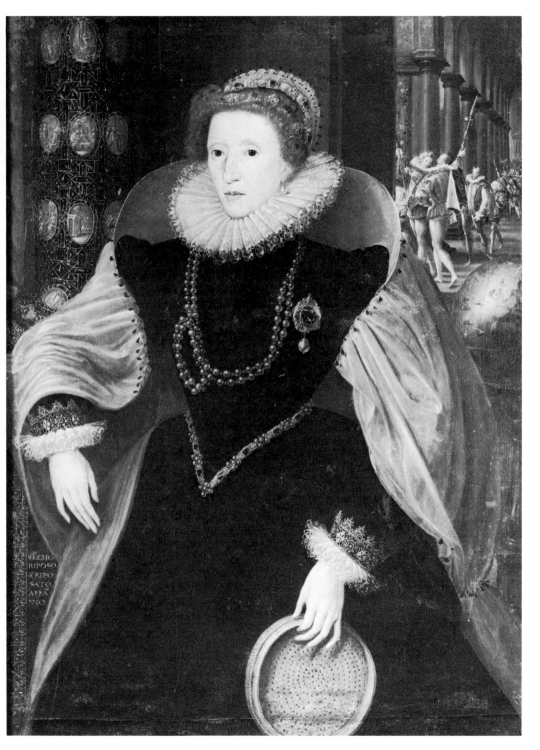

well able to give a lead to the painters in the symbolism they used. The sieve she holds in the portrait by an unknown painter, said to have been her favourite device, refers to the test of chastity triumphantly passed by the Vestal Virgin, Tuccia, who to prove her continence filled a sieve with water from the Tiber and brought it back, with no drop lost, to the Temple of Vesta. The ermine in unblemished white fur that nestles on her sleeve in the portrait at Hatfield House was an emblem of similar purport.

There was a further use in emblems to signify the extent of her authority and the new Golden Age represented by her reign. She towers above the map on which she stands in the 'Ditchley' portrait (facing page 66), a pictorial sequel to the entertainment provided for her by Sir Henry Lee at his house at Ditchley in 1592. The globe is subject to her imperial will in the 'Armada' portrait of which, in celebration of that decisive victory, several versions were made. Engravings gave a wide circulation to the portraits that combined majesty with eternal youth. The sumptuous fantasy of dress, the ruff expanding into an extravagant double collar round the ageless features, the gown bejewelled and vastly hooped, gave a dazzling impression of 'the admired Empresse through the worlde applauded', the embodiment of the ideal Gloriana who was her counterpart in Edmund Spenser's *The Faerie Queene*.

Though astonishing works were produced on a large scale and with an almost Byzantine formality of style, the miniature was the most typical product of the Court art of Elizabeth's reign. As practised by such an artist of genius as Nicholas Hilliard, the small portrait, usually not measuring more than an inch or two, took on a singular beauty and had an influence on painting generally out of all proportion to its size and intimate use. The miniature was a sign of personal affection and friendship, a memento to be kept at hand in the private cabinet, a gift to the favoured lover or acquaintance. The technique, a continuance of the art of manuscript illumination, was necessarily minute in detail, the artist working with fine brushes in opaque watercolour on a parchment ground. The result was made the more precious by an ornamental

The 'Ermine' portrait of Queen Elizabeth I, sometimes attributed to Nicholas Hilliard

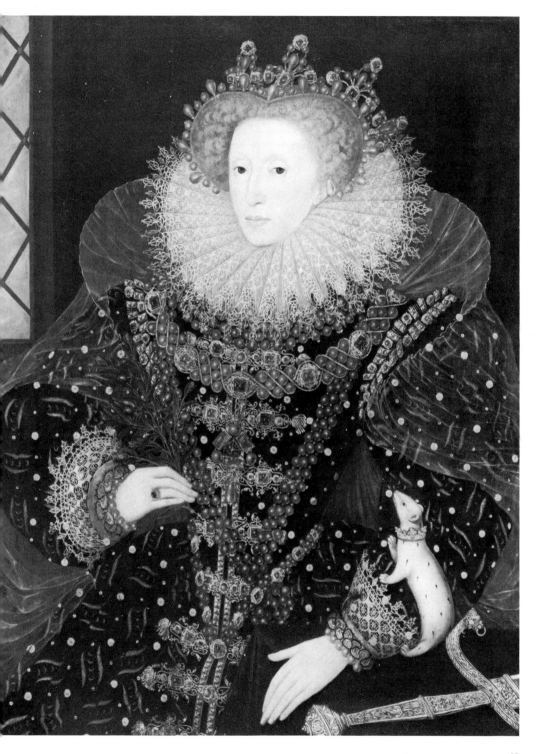

frame of gold or silver that made it as much a jewel as a picture.

In these respects, as Nicholas Hilliard himself was at pains to point out, it was 'a thing apart from all other painting or drawing'; not an item of house furniture or design for some larger work, but an exquisite object for contemplation. Both the scale and the link with jewellery made for the use of pure and brilliant colour. Fresh in contrast with the darkly toned canvases of immigrant practitioners of oil-painting, the art of the miniature was like a burst of lyric song, a parallel with the 'flourishes and fragrant flowers' of Elizabethan verse.

Though particulars of Hilliard's life are fragmentary, he is the one artist of his time of whom it is possible to gain an individual impression. He is to be seen in the self-portrait of 1577, at the age of thirty, with a look of lively intelligence, a neatly trimmed and pointed beard and a spruceness of dress that seems to proclaim his distance from the craftsmen whose more laborious media called for rough working-clothes. It was his own dictum that the miniature was an art proper for a gentleman to practise. Members of his family, as he depicted them, come to life with equal vividness; his father Richard Hilliard, goldsmith of Exeter and local dignitary, snugly prosperous in his fur-tipped gown; his first wife, the young Alice Brandon, with all the delicate bloom of her twenty-two years, daughter of Robert Brandon, the Queen's goldsmith who had been Hilliard's master in the craft.

At all times, in the reign of Elizabeth and for several years in that of James I, Hilliard worked as miniaturist, goldsmith and engraver. By his own account he modelled his 'manner of limning' on the miniature portraits that Holbein had produced in his later years. Though in various ways he departed from the earlier master's example, he took a similar advantage of the pleasing background quality of a rich cerulean blue, the silhouetted forms that made black and white the equivalent of colour in incisive brilliance, the arrangements of lettering that became a decorative adjunct.

Less obvious an influence, but also an object of his admiration, was Albrecht Dürer. Hilliard's *Treatise concerning the Arte of Limning*, extant in a single

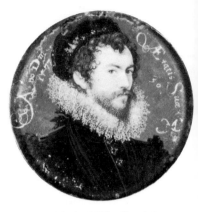

*Above:* Nicholas Hilliard's miniature self-portrait

*Right:* Hilliard's manuscript – a page from the only copy extant of his *Treatise concerning the Arte of Limning*

1 Complection
2 Proportion       Being the favore
3 Countenance

So remember the goodnes of a picture after the liffe, standeth
cheifly allso uppon these points

1 Liffe    wch cheifly consisteth in these    Eye
                three features                 nose
2 Favor                                        mouth
3 Lines

manuscript copy made in the early seventeenth century, from which an edition was printed in 1912, advocates hatching with a pen in imitation of Dürer as an exercise prior to limning. This prepared the way for the subtle delicacies of modelling appropriate to the art, to be obtained 'with the pointe of the pencil by littel light touches with cullor very thine'.

His references to art past and present bear witness to his intelligent receptiveness of mind. A stay in France, when he worked for a while for the Duke of Alençon (a Valois candidate for Elizabeth's hand), introduced him to the refinements of French Court art, as well as to the renowned poet of the *Pléiade*, Pierre Ronsard. His conversation with Queen Elizabeth, quoting her opinion 'that best to show oneself nedeth no shadow of place but rather the oppen light', while not exactly dictating his style, suggests the measure of accord between them that made him her favourite and officially designated 'Queen's Limner'.

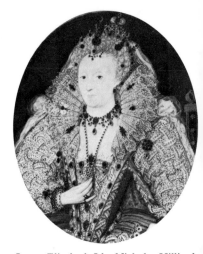

Queen Elizabeth I by Nicholas Hilliard

In the remarkable series of royal portraits beginning with that of 1572, he gave a tactful indication of the pale features, the small dark eyes, the hooked nose, with due attention to her panoply of jewels. It is likely enough that Hilliard's skill as a goldsmith fashioned the 'Phoenix' jewel, a truly regal profile in gold set in an enamelled frame of Tudor roses, red and white, the reverse side bearing beneath the royal monogram the phoenix, emblem of chastity, rising from the flames.

The 'Phoenix' jewel, possibly made by Hilliard, has a phoenix rising from the flames on the reverse side

Hilliard retained his Court appointment under James I. The united skills of artist and craftsman appear in the 'Lyte' jewel given by James I to Thomas Lyte the genealogist, who won favour by drawing up a comprehensive pedigree, tracing the King's ancestry back to the supposed founder of the British nation, Brut the Trojan. Hilliard's portrait of the King was set in a wonderfully ornate locket, studded with diamonds and rich in openwork enamel design.

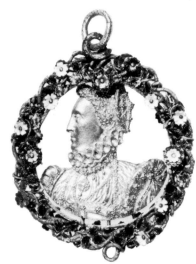

The Court, in the broad sense that comprised all the aristocratic, handsome, talented and highly literate company that basked in the royal ambience, held Hilliard in high esteem. In addition to such patrons of the arts as Elizabeth's favourite, Robert Dudley, Earl of Leicester,

*Above:* The 'Lyte' jewel, given by James I to Thomas Lyte

*Right:* George Clifford, Earl of Cumberland, portrayed as Queen's Champion by Nicholas Hilliard

and Henry Wriothesley, Earl of Southampton (the possible Mr W. H. of the Dedication to Shakespeare's Sonnets), were all the many enamoured of poetic and even fantastic expression. To trace this current of ideas and fashion was one of Hilliard's achievements, incidental to his portraiture. To recall the chivalry of an imagined past was a nostalgic indulgence of the age, brought to an absurdity of splendour in the fanciful attire and pageantry of the mock battles of the tiltyard. The portrait of George Clifford, Earl of Cumberland as Queen's Champion, with the royal glove pinned to his plumed hat and spangled coat over his star-studded armour, holding an ornamental lance, sums up the heroic pose.

45

An attitude of another kind appears in those portraits by Hilliard in which his own poetry of feeling was combined with the delight of a poetic generation in the symbols that stood for the ardours of love. The flames of passion turned into a flamboyant background must have been a gratifying conceit to the unknown sitter round whose portrait they burn. Directly or indirectly the sentiment of Petrarch's lyrics declaring his unrequited passion for Laura must have been transmitted to England, fostering a mood of love-sick melancholy, just as at a later time Goethe's *The Sorrows of Young Werther* filled Europe with a fashionable despair. Hilliard's 'Young Man leaning against a Tree' with hand on heart may call to mind the melancholics of Shakespeare, and at the same time it marks the highest level of a purely Elizabethan art in the freshness of colour and the briar rose pattern so lyrically realized, in a setting at once natural and symbolic.

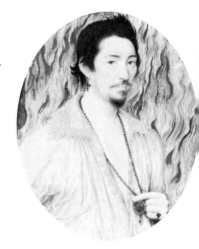

*Above:* 'Flames of Love' – portrait of an unknown man against a fiery background, by Hilliard

*Below:* 'Young man leaning against a tree' marks the highest level of a purely Elizabethan art. By Nicholas Hilliard

Painting at Court was much influenced by Hilliard in two ways. He stands at the head of a line of miniaturists. His example in design and colour was also fertilizing in effect on the work of portrait painters on a larger scale. He had an able pupil in the miniaturist Isaac Oliver, who was of French origin, the family history recalling the deadly strife of Catholic and Protestant that poured refugees into England from France as well as the Netherlands. Oliver's parents were Huguenots from Rouen who brought him to London as a child in 1568. Hilliard's lessons in 'limning' were supplemented by a visit to Italy, and a classical element, derived from Oliver's study of Italian art, is traceable in his work. In the reign of James I he was Hilliard's rival, and while the latter retained his status and privileges as King's Limner, Oliver was favoured by James I's Queen, Anne of Denmark, and their son, Henry Frederick Prince of Wales, until the Prince's death from typhoid at the age of eighteen cut short his promise as a patron of discernment.

In comparison with Hilliard, Oliver was more of a realist, less poetic in feeling and less inclined to regard the miniature as an art distinct from that of the larger-scale panel or canvas. His unfinished portrait of the ageing Queen Elizabeth (page 38) in no way evokes the myth of

'Young man reclining against a tree' by Isaac Oliver: this picture contrasts with that of Hilliard on a similar theme

Gloriana, the eternally youthful Spenserian Faerie Queene. His full-length portrait of a young man reclining against a tree supposed—though not beyond doubt—to represent Sir Philip Sidney, contrasts with Hilliard's treatment of a like theme. The sparkling silhouettes of Hilliard's young man amid the briars are replaced in Oliver's portrait by subdued qualities of tone. Melancholy itself has its shades of nice difference. The affected pose of the lovelorn courtier is quite unlike the attitude of serious meditation of Oliver's sitter.

Far from wishing to keep limning as a gentlemanly preserve, Oliver was ready enough to paint on a normally large scale. Though Hilliard rarely did so, his emancipated use of colour as a source of pleasure in itself and

47

his decorative sense gave a new impulse to a number of painters, making for the distinctively late-Elizabethan style. George Gower, no 'stranger' (as the word was applied to artists of foreign origin) but a Yorkshire gentleman turned painter and appointed Sergeant-Painter to the Queen in 1581, was one of those so influenced. His gaiety of colour is delightfully exemplified in his portrait of Lady Kytson which, together with that of her husband Sir Thomas Kytson, is in the Tate Gallery. A decorative masterpiece was his portrait of the Queen which celebrated the defeat of the Spanish Armada.

The Elizabethan style is distinct in the works of Robert Peake to whom is attributed the remarkable processional picture, *c.* 1600, in which Queen Elizabeth is borne along, almost like an Oriental idol, in a kind of palanquin on the shoulders of her retainers, preceded and followed by a noble throng. William Segar, who eventually became Garter King of Arms and was knighted by James I, was close to Hilliard in style. It has remained a question which of them was responsible for the portrait of Elizabeth (page 41) using the formula of splendid costume and ageless features, with the ermine, symbol of chastity, on the royal sleeve. Enlightened modern study of the period has brought into new prominence William Larkin as a master in the Hilliard tradition. His series of full-length portraits, gorgeous in pattern and detail, and distinctive in a form of Mannerism that imparted a curious geometrical interest to the folds of curtains and costumes, was a magnificent finale to art in the Elizabethan age.

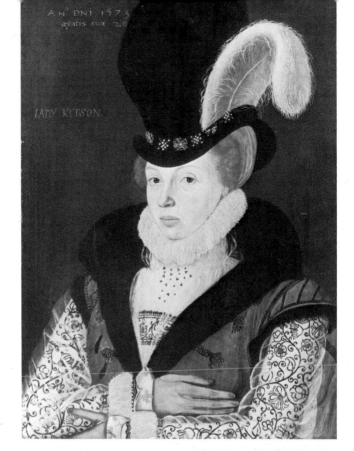

Lady Kytson by George Gower

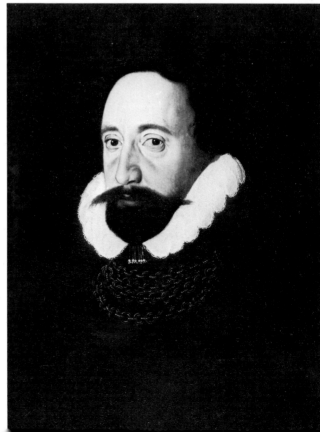

Sir Thomas Kytson by George Gower

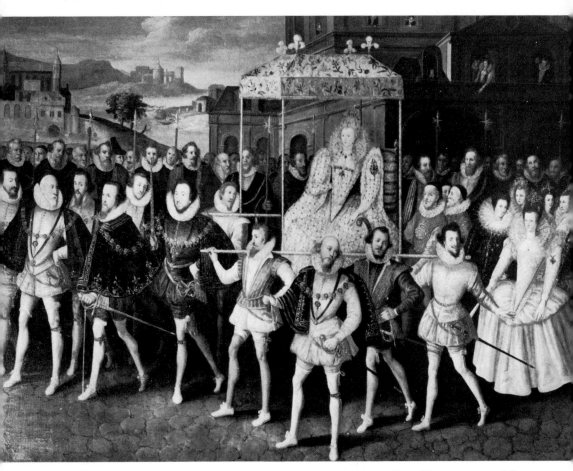

*Above:* The procession of Queen Elizabeth I, probably by Robert Peake, painted in about 1600

*Right:* Lady Cary by William Larkin, now regarded as a master in the Hilliard tradition

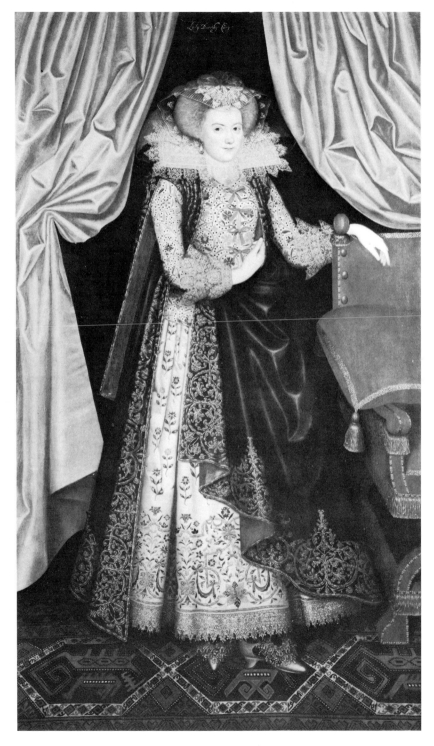

## Chapter 4
## At the Court of James I

James I by Nicholas Hilliard

The accession of James VI of Scotland to the English throne as James I did not at the outset seem to augur any great change. He was welcome, though a Scot, as a descendant of Margaret, the daughter of Henry VII who had married James IV of Scotland. The importance attached to this ancestral link caused Elizabeth on her deathbed to acknowledge 'our cousin in Scotland' as rightful heir, overlooking the fact that he was the son of Mary Queen of Scots to recall that he was the great-grandson of a Tudor. A Protestant of a sort, though heckled in Scotland by his Presbyterian subjects as well as the Catholic gentry, he was little inclined to alter the religious settlement arrived at in England, or in other ways to disturb the existing state of affairs. Coming after impecunious years to an imagined El Dorado, he looked forward to a prospect of lavish spending—though not on art.

James took small interest in painting, his indifference extending to the necessary art of portraiture. Whereas Elizabeth had exercised censorship over the reproduction of the royal countenance, James had no wish for any image at all and was much averse to sitting for his portrait. Yet he did not interfere with the routine appointment of Court painters or disturb existing commitments. A number of artists who may be thought of as Elizabethan were also Jacobean, as they continued active in the new reign.

Secure in the stability of what was almost a family monopoly, the miniaturists worked on. Nicholas Hilliard, confirmed in his appointment as Limner to the Crown, continued active for sixteen years after the death of Elizabeth in the production of his jewel-like miniatures and designs for the royal medals. When he died in 1619 he was succeeded by his son Lawrence, who had the same functions though displaying a lesser talent. Isaac Oliver, who lived until 1617, was admired and much employed

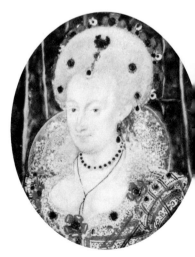

Anne of Denmark by Nicholas Hilliard

Charles I as a boy, by Nicholas Hilliard

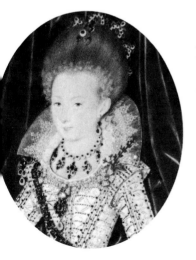

Anne of Bohemia by Nicholas Hilliard

by Anne of Denmark, James I's perceptive Queen, and by Henry Prince of Wales during his unfortunately short life. Oliver's son Peter, who had been assistant in his father's workshop, followed him in Court employment and later was to make miniature copies of masterpieces in Charles I's great collection.

Robert Peake, who had painted the processional picture of Queen Elizabeth in her later years, became a member of Prince Henry's household and again showed a bent towards group composition. Animals, landscape and human portraits were ambitiously combined in the prototype of the sporting picture attributed to him, in which he paid tribute to Prince Henry's prowess in the hunting field. Peake was made Sergeant-Painter to the King jointly with John de Critz, a painter of Netherlandish origin brought to England like other refugees as a child. De Critz does not stand out as a portrait master. His role as Sergeant-Painter (a term elastic in its definition of duties) seems mainly to have been that of handyman, entailing the restoration of decorative detail where it was needed, the painting and gilding of the royal coaches and barges, and such other minor tasks as drawing the signs and letters on a sun-dial adjacent to the royal lodgings. Fees for work of this kind augmented a retainer of £40 a year.

The exiles from the Continent drew close together in mutual support and were strengthened as a group by intermarriage. A sister of de Critz married Marcus Gheeraerts the younger, a Flemish settler whose popularity as Court painter extended from the reign of Elizabeth to that of James and, with some diminution, to Charles I's time. Gheeraerts (his name as variously spelt as Eworth's) was born at Bruges and brought to London in 1568 by his father, a painter and one of the many who fled from religious persecution.

The young Gheeraerts in his twenties is credited with so masterly a piece of emblematic fantasy as the 'Ditchley' portrait of Elizabeth (facing page 66) in imperial splendour and with a symbolic background of light after storm. He took readily to the decorative style and colour of the miniaturists, an impressive example being his portrait of Robert Devereux, second Earl of Essex,

*Left:* Henry, Prince of Wales, in the hunting field, attributed to Robert Peake

*Right:* Robert Devereux, Earl of Essex, painted when still high in Queen Elizabeth's favour, by Marcus Gheeraerts

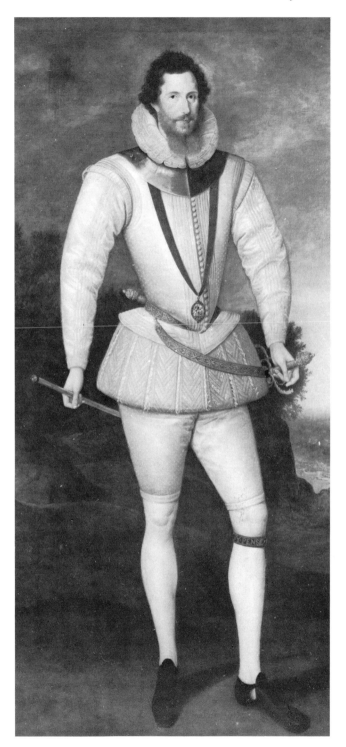

painted when Essex was still high in the Queen's favour after his successful raid on Cadiz. In Gheeraerts and Isaac Oliver, who married Gheeraerts' sister, the Elizabethan tradition lingered on. Both had an admiring patron in Anne of Denmark.

Changes in the character of royal portraiture were inevitable. James I's reluctance to have his picture painted seems discernible in the awkward stance, the dour expression typical of official portraits turned out in the studio of de Critz. The fabled image of Gloriana belonged to Elizabeth alone. Anne of Denmark, however picturesque her costume, could only be portrayed as a lady of fashion and taste and not as a divinity, awesome in power. Changes in the methods of art, apart from the nature of the painter's sitters, were not to be resisted.

A new wave of immigration from the Netherlands brought an alteration of style that finally put an end to the lyrical expression of the surviving Elizabethans. The shadowing that Hilliard had so sharply criticized as disgracing a picture by making it 'greatly smutted or darkened' and in his view 'like truth ill towld', was a force to be reckoned with. Light and shade, directed to the stronger modelling of features but giving depth also, replaced the sprightly brilliance of surface colour. The technique used by the great masters of the century was capable of profoundly dramatic effect, though in the hands of lesser artists liable to the criticism Hilliard voiced.

The Flemish artist Paul van Somer was principal among those who set Court painting in England on an altered course. Born at Antwerp, he worked in the Netherlands, north and south, before coming to London in 1616. Probably at the instance of the Queen, he was soon employed painting royal portraits. Without the spark of genius, they were competent and enlivened by the interest of setting—as in his portrait of Anne of Denmark in hunting costume with horse and Italian greyhounds in the park of Oatlands House. The gateway of the palatial building, designed for her by Inigo Jones and prominent in the background, draws attention to her interest in architecture as well as painting. This is again reflected in another of her portraits by van Somer with the

Paul van Somer's portraits of the Jacobean court were enlivened by interesting settings: here Anne of Denmark is set against the park of Oatlands House and the gateway designed for her by Inigo Jones

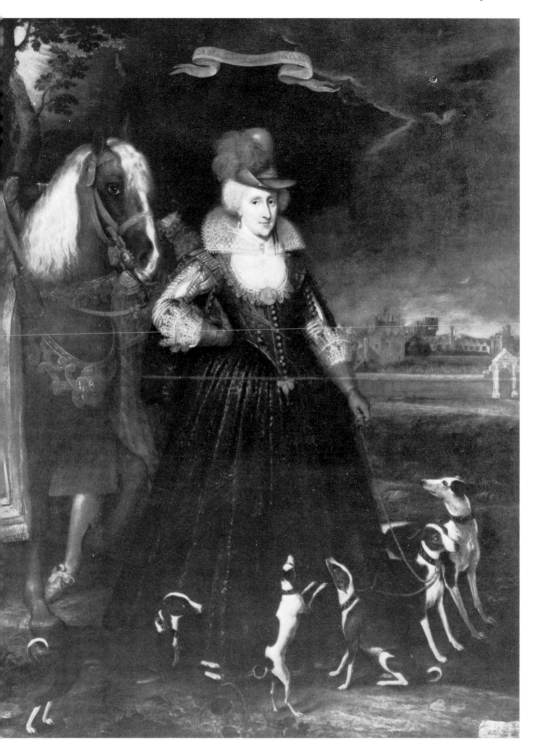

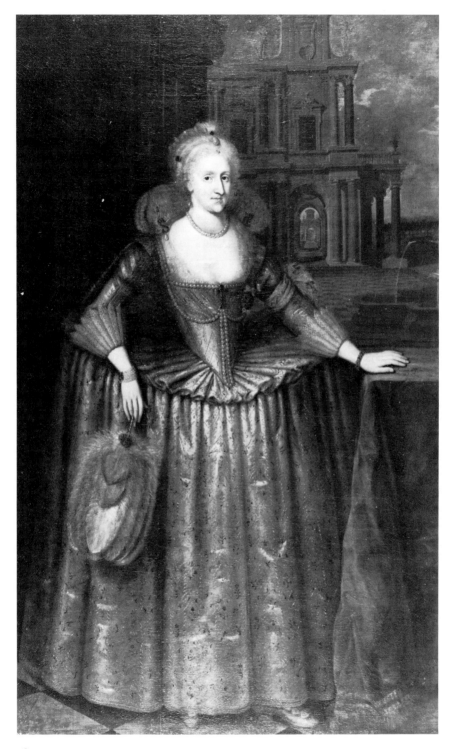

Anne of Denmark by Paul van Somer:
the building behind her reflects her
interest in architecture

inclusion of a fanciful palace of the kind that Flemish painters of van Somer's generation delighted to imagine. His portrait of James I in full regalia—with something of his aversion to being portrayed perhaps to be detected in his morose look—affords a glimpse of the great new Banqueting Hall at Whitehall, then in process of erection.

Other Netherlandish artists who can be grouped with van Somer, and were for a time his neighbours in St Martin's Lane in London, were Abraham van Blyenberch and Daniel Mytens. Van Blyenberch went back to Antwerp in 1622 after a three years' stay in England, but during that time, besides designs for Mortlake tapestries, he produced or is credited with a number of portraits not lacking in character. They included those of Charles I when Prince of Wales, the formidable scowl of Ben Jonson, and the subtle features (in the portrait attributed to him) of the Spanish Ambassador Gondomar, whose wiles entangled the royal house in the vain project of marriage between the Prince and the Spanish Infanta.

The most able of the artist-immigrants, in an unpretentiously realistic way, was Daniel Mytens. Born at Delft, he worked as a young painter at The Hague and came to England when about the age of twenty-eight, finding steady employment thereafter in royal commissions. That James I approved of him may be gathered from his being granted an annual life pension of £50. Most of his work was done in Charles I's reign when he had a life appointment as 'one of our picture-drawers of our Chamber in ordinarie'. His portraits of Charles and Henrietta Maria had a quiet merit in bringing them into realistic focus, though he was to be overshadowed and his conception of the royal pair replaced by the coming of a greater artist, Anthony Van Dyck.

It was only in a limited sense that the 'strangers', worthy pictorial craftsmen who in James I's time outmoded the Elizabethan spirit in art, could be said to have effected a revolution. Van Somer and his kin give no more than a hint of the mighty stir of Europe, the recharging of art in Italy with dynamic life, the forces that produced great compositions, new intensities of movement and depth in painting after the Renaissance had passed into history. They were waifs and strays from the

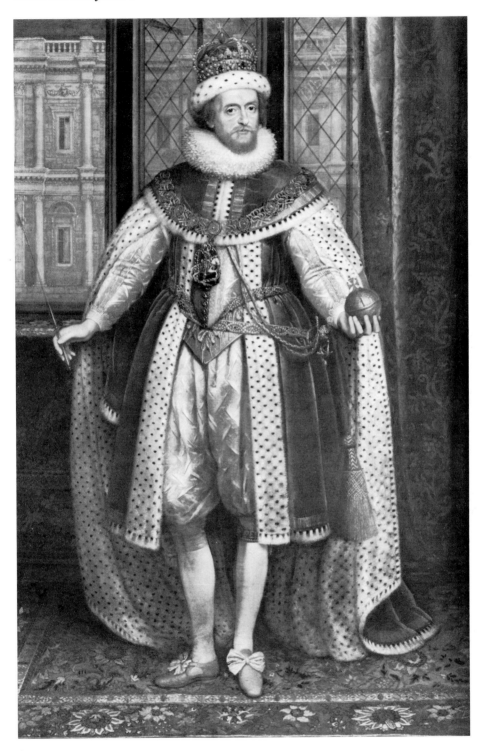

*Above:* Ben Jonson, portrait after Abraham van Blyenberch

*Left:* James I in full regalia, by Paul van Somer

*Below:* Count Gondomar, attributed to Abraham van Blyenberch

inspired Netherlandish worlds of Frans Hals and Rembrandt, of Rubens and Van Dyck. In one form or another the developing drama of European painting was yet to come fully within the purview of the English court. The great revolution at least forecast in James's reign was that of architecture, implicit in the creations of a single man of genius, Inigo Jones. The most interesting form of aesthetic expression was the masque, to which Inigo Jones also applied his creative gift. Not a Court painter in the narrowly defined field of portraiture, he was the great and 'universal' artist of the Jacobean Court.

There is some likelihood that Inigo Jones set out on his career with the intention of becoming a painter. Born in London in 1573, he was the son of a clothworker (with the same mysterious first name) who seems to have come from Wales. The young Inigo was able to travel abroad, probably as one of the retinue of a titled patron under whose wing he first became acquainted with Italy and Italian art. It is not unlikely that he would have been employed in making copies of paintings or drawings. A visit to Denmark brought him to the notice of the King, Christian IV, who no doubt recommended him to Anne of Denmark, the King's sister. Hypotheses at this point can be replaced by fact. He was commissioned by Queen Anne, as a knowledgeable draughtsman in 1604, to design settings and costumes for the first of the Jacobean Court masques, *The Masque of Blackness*, and to collaborate with its poet–author Ben Jonson.

The masque was a product of the love for dazzling spectacle in which every important European court had long indulged. The meeting of Francis I and Henry VIII on the 'Field of the Cloth of Gold', with its luxurious and artificial props, its daily changes of raiment glittering with silver damask, satin, and gold tissue, had been almost a masque or a series of masques in itself, as well as a political occasion. In the course of time, spectacle had had its evolution. The jousts which were the essential feature of the periodic entertainments for which Henry VIII in 1546 created the official post of Master of the Revels, had ceased to have their main importance. Fancy dress and dancing diminished the role of the performances of the tiltyard, the sham fights with more or less harmless

weapons, the romantic mimicry of the chivalrous past. The ladies of the Court took a more active part than that of merely bestowing favours on the victorious contestants; the periodic revels veered towards the nature of ballet.

Queen Elizabeth, little inclined to extravagant outlay except on her personal adornment, enjoyed the lavish entertainments her courtiers provided on her rounds of visits to their country houses. She was flattered as the sovereign deity greeted with reverence by the lesser gods and goddesses of an impersonated Olympus. Resort to classical myth thus made an apt supplement to the fanciful rehabilitations of the medieval past. In its final evolution the masque combined pageantry, poetry, music and song in the themes that a poet and playwright could fittingly devise. Words and action had their propagandist message. Allegories in praise of monarchy showed wise and gracious rulers setting to rights the confusions that lesser beings were prone to create. The singing and spoken parts of these subsidiary characters were assigned to professional performers.

Such was the type of masque that long exercised the united gifts of Jones as designer and Jonson as poet until they quarrelled—as partners in a successful collaboration, different in both temperament and their estimated value of what each had contributed, are apt to do. The masques occupied Jonson, and all his great learning and invention, in the intervals of writing his masterpieces of comedy; and Jones, in the intervals of his work as architect and surveyor to the Crown. A second visit to Italy in 1613 confirmed him in his attachment to the ancient principles of classical architecture revived and newly applied by the great Renaissance architect, Andrea Palladio. They inspired Jones to make his own triumphal innovations in architectural style: the Queen's House at Greenwich for Anne of Denmark (1616–18) and the Banqueting Hall, Whitehall (1619–22). They contributed also to his resource in devising theatrical settings on Renaissance lines. As a designer of masques he continued active throughout the reign of Charles I, up to the last making efforts to convey the divine right to rule (in the masque of 1638, *Britannia Triumphans*, a justification of the levy of Ship Money). Finally the *Salmacida Spolia* of

1640, not without pathos, pictured the King as a divinity bravely enduring ingratitude.

Ephemeral as the masque might be it was in a way a form of Court painting. 'Pictures with light and motion', was Inigo Jones's own definition of its visual aspect. His use of colour can only be imagined, though spectators admired such effects as that of *The Fairy Prince* where a rock opened 'discovering a great throne with countless lights and colours all shifting, a lovely thing to see'. The sky was of importance symbolically as the abode of celestial beings, and the stage machinery of the masque, operating at different levels, gave material perspective to illusions of the supernatural like those of a painted baroque ceiling. Engravings after Parmigianino, the Carracci, and other Italian masters, as well as the etchings of Callot, supplied Inigo Jones with ideas for compositions and figures. From them he learned to draw in the free style of his many pen-and-wash designs for settings and costumes. As an architect he drew differently, with a fine precision in which it is evident he profited by Palladio's example. Van Dyck, who portrayed Inigo Jones in his *Iconography* of leading contemporaries, admired him as one of the master-draughtsmen of his time, according to Jones's pupil, John Webb. A means to an end rather than an end in themselves, his drawings add their testimony to the alert intelligence that in other ways had a great influence on the development of taste.

# Chapter 5
## The development of taste

The desire to possess great works of art and to attract the greatest living artists to England, which became characteristic of Charles I and his Court, was fostered in various ways. James I, indifferent as he was to art, had an indirect, a vicarious, role in this development. As he had promised himself, he embarked on a spending spree, though the English El Dorado proved an illusion and Elizabeth had left formidable debts. A goodly part of his revenue, augmented by forced loans, the sale of offices and titles, the creation of monopolies and other devices, was given to the handsome young men on whom he doted. The huge sums and valuable properties he bestowed with a crazy munificence on his favourites created in them a wish to surround themselves with every appurtenance of splendour. They had, if not necessarily a love of painting and sculpture, a keen sense of the prestige that the possession of such things could bring to their owner. Competition among them in luxurious living was an added spur to collecting and patronage.

The King's early favourite Robert Carr, who starting as a Scottish page-boy ascended to be Earl of Somerset, gives a prime example. Before he was discredited and supplanted by George Villiers, he had agents scouring far and wide for pictures and statues to add to his collection. George Villiers who replaced him in the King's regard, prodigally rewarded and made Duke of Buckingham in 1623, was still more avid to surround himself with the magnificence of the arts. With no great amount of education, calamitous in all his political undertakings and his influence on affairs of state, he may yet be credited with some measure of genuine appreciation for the work of masters past and present.

More generally viewed, the enthusiasm for art that became so intense in the reign of Charles I, leading to the formation of collections without rival and a respect for living European celebrities that went far beyond the

employment of minor pictorial craftsmen, was due to a better acquaintance with the world across the sea.

England was no longer shut off from Europe to the extent it had been in the time of Elizabeth. Whatever the follies and aberrations of James I's reign, peace was the sensible aim he pursued. If the King's Lutheran son-in-law Frederick V, the Elector Palatine, and his wife Princess Elizabeth, Bohemia's 'Winter Queen', were driven from Prague by Imperial troops in 1620, this was not allowed to involve England in the Thirty Years War that then began with all its resulting devastation of Germany. If peaceful, though always precarious, relations with the courts of Catholic Europe were politically suspect to insular bias, they re-established, or established for the first time, links with the heights of European culture. Ambassadors and diplomats abroad were in a favourable position to see great works in the Netherlands, Italy, France and Spain, to collect them on their own account and to convey information to the Court at home. A buyer such as George Villiers relied to a large extent on these channels of communication and on the advice of other agents who could claim special knowledge. They were equally of service to those well grounded in connoisseurship and capable, in their feeling for quality, of making their own decisions.

It has been said that at various times some fifty years have usually elapsed before the great movements of Continental art have made their impact on England. This might apply to the Jacobean discovery of the visual wonders of the Renaissance, no less powerful in effect for being belated. Yet the reverence for Raphael or Titian did not exclude a lively interest in contemporaries who might also be regarded as giants.

A key figure in this development was Thomas Howard, second Earl of Arundel and Surrey. He was the son of Philip Howard, the first Earl of Arundel of the Howard family, whose long history had been both distinguished and liable to a number of political ups and downs. Philip Howard was one of its unfortunate members. Charged with Catholic and treasonable sympathies—they included having said Mass for the success of the Spanish Armada and entering into subversive communication

with Mary Queen of Scots—he was committed to the Tower and died there in 1595. His son Thomas was brought up by his widowed mother in an austere Catholic household at the village of Finchingfield. The relaxed atmosphere of James I's accession brought him the return of title and properties when he was eighteen. His marriage to Lady Aletheia Talbot, daughter of the Earl of Shrewsbury and heiress to the fortune accumulated by her grandmother, Bess of Hardwick, made him all the better off.

His love of art was nourished by inheritance, travel and friendship. The Fitzalan collection dating back to the Tudor Earl of Arundel, Henry Fitzalan, bringing with it such masterpieces by Holbein as the 'Duchess of Milan' and the 'Erasmus', as well as the 'great book' of his drawings, inspired a deep admiration for the artist. James I presented Thomas Howard with paintings and statuary from the sequestrated possessions of the Earl of Somerset after his conviction for taking part, together with his wife, in the plot to poison Sir Thomas Overbury. The paintings, by Veronese, Tintoretto, Titian, and other Venetian masters, together with antique figures and busts, led the young Earl of Arundel to study and acquire Renaissance pictures and classical sculpture with zeal.

A stimulating friendship was that with Inigo Jones, so greatly influential in furthering knowledge of the arts in Italy. As a young man Arundel took part in the Court masques. He seems to have first met Inigo Jones on one of these occasions, the performances of the masque *Hymenaei* celebrating—ironically as it turned out—the marriage of the Earl of Essex to Frances Howard, who was later to be divorced, married to Somerset, and to become his associate in that same Overbury poisoning case. Elaborate stage machinery devised by Inigo Jones accompanied Ben Jonson's learned and poetic allusions to the marriage ceremonies of classical times.

Learned in his own way, knowing Italy and Italian, a man of forty of mature experience, Jones was to prove a valuable guide-companion to Arundel and his wife when they went to Italy in 1613. He was no less enlightening about Italian paintings than about Palladio's palaces at Vicenza.

In the 'Ditchley' portrait of Queen Elizabeth I, by Marcus Gheeraerts, the Queen's authority is symbolized in the way she towers above the map (see page 40)

The Duke of Buckingham, a collector of paintings and sculpture to rival the Earl of Arundel, painted by Daniel Mytens (see page 69)

Arundel's progress to becoming, as the diarist John Evelyn called him, 'the Father of Vertu in England', 'the great Maecenas of all politer arts and the boundless amasser of antiquities', was also advanced by the help of diplomats of like mind. Among them was Dudley Carleton who, after taking a degree at Oxford, had entered the diplomatic world as secretary to the Ambassador to France. He survived a suspicion of being concerned in the Gunpowder Plot with the alibi of being in Paris at the time, was knighted by James I in 1610, succeeded Sir Henry Wotton as Ambassador at Venice and was afterwards Ambassador at The Hague. Pictures that Carleton acquired in Venice were among Arundel's first purchases. With much acquaintance among Netherlandish artists, Carleton was a particular admirer of the Italianate Gerritt van Honthorst, whose 'Aeneas flying from the Sack of Troy' he presented to Arundel. It is possible that Charles I, as Prince of Wales and later as King, was induced by sight of this work to invite the artist to England. Van Honthorst paid two visits in 1620 and 1628, when he painted large subject compositions for the King as well as portraits. The later visit has its commemoration in the allegorical painting that represents the Duke of Buckingham as Mercury presenting the Liberal Sciences to the King and Queen in the guise of Apollo and Diana.

Antique sculpture called for investigation farther afield. Sir Thomas Roe, a diplomatic agent whose missions had taken him all over the world when Ambassador at Constantinople, did his best, in an area 'so full of trouble that I scarce live safely', to collect antiquities both for Arundel and the Duke of Buckingham. One of his letters made tantalizing reference to 'the innumerable pillers, statues and tombstones of marble with inscriptions in Greeke' to be found 'on the Asia side about Troy, Zizicum and all the way to Aleppo'.

Arundel House in the Strand, a London property restored to Howard ownership by James I and altered (no doubt with the assistance of Inigo Jones) into the semblance of an Italian palace, became a treasure house. In Arundel's cabinet were his Italian drawings, including those by Leonardo da Vinci now preserved in Windsor

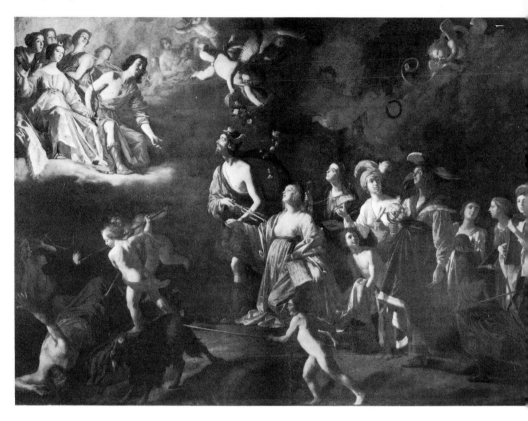

Castle. In the grounds were the sculptures that were eventually to be the prized Arundel Marbles of Oxford University. The portraits of the Earl and Countess by Daniel Mytens, painted at the outset of that artist's long and industrious Court career, included both intimate studies of their features and dignified full-length portraits that showed them against the background of their art collections.

Arundel had both an enemy and a rival collector in the Duke of Buckingham. York House in the Strand was the latter's London headquarters, an old house repaired and largely reconstructed at vast expense. Here he had a miscellany of paintings, sculpture and costly *objets d'art*. As would be expected of so spectacular a character, he was portrayed often and at various times in works that ran the whole gamut of post-Tudor art. An early full-length portrait, *circa* 1616 when he was about twenty-four and at the beginning of his meteoric rise to fortune, but already

Allegorical painting by Gerritt van Honthorst depicts Mercury (the Duke of Buckingham) presenting the Liberal Sciences to Apollo and Diana (the King and Queen)

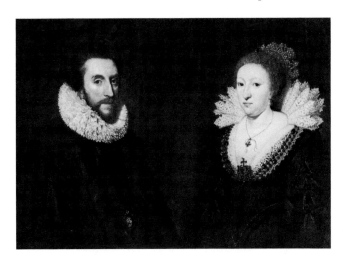

The Earl and Countess of Arundel by Daniel Mytens. Arundel was a great patron of the arts

invested with the Order of the Garter, has the stamp of William Larkin's still late-Elizabethan style, and is attributed to him. The artist's mannered habit of elongation laid stress on the shapeliness of Villiers's legs. Four years later, by then Marquess of Buckingham and Lord High Admiral, he was portrayed with similar emphasis on his grace of limb by Cornelius Johnson, somewhat after the style of Marcus Gheeraerts whose pupil this artist of Netherlandish origin may have been.

Buckingham was portrayed in armour with Daniel Mytens's sedate realism (facing page 67); and in a more dashing aspect by the Dutch painter, Michiel van Miereveld, during an embassy to the Netherlands, the pointed beard of the period giving him a Mephistophelean look, his marvellously elaborate collar of lace and ropes of pearls adding to the impression of an extravagant personality. His equestrian portrait by Rubens, whom he met in Paris in 1625 when he attended the marriage by proxy of Charles I and the French princess, Henrietta Maria, had a place of honour in York House, though it has not survived.

He pleaded with Rubens to sell him the collection the great artist himself had formed. In addition to a number of Rubens's own works there were listed others by Leonardo, Raphael, Titian, Tintoretto, Veronese, as well as statues, portrait busts, reliefs and gems. With reluctance Rubens accepted the offer of some £10,000 for

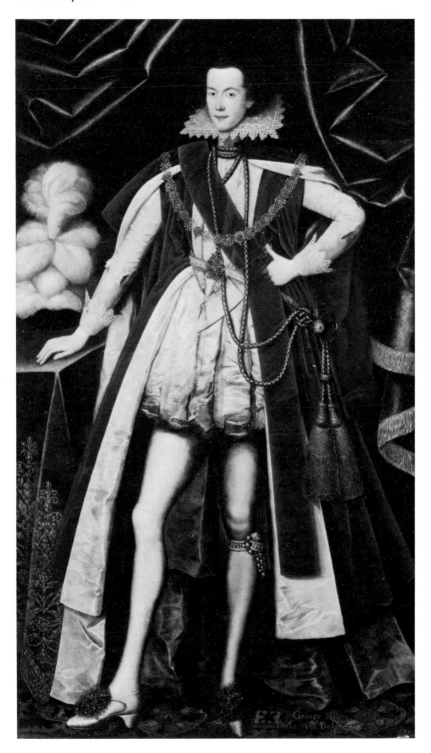

George Villiers, first Duke of Buckingham, at the start of his meteoric rise to fortune. Attributed to William Larkin

the whole, though stipulating that the purchaser should at his own expense supply him with casts of the sculptures in the sale.

Inevitably Buckingham made use of the same agencies as Arundel—the ambassadors Wotton, Carleton, Roe; and others on the fringe of diplomacy such as Toby Matthew, the adventurous son of the Archbishop of York, banished for a long period because of his conversion to Roman Catholicism while travelling in Italy but allowed to return through Buckingham's influence. Matthew's friend, George Gage, was also one with Catholic sympathies and the better fitted on that account to negotiate as agent for works of art produced in the Catholic lands. Others important in the machinery of international dealing were agents such as Endymion Porter and Balthasar Gerbier. Porter, made familiar to us in appearance by William Dobson's masterly portrait (page 115), was a member of an old land-owning family in Gloucestershire. A whimsical thought of the shepherd of classical legend may have led to his being called Endymion. The family had Spanish relatives through whom as a young man he obtained a post in the household of Count Olivares.

This introduction to the refinements of a cultivated court made him a useful acquisition later in the Duke of Buckingham's service. He went with the Duke and Charles (then Prince of Wales) on the journey to Madrid in 1623 which purposed to arrange a marriage between Charles and the Spanish Infanta. The Infanta's horror at the idea of marrying a heretic, the embarrassment from the English viewpoint of the Spanish demand that Charles should turn Catholic, and not least the freakish and insolent behaviour of Buckingham, conspired to reduce the proposal to absurdity. Endymion Porter however then gained Charles's esteem. Buckingham's assassination in 1628 by the disgruntled naval lieutenant John Felton, had no adverse effect on Porter's fortunes. He flourished at Court during Charles's reign as a man of cultivated taste in literature and the visual arts, and a valued auxiliary in adding to the King's art collection.

A minor character of the period, but one who throws a vivid light on its entangled webs of art, politics and

religion, was Sir Balthasar Gerbier, knighted by Charles I in 1638. He professed many talents, was architect, painter, a linguist fluent in English, French, Spanish, German and Dutch, a shrewd judge of pictures. He was also one who revelled in complicated plots, devious intrigues, secret missions. France, Holland and Spain all had some claim to his allegiance. His parents, it would seem, were French and had fled from Paris at the time of the Massacre of St Bartholomew to Middelburg in the Dutch province of Zeeland, where Balthasar was born. He was thus something of an international problem. He did not care to be taken for a Frenchman nor could he be described as Dutch, though the Spanish with their persistent claim to the north Netherlands chose to regard him as 'the King of Spain's natural born subject'. After coming to England in 1616, being then twenty-six, he declared himself with impassioned emphasis to be 'heart, tooth and naile English'.

It is a measure of the distance between the Court and its adherents and the English population generally, especially the Parliamentary party, that he was regarded as a foreign spy. The fact of his being a servitor of Buckingham and later an agent of Charles I did nothing to dispel the hearty dislike he aroused. A bill for his naturalization was promptly thrown out by the Commons in 1628. Buckingham made him Keeper of York House and welcomed his advice on collecting. Gerbier encouraged him with the remark that: 'Our pictures if they were to be sold a century after our death would sell for good cash and for three times more than they have cost. I wish I could only live a century in order to laugh at these facetious folk who say "It's only money cast away for bobles and shadows." '

The manoeuvres of politics equally fascinated him. A capable scribe, he was admitted to the secrets of Buckingham's cipher and foreign correspondence, and had his part in the excursion to Madrid to woo the Infanta. His role was to paint the Infanta's portrait in miniature. This no doubt was the portrait brought back for James I's inspection and irritably dismissed by him with the words: 'Take away the painted doll.' As a buyer of paintings for Buckingham, Gerbier came into contact

with Rubens, and his part in the negotiations that brought the great artist to England, and his acting as host during Rubens's stay, allow him credit as the devotee of genius.

That Charles I as King should display a love of art for which neither his Tudor predecessors nor his own father had been noted—an urge that went far beyond the need to have the record of a painted likeness—could be simply accounted for by the natural fineness of taste which unquestionably he possessed. The ground, however, was well prepared in several ways for the exercise of his activities as collector and patron. His mother Anne of Denmark and his elder brother Henry Prince of Wales had set a family example. The Queen had amply made up for James's indifference by her interest in both painting and architecture. Prince Henry shared her tastes. With a wish to meet exceptional persons, he planned contacts with artists abroad. He liked to appear in those classical and chivalrous roles that the masques devised in his honour suggested. Isaac Oliver portrayed him in the style of an antique cameo, in supposedly Roman costume. Attributed to Oliver is an equestrian portrait in which the Prince in armour rides in martial pride, the vigour of pose recalling Italian Renaissance models and equally a source of satisfaction to artist and sitter.

That the tastes of the elder brother influenced the younger, even though Prince Henry died at the age of eighteen before his intentions regarding the arts could be fully estimated, seems a reasonable assumption. Royal enthusiasm was heightened also by the infectious spirit of the age that had made the cultivation of art a serious pursuit of many of those associated with the Court in some position of authority. In building up a peerless collection of works of art, Charles could profit by the wide experience and advice of Arundel. He had the help of James Hamilton, the first Duke of Hamilton, his adviser on Scottish affairs, who brought him pictures from abroad, and of Robert Ker, first Earl of Ancrum, who returned from a diplomatic errand to Holland with paintings by Rembrandt as a gift to the King. Buckingham's collection, formed with Gerbier's aid, astonishing even to Rubens in the number and quality of the works it comprised, incited admiration equally for the

73

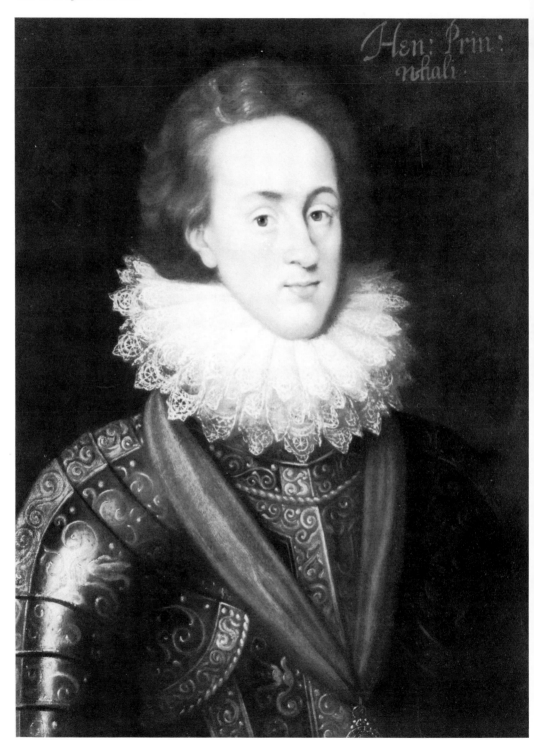

Henry, Prince of Wales, after one of the several versions of his portrait by Isaac Oliver

masters of Antwerp and Venice. Charles was the more impressed by the Venetian masters from the time spent in Madrid, which at least enabled him to see the great works of Titian acquired by Charles V and Philip II. He could hardly have wished for a more magnificent parting gift from Philip IV than he received in Titian's 'Venus of the Pardo'.

To make a collection comparable with the greatest in Europe was Charles's aim on his accession. He already had an excellent nucleus to build on. There existed an army of agents and dealers conditioned to inquire and purchase in Europe on whose services he could draw. Works of art were his happiness as King, and from 1625 to 1639, until dire change threatened and unsolved problems of government came to the crisis point, he could consider himself the happiest of monarchs. In this illusory period of peace, in spite of the embarrassing mountain of debts left by James I and the warning signs of Puritan hostility and political complaint, he pursued the course that led Rubens to pronounce him 'the greatest amateur of painting among the princes of the world'.

There were two sides to this pursuit. It was a worthy ambition to bring together masterpieces of an earlier age but no less desirable to encourage the production of new masterpieces. To attract to the English Court great living artists whose genius would add to its lustre was a creative exercise of taste. Portrait painters from the Netherlands had needed little persuasion, were as eager to come to England and stay as Daniel Mytens, who after working for Arundel looked forward to royal employment. His full-length portrait of Charles when he was still Prince of Wales, painted soon after his return from Madrid, was recommendation enough to secure him a permanent appointment as 'picture-drawer' to the King in the new reign. He was granted full rights of citizenship and was kept busy in his studio in St Martin's Lane until 1634. In a realistic style that was free from pretentiousness or flattery, Mytens gave a distinction of his own to his many portraits of the King and his Queen, Henrietta Maria, which were often gifts to friends and friendly powers. He painted a variety of Court characters, including the dwarf Jeffery Hudson who was small enough to emerge from a

pie at a dinner given for the King and Queen. Mytens also made copies of earlier works in the royal collection, including 'Titian's great Venus'.

He could surprise, now and then, by the boldness of light and shade that gave a romantic intensity to his self-portrait, or the dashing character he imparted to his portrait of the Duke of Hamilton, though in the main he painted with restraint and disciplined sense of fact. He might on this account be underestimated in comparison with the greatness of Van Dyck, but his realism gives an historical corrective to the greater artist's poetic vision. The arrival of Van Dyck did not cause Charles to treat Mytens with less consideration than before. The later critical years of the reign when the Civil War was imminent, or perhaps had already begun, decided the Dutch painter to return to his native land.

Italian painters were not so ready as the Netherlanders to quit their own country, where Rome gave much encouragement to the painting of religious themes as part of the Church's countermoves against the Reformation. Nor did Rome as yet come so directly within the purview of the English connoisseur as a century later when the city was the culminating experience of the Grand Tour. The Vatican was regarded with political suspicion as the source of plans to overturn the established Protestant regime. The suspicion attached to visitors. On his journey to Italy, Arundel, visiting Rome out of his interest in Michelangelo and Raphael, incurred anxiety on his behalf at thus daring to tread on forbidden ground.

The Puritans of the English Parliament could only think of the baroque style and the productions of such contemporary painters at Rome and Bologna as Francesco Albani, Guido Reni and Il Guercino (Giovanni Francesco Barbieri) as papal wiles intended to corrupt King and Court. There were qualms, it may be supposed, on the other side, about leaving a sympathetic Italian milieu for a cold and distant land. Barbieri, occupied with religious compositions at Bologna, declined Charles's invitation to come to England; so, too, did Albani. If the King's collection was to include a remarkable number of Italian paintings including those of then living artists, it was partly through the industry of agents abroad acting

Self-portrait by Daniel Mytens, a Dutch artist who had a long and industrious career at Court

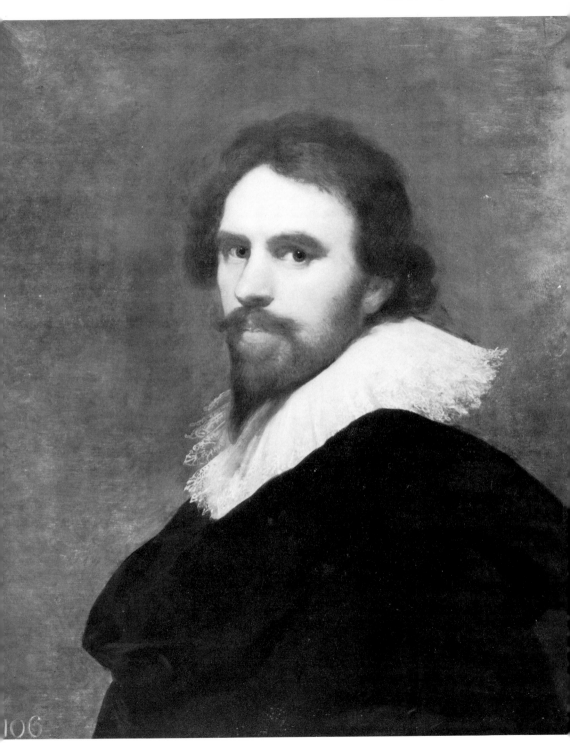

106

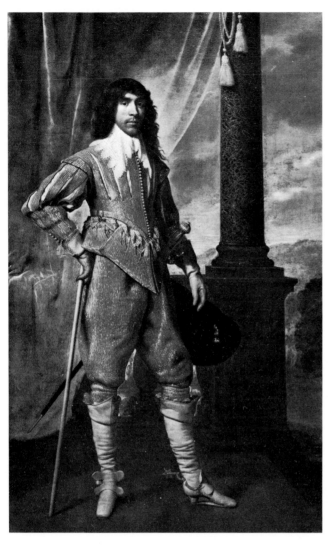

on his behalf, partly the gifts of pictures from papal emissaries hopefully intended to make for some measure of religious reconciliation, and partly the example of Arundel and Buckingham.

The first Duke of Hamilton, by Daniel Mytens. Though usually restrained and realistic, the artist here imparts a dashing character to the subject

An Italian who accepted Buckingham's invitation to come to England was the baroque painter Orazio Gentileschi, a follower of Caravaggio in Biblical themes treated with dramatic contrasts of light and shade. A native of Pisa, he had worked for a long time in Rome for a succession of Popes and afterwards at Genoa and Paris. He was sixty when the promise of liberal reward brought

Artemisia, daughter of the Italian painter Gentileschi, was an artist in her own right. Her self-portrait is called 'La Pittura'

him to London. Through Buckingham he was introduced to the King, in whose service Gentileschi was content to remain for the rest of his life. The emotional atmosphere of his 'The Penitent Magdalen', a reclining figure with eyes upturned and a skull—reminder of mortality—by her side, recommended him.

A principal work was his series of ceiling paintings for the Queen's House at Greenwich. James I had lost interest in the building when Anne of Denmark died in 1619, and it remained unfinished for ten years until Charles I required its completion for his own Queen, Henrietta Maria. Gentileschi's paintings for the entrance hall, designed by Inigo Jones as a perfect cube forty feet in each direction, depicted the Arts of Peace. They were eventually to be transferred to Marlborough House. In their execution the painter was assisted by his daughter Artemisia, an artist in her own right, though she did not stay long in England, finding Naples more congenial. Her self-portrait with palette and brush in the symbolic guise of *La Pittura* remained in the royal collection. She painted herself as a bohemian figure, unconventional in pose and as dramatically illuminated as one of Caravaggio's own Neapolitan characters.

A visit and a denization that eclipsed all others in aesthetic importance and splendour of result, were the climax of the long-established relation with the Netherlands, represented by the stay in England of Peter Paul Rubens and the settlement in the country of Van Dyck as Charles I's principal Court painter.

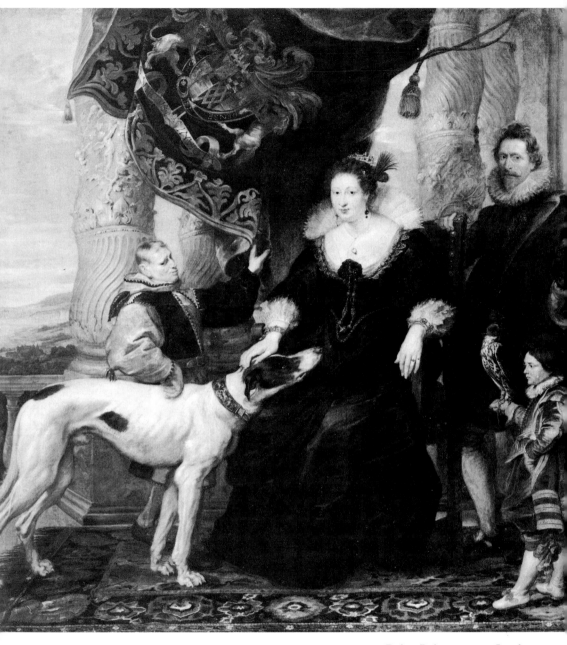

Before Rubens came to London,
English connoisseurs sought him out
abroad. He painted Lady Arundel in
Antwerp in 1620: the Earl may have
been painted in later

## Chapter 6
# Rubens and Van Dyck in England

To have the great Rubens at the English Court, even for only a short while, was a tremendous event, hoped and planned for years in advance. Negotiations of different kinds, involving his painting, his activities as a collector, and his special relation with the intricate world of politics and diplomacy, preceded his coming. The eyes of the insular connoisseurs had been directed from a distance towards the genius of the age, the man with a wonderful constellation of faculties, renowned throughout Europe. Sir Dudley Carleton was already in touch with him in 1616 through the agency of Toby Matthew and George Gage, for the purchase of one of his hunting pieces. They were instructed to offer a gold chain in part-payment. It was an instance of Rubens's firmness in business matters that he conceded no reduction of his stipulated fee which was a good deal more than the estimated value of the gold chain. 'His demands', Toby Matthew wrote to Carleton, 'are like the Laws of Medes and Persians which may not be altered.'

The exchange of letters between Rubens and Carleton brings into view the artist's passion for collecting antique works of sculpture. George Gage had given him such a glowing description of Carleton's own collection of antique marbles as aroused Rubens's desire to acquire them. Carleton for his part admitted to a transfer of interest from sculpture to painting — 'more particularly to Mr Rubens'. A bargain was struck accordingly. Rubens was to have the marbles and to pay for them with a number of his own paintings. They, he explained, had cost him nothing and as in that year (1618) he had spent 'some thousands of florins on my buildings' (his grandiose Antwerp residence and studio) he did not wish, 'for a caprice, to exceed the bounds of a good economist'. In fact, he added: 'I am not a prince but one who works with his hands.' Carleton turned a compliment in reply. 'I cannot subscribe to your denial of being a prince because

I esteem you the Prince of Painters and of Gentlemen.'

A slight disagreement concerning the hunting piece destined for Prince Charles has a sidelight to throw on the busy picture-factory over which Rubens reigned in Antwerp. The *Caccia*, Matthew reported, was 'of an excellent design'. His words enable one to envisage a typical Rubens. 'There are Lyons and Tygars and three men on horse backe (some in halfe figures) hunting and killing beasts and beinge killed by them.' But, as Rubens confessed: 'It was not all of his owne doing.' Assistants had worked to his design, though, as his habit was, he had retouched the whole. A statesman zealous on the Prince of Wales's behalf, Lord Danvers, objected that 'men of skill' had declared the picture unworthy of Rubens or of the Prince's collection. Magnanimously, Rubens consented to paint a picture entirely by his own hand, glad that it should 'be located in a place so eminent as the Gallery of H.R.H. The Prince of Wales'.

In other ways the ground was prepared for a closer acquaintance with England and the English. It is evident from his letter to William Trumbull, the royal agent at Brussels in 1621, that the scheme was already in train to invite him to decorate the new Banqueting Hall at Whitehall. Work on the new building to replace the old Banqueting Hall destroyed by fire in 1619 was then beginning. As always, the idea of decoration on a grand scale appealed to Rubens: '. . . with respect to the *Hall in the New Palace*, I confess myself to be, by a natural instinct, better fitted to execute works of the largest size rather than little curiosities.'

The connoisseurs on their travels sought him out. In 1620 Rubens painted Lady Arundel at Antwerp as the central figure of an opulent composition together with jester, dog and dwarf. Arundel, less distinct in the background, may have been painted in later by another hand. Buckingham, who met Rubens in Paris in 1625 when the great artist was completing the vast cycle of paintings now in the Louvre, glorifying the history of Marie de' Medici, took every advantage possible of the introduction. As well as persuading Rubens to part with his superb art collection, he commissioned from him an equestrian portrait and a ceiling. Rubens consented,

The gorgeous allegory 'Peace and War' was painted by Rubens as a gift for Charles I (see page 88)

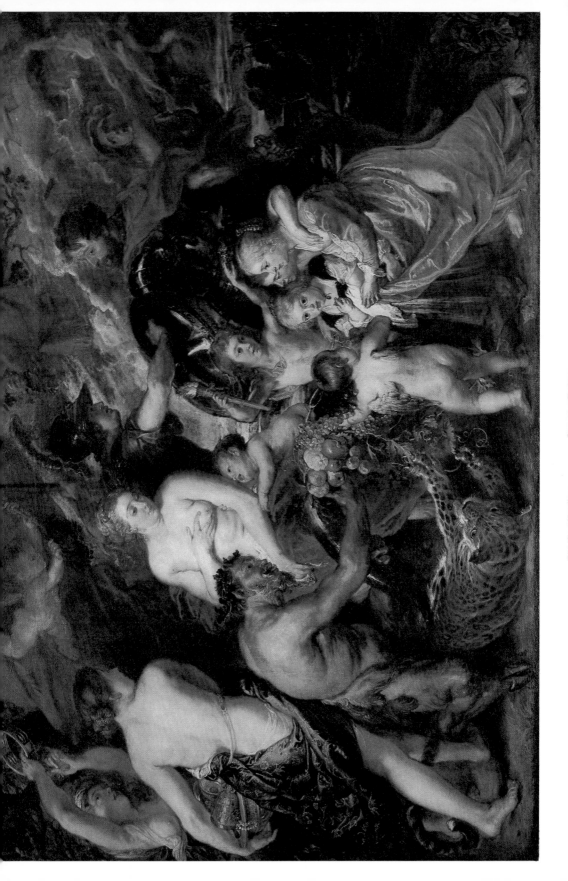

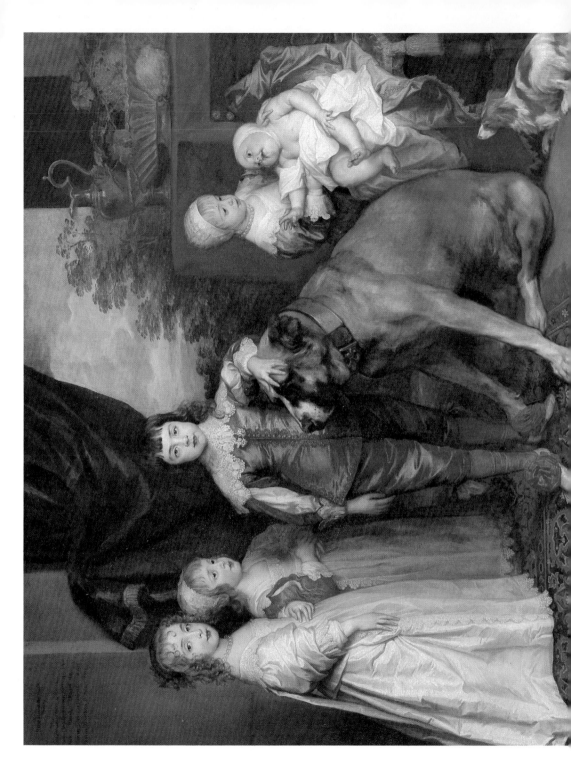

The five eldest children of Charles I, by Van Dyck. His success in portraying children and animals resulted from his careful study of them (see page 106)

though quite aware of Buckingham's caprices and arrogance. The Duke, on his mission to arrange for the marriage of the fifteen-year-old French princess, Henrietta Maria, to the newly enthroned Charles I, contrived to offend the French Court as previously he had offended the Spanish. Rubens felt pity for the young King saddled with such a deputy, though able to look on the Duke's antics with the serene detachment typical of him.

The allegorical machinery was set in motion. In the equestrian portrait (since destroyed) the Duke appeared in warlike authority, attended by the symbolic female figures of an imaginary triumph. The veil of allegory cloaked the dismal record of the Lord High Admiral and the various mishaps and financial misuses that were to lead to his impeachment by Parliament in 1627. The ceiling he commissioned from Rubens to occupy a place of honour at York House was a magnificent baroque design. Though it was destroyed by fire in this century, a sufficient idea of the painting is given by the oil sketch now in the National Gallery, titled 'Minerva and Mercury conduct the Duke of Buckingham to the Temple of *Virtus*'. The ecstatic movement upwards into the empyrean of a host of fluttering figures as witnessed from below, always the supreme moment of baroque propagandist art, thus had its first employment in England.

The title corrects the idea that the work could be called an 'apotheosis'. Allegory stopped short of investing Buckingham with divine status and was ambiguous enough not to flatter too grossly. *Virtus*, to whose temple the Duke ascended with the help of Wisdom and Eloquence personified, might be taken to represent excellence of some kind — Valour or even resolution in the face of difficulties. Difficulties existed in plenty, though no direct reference would have been in place to the enmity between Buckingham and Richelieu in France, Olivares in Spain, and the House of Commons men in London. One could interpret according to one's liking the snake-crowned figure of Envy seeking to pull the Duke down, and the lion roaring its anger. But Rubens, absorbed in the swirling rhythms of his design, the fleshly charms of the three Graces holding out their crown, and the

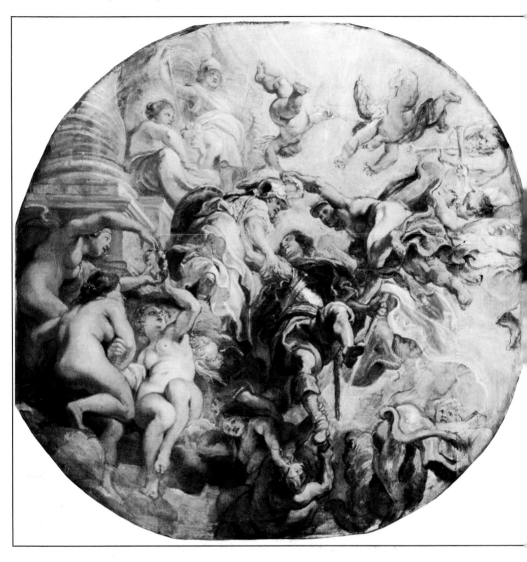

technique of an unusual perspective, had already a pattern to make use of when he came to paint his composition for the Banqueting Hall, Whitehall.

Though welcome on every aesthetic ground and from preceding contacts as a visitor to England, Rubens's deciding motive was his diplomatic mission. On the face of it, the role of political mediator might seem surprising for an artist to be asked to undertake, or inclined to accept. On the other hand it could be assumed that his profession as a painter made a good cover for negotiations

'Minerva and Mercury conduct the Duke of Buckingham to the Temple of *Virtus*': a ceiling commissioned by the Duke of Buckingham from Rubens, for York House. It was destroyed by fire and this oil sketch is all that remains

of quite another bearing. In pursuing them, his detach-
ment as an artist was calculated to inspire confidence. At
an earlier time, in like fashion, Jan van Eyck as Court
painter to Philip the Good, Duke of Burgundy, had been
entrusted with secret missions to the ruler of Spain and
Portugal.

Rubens, unworldly to the extent that great artists must
be, was at the same time a man of well-balanced and
shrewd intelligence. His sensible advice, tending to
moderation, was valuable to the Spanish Regency in the
Netherlands when the milder regime of the Archduke
Albert and the Infanta Isabella followed the fury of effort
to stamp out heresy. So it was that the Infanta, the sole
Regent after Albert's death, turned to Rubens as the
instrument of an important project: the general suspen-
sion of hostilities between Great Britain, Denmark, Spain
and the States-General of the virtually independent
northern Netherlands. His knowledge of the courts of
Europe from north to south (though he expressed a
horror of courts), his fluency in languages, his tact and
distinction of manners, all fitted him for the task. A main
inducement was his own sincere belief in the need for
peace and the grand design of promoting a European
harmony. An alliance between England and Spain would,
in his view, be as worthy to be called a masterpiece as any
painted work on canvas.

Buckingham appointed Balthasar Gerbier to concert
the preliminaries with Rubens. Protracted discussions
and correspondence followed. The combustible nature of
the political situation demanded secrecy. Each country
suspected the others. Gerbier was in his element in
confidential meetings, letters in cipher and signed with
assumed names, documents setting out the complex
problems to be solved. They bring out the contrast
between the character of Rubens and that of the devious
agent, though their relation was friendly, and continued
after Buckingham's assassination when Gerbier became
more directly the agent of the King. There seemed some
promise then of clearing the political morass that
Buckingham had done so much to create, of overcoming
the enmity aroused by his attempt to make love to the
French Queen, of erasing the memory of his attack on

Cadiz, the ignominious failure of the expedition to relieve the Huguenot city of La Rochelle. There was the rooted objection of the English Parliament to any Catholic alliance or connection still to be taken into account but not allowed to hold up negotiations. With the acquiescence of the Spanish minister Olivares, though not in the official role of ambassador, Rubens took ship for England from Dunkirk in 1629. He insisted on an English ship, being, it was said, 'mightily afraid of the Hollanders'; and arrived in London at the end of May.

Diplomatically the visit was a qualified success. The peace treaty with Spain was concluded without causing France too much alarm. The 'masterpiece' was disappointing to Rubens in one main respect—the Dutch firmly refused to have anything to do with his cherished project of reuniting the Netherlands, north and south. The details of the treaty were handled by the official English and Spanish ambassadors, Sir Francis Cottington and Don Carlos de Colonna. Rubens had leisure enough to observe insular society, and time to paint the while, in the nine months that elapsed before his return to Antwerp.

Cambridge invested him with the honorary degree of Master of Arts. The King conferred knighthood on him early in 1630, presenting him with the ceremonial sword then used, its handle richly encrusted with diamonds. Rubens seems habitually to have taken as favourable a view as possible of people and places, and this certainly was his opinion of as much of Stuart England as he was able to see. With some reflections on declining bodily health (uncalled for in this vigorous and active man of fifty-two) he wrote to his friend in Paris, Pierre Dupuy, that he felt consoled by the enjoyment he found in the beauty of English landscape, the brilliance of culture and 'the incredible number of excellent paintings, statues and ancient inscriptions' to be found at the Court. Mild in criticism, he stated no more than the truth when he observed that 'all the leading nobles live on a sumptuous scale and spend money so lavishly that the majority of them are hopelessly in debt'. He had admiring comments to make on English scholars and antiquaries, for example John Selden, 'of resourceful and polished genius',

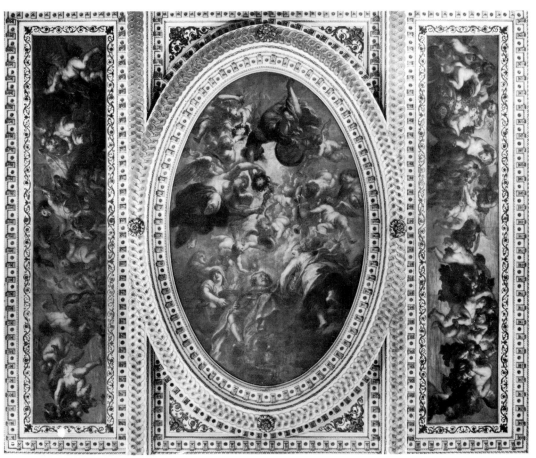

The centre section of the ceiling of the Banqueting Hall in Whitehall – chief among the results of Rubens's visit to the English Court

regretting only that the author of a learned work on the Syrian gods 'has now become implicated in political movements'—a cautious enough description of a signatory of the Petition of Right and so determined an opponent of unlimited royal authority as to be committed to the Tower. Rubens admired Robert Cotton also as 'a great antiquary and eminent in various fields of learning', overlooking the fact that he too was a determined opponent of the Court. Their kin in scholarship, he forgot their politics; and after all painting was his proper business. Chief among the results of his visit was the great series of paintings for the ceiling of the Banqueting Hall, begun while he was still in England and finished after his return to Antwerp.

In the great work eventually installed and still *in situ* as a superb complement to the architecture of Inigo Jones,

Charles I might congratulate himself on endowing his country with one of a trio of supreme masterpieces; the others being the New Testament cartoons of Raphael, which Rubens advised the King to buy, and 'The Triumph of Caesar' by Mantegna, from the Gonzaga collections. The Rubens ceiling was a characteristic assertion of his powers in composition, vigour of movement and resource in allegory. It was also an assertion of the divine right of kings, an essential tenet of James I transmitted to his son Charles. Unequivocally the ceiling was an apotheosis, the elevation of James I to receive a heavenly crown surrounded by a multitude of figures intended to convey the benefits of his reign.

In the enjoyment of such an exercise of his giant abilities, the sheer delight of orchestrating form and colour on the large scale that most appealed to him, Rubens, it is possible, thought less of its purpose in other respects. The spectator may do likewise with a comparable pleasure. The fact remains that as a statement of the anciently established connection between religious and royal authority, the ceiling spoke the language of absolutism. From this viewpoint it was an instance of how far distant was the art that defined the nature and aspirations of the Court from the sympathies of the co-existing parliamentary democracy.

Apart from beginning the Whitehall ceiling, Rubens was busy in England as a painter. Though he made no portrait of Charles I or Henrietta Maria during his stay, there is a suggestion of their appearance in idealized form against a background impression of the Thames in the painting of St George and the Dragon, bought by Endymion Porter to add to the royal collection. He painted the group portrait of Gerbier and his wife and nine children, completed in Rubens's Antwerp studio. He lodged with them, and members of the family (Gerbier's son George and his daughters, Elizabeth and Susan) again appear in the masterpiece Rubens painted as a gift to the King, the gorgeous allegory long known as 'Peace and War' but since given the revised title, 'Minerva protects Pax from Mars' (facing page 82). According to the allegorical plan, Wisdom drives away War; Peace (a resemblance has been seen to Deborah

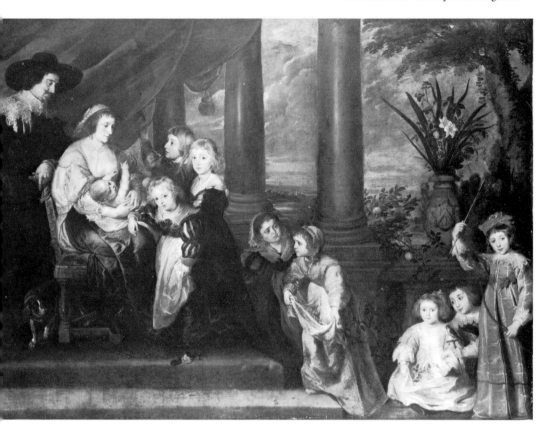

Balthasar Gerbier, his wife and nine children, painted by Rubens, who lodged with the family during his stay in England

Kip, Gerbier's wife) fosters Wealth; and Nature, in the guise of a satyr, pours out the fruits of the earth from his cornucopia. A beautiful outcome of a diplomatic mission, the painting projected the blessings of the peace it was his practical purpose to promote.

Time was left to renew acquaintance with the Arundels and to make studies from life for the imposing three-quarter-length portrait of the Earl in armour. But Rubens's mission once accomplished, he felt no inclination to stay in England. He was, after all, Secretary to the Spanish Privy Council for the Netherlands, 'Gentleman of the Household of Her Serene Highness, Princess Isabella'. Back in Antwerp in 1630, the widower of fifty-three married Hélène Fourment, the sixteen-year-old daughter of a wealthy silk merchant. He painted her, dimpled and smiling, in her wedding dress. There was still much work to be done on the outsize canvases for the Banqueting Hall. For one reason or another, delay in

89

The Earl of Arundel in armour, by Rubens

payment among them, it was long before they were installed.

Man of many anxieties and complaints, Gerbier wrote to Charles I from Brussels in 1634 to relate 'what malicious tongues and ignorant spirits' had to say, that 'the great works Sr Peter Rubens hath made for Yr Majys Banqueting House lye here as if for want of money'. In October, 1635, the canvases were brought by wagon to Dunkirk and arrived in London at last in December. Rubens's purchase of the Château de Steen in that year turned him increasingly to landscape and paintings produced for his own satisfaction, though up to the time of his death in 1640 he was much occupied also with his scheme of decoration for Philip IV of Spain's hunting-lodge, the Torre de la Parada. England, while a pleasant memory, had been only a brief episode in his abundant experience. Far otherwise for his former assistant, Van Dyck, the country and its Court were to become of major consequence.

Antoon van Dijke, Sir Anthony Van Dyck as he was to be called, was a Court painter different in character from Rubens, closely associated though they were for a time. After apprenticeship to the Flemish portrait painter, Hendrick van Balen, Van Dyck at the age of nineteen became a leading assistant to Rubens in the production of religious compositions for the churches of Antwerp. He entered into the dynamic spirit of the baroque as practised with confident mastery by the older artist, but was not content to stay under his kindly auspices for long. Both the Duke of Buckingham and the Earl of Arundel had their part in his early advancement. The commission to paint a picture for York House, 'The Continence of Scipio', may have been the immediate reason for Van Dyck's coming to London as a young man in 1620. Arundel recommended the 'famous *allievo*' of Rubens to James I, who granted him a retaining fee of an annual £100 and a further £100 'for special services' of a nature unspecified. Arundel obtained him a pass to go to Italy, which implied, presumably, an obligation to return after some months spent in travel and study. It may have been a disappointment to his English sponsors that the months in Italy became years spent in Genoa, Rome and Venice.

In this period he blossomed as a brilliant portrait painter, much inspired by the example of Titian.

He was twenty-eight when he left Italy, but not yet ready for England. Going back to Antwerp in 1627, he was for a time a rival to Rubens in religious compositions, such as the 'Ecstasy of St Catherine' in the church of St Augustine at Antwerp. He had his own individual command of the dramatic and emotional expression required in such works, yet even though Rubens was for some time away in Spain and England on his diplomatic errands, Antwerp in a sense belonged to him. There remained the need for Van Dyck to avoid a daunting competition with the master and his large and able following, and to cultivate his personal gifts elsewhere.

*Above:* Detail from 'Rinaldo and Armida' by Van Dyck

*Right:* Nicholas Lanier by Van Dyck. Lanier was Master of the King's Music and often travelled abroad to buy pictures for the King

If any pique had been caused at the English Court by Van Dyck's prolonged stay in Italy and the Netherlands, it was long forgotten. Charles I welcomed the paintings by Van Dyck obtained for him through his agents abroad before the artist came again to England. Through Endymion Porter the King acquired in 1629 'Rinaldo and Armida', a composition suggested by Tasso's *Gerusalemme Liberata*. The portrait of Nicholas Lanier, Master of the King's Music, painted on one of Lanier's expeditions abroad in quest of pictures for the King, had an elegance that made it a distinguished addition to the pictures at Whitehall. A religious subject favoured by Van Dyck, 'The Mystic Marriage of St Catherine', bought by Balthasar Gerbier, was a New Year present to the King and Queen at the end of 1631.

Van Dyck was warmly greeted in person when he came to England in the following year. He was knighted at once and appointed 'principalle paynter in ordinary to their Majesties', without prejudice to the position of Daniel Mytens as portrait painter to the King. Van Dyck was then thirty-three years of age. It was obvious enough that portraiture was to be his main occupation. His abilities were such as to have fitted him for works of wider scope, though to be confined to portraiture was the seemingly inevitable lot of a painter in England. The religious themes that had been called for in the Counter-Reformation mood of Antwerp had no place in a Protestant land, where propaganda of any kind was

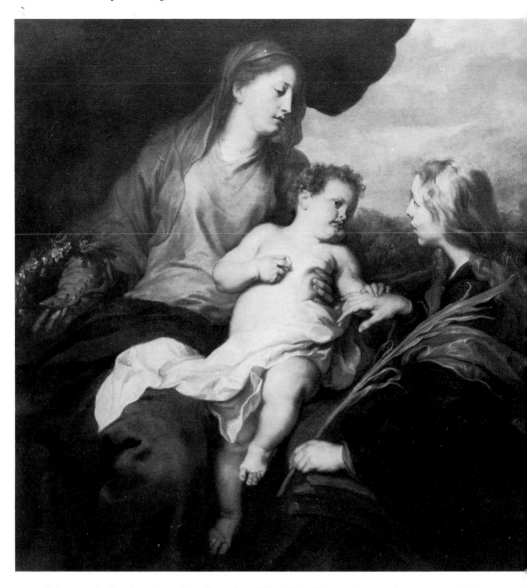

turned in precisely the opposite direction. Van Dyck's 'Mystic Marriage of St Catherine' was more suited to the private chapel of a Catholic Queen than to public showing in an Anglican setting. For reasons in which finance had a part, no grand decorative scheme was projected in succession to Rubens's Banqueting Hall ceiling. The final payment for that great work was not made until three years after its installation. Otherwise any allegorial scheme in its wake, of similar import, might well have

'The Mystic Marriage of St Catherine' by Van Dyck

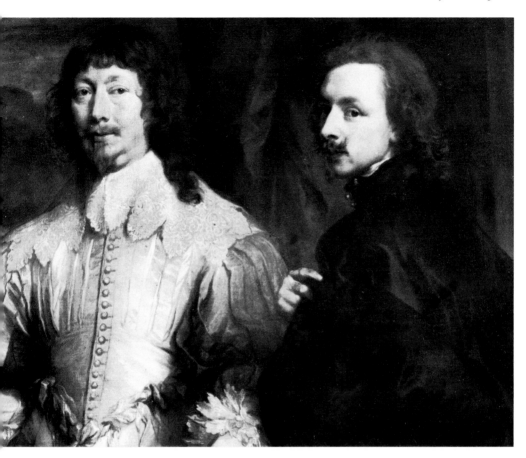

Double portrait of Endymion Porter (*left*) and Van Dyck himself, by Van Dyck

seemed an anti-climax. What could have been a splendid series of tapestries illustrating the historic pageantry connected with the Order of the Garter, remained an idea, going no further than Van Dyck's oil sketch of Charles I and the Knights of the Garter in procession.

Concentration on the portrait had its advantages. Van Dyck was able to enrich the art from the breadth of his European experience, coupled with an eye for nature in various forms that was always keen, and the poetic feeling inherent in his character. The years spent in Italy, in the study of Titian and the portrayal of the Genoese nobility, had served him well, fitting him to combine dignity and grace with an easy naturalness of effect. He was even better equipped than Rubens as a Court portraitist in responding sympathetically to the persona of his subjects rather than affixing to them the stamp of a preconceived type.

95

Something of the refined intelligence he applied to his painting might be guessed from his own features as they can be studied in his self-portraits. His slight and delicate frame appears in marked contrast to the bulk and robust look of Endymion Porter, as they are seen together in Van Dyck's double portrait. Delicacy of perception implied no physical frailty. A capacity for sustained effort has its impressive evidence in the large output of the nine years from 1632 to 1641, mainly spent at the house Charles I provided for him at Blackfriars with a special causeway for the King's convenience in visiting the artist.

It has been estimated that Van Dyck painted forty portraits of Charles I, thirty of Henrietta Maria, nine of the Earl of Strafford, seven of the Earl of Arundel, and four in one year of the beautiful Venetia Stanley at the urgent request of her adoring husband, Sir Kenelm Digby. To these are to be added the many portraits and portrait groups of gentlemen and their ladies that complete his picture of the Court as a whole. Van Dyck's fellow feeling for those concerned with one or other of the arts is shown in the portraits of painters, poets and musicians who were also in some degree Court characters.

A late addition to his *Iconography*—the drawings of his contemporaries from which engravings were made, begun in Antwerp and added to from time to time in England—was the striking likeness of Inigo Jones. Lanier merited his place in the Bear Gallery at Whitehall both as musician and amateur painter, and as an instrument in securing the great collection of the Gonzagas, Dukes of Mantua, for the King. Sir Thomas Killigrew, dramatist, and as theatre manager the first to allow women actors on the stage, was depicted in a masterpiece of double portraiture together, it has been assumed, with his brother-in-law, Lord Crofts. The engraver and publisher, François Langlois, an art dealer also from whom Charles I and Arundel bought works of art, was portrayed as an amateur musician and acting the part of a Savoyard peasant playing on so uncourtly an instrument as the bagpipe. This essay in the picturesque was as far from Van Dyck's usual decorum as he would go. The court circle enclosed him in its illusionary idyll.

It was not for Van Dyck to make remark on simmering

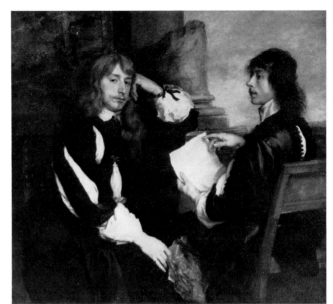

Thomas Killigrew, dramatist and theatre manager, with his brother-in-law Lord Crofts. By Van Dyck

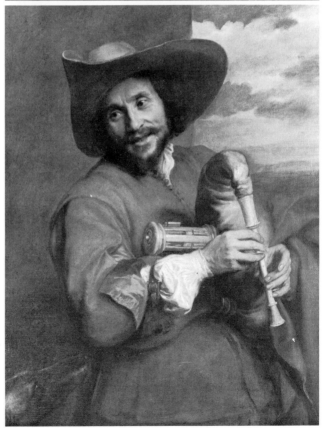

The engraver and publisher François Langlois, portrayed as an amateur Savoyard musician, by Van Dyck

political and religious discord, to give any glimpse of the austere tribe of Puritans whom the dictates of William Laud, Archbishop of Canterbury, were causing to emigrate in droves to seek freedom in the New World across the Atlantic. There was nothing in outward appearance to distinguish among the men of title he portrayed those who would remain loyal to the King and those who would go over to the Parliamentary side when civil war at last broke out. He portrayed the King as he would wish to be seen, serene at the head of a nation ostensibly at peace with the rest of the world, confident in the support of Laud and Thomas Wentworth, Earl of Strafford, as the bulwarks of his absolute rule. The period of personal government from 1629 to 1640 when the angry clamour of Parliament—the very name was odious to the King—was for the time being stilled, coincided with the period of Van Dyck's activity in England. He transferred the appearance of idyll to canvas. Van Dyck's portraits of Charles I evoke as distinct and memorable a royal image as the portraits of Henry VIII by Holbein and of Philip IV of Spain by Velazquez. Masterpieces of the first order are the equestrian portraits. A superb authority belongs to the life-size painting of the King mounted and attended by his riding-master which made so great an impression on visitors when seen at the end of the Long Gallery at St James's Palace. He is made to seem taller than in Mytens's portraits. Grandeur and triumph are sufficiently conveyed, without recourse to allegory, by the arch through which he rides. His white horse, for which Van Dyck made careful studies from life, had a nobility matching that of the rider.

As magnificent, though less formal, was the portrait of Charles I, shown beside his horse and in a country setting, (frontispiece)—informal, though there is no mistaking the gesture and pose of command. No less memorable than works such as these are Van Dyck's portraits of Henrietta Maria. In the freshness of complexion, the delicacy of feature accentuated by the little curls round her brow, the Queen as Van Dyck painted her was a radiant vision of youthful beauty.

Unconsciously perhaps, not so much in deliberate flattery as in response to an idea, he heightened the effect

Van Dyck's great equestrian portrait of Charles I attended by his riding-master M. de Saint-Antoine

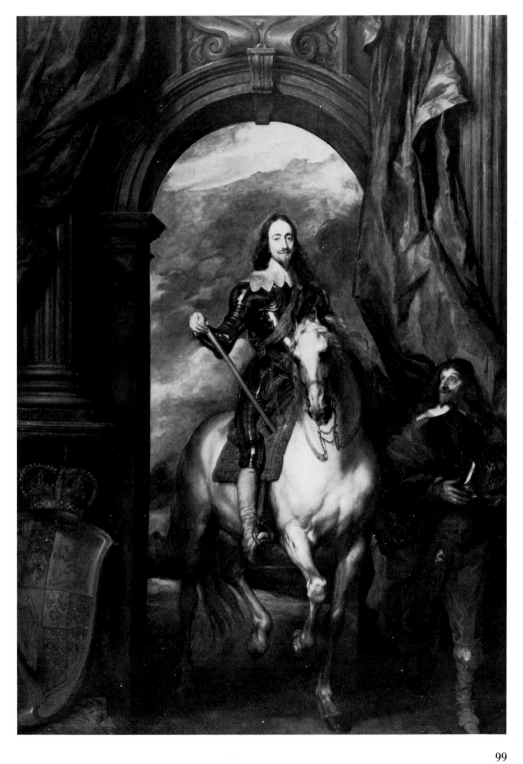

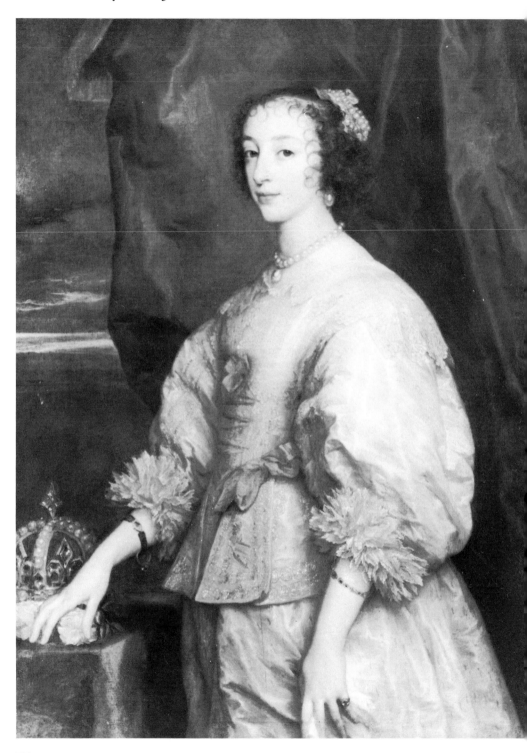

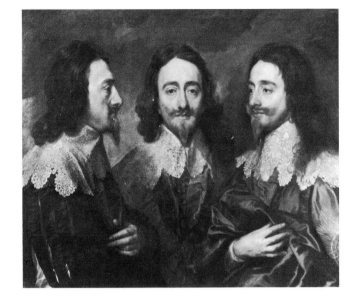

*eft :* Henrietta Maria, Charles I's
Queen, by Van Dyck. It is estimated
that he painted thirty portraits of her

*Right :* Charles I in three positions,
painted by Van Dyck to serve as a
model for a bust by Bernini

*Below :* Bernini's bust of Thomas Baker

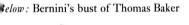

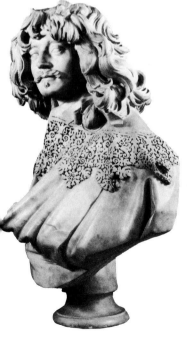

of dignity in the one and vivacity in the other. There is no
outward sign in these beautifully painted ideal images of
any of those flaws of character that historians impartially
deal with. One could not predict from the work of the
painter the weakness of Charles I that would lead him to
abandon Strafford to his enemies. Yet in some way the
impression could be gained from the portraits that all was
not well. This was the opinion formed by the sculptor
Bernini from Van Dyck's painting of the King's head in
three positions, full-face, profile and three-quarter view.
Bernini could not leave Rome, so the picture was to serve
as a model for the marble bust commissioned for the
Queen as a papal present, three views facilitating the
conversion into three dimensions. As quoted by John
Evelyn, Bernini perceived what Van Dyck conveyed
without being consciously aware of it, 'something of
funest [ill-fated] and unhappy which the Countenance of
that Excellent Prince foreboded'. Whether the finished
bust had a like suggestion it is now impossible to tell, as it
was destroyed in the fire at Whitehall in 1698. The King
and Queen saw only an admirable likeness, carved in
marble with all Bernini's virtuosity. With what skill he
would have counterfeited the intricacy of lace in the royal
collar, what balance of realism and sculptural design he
would have imparted to the royal locks, can be guessed

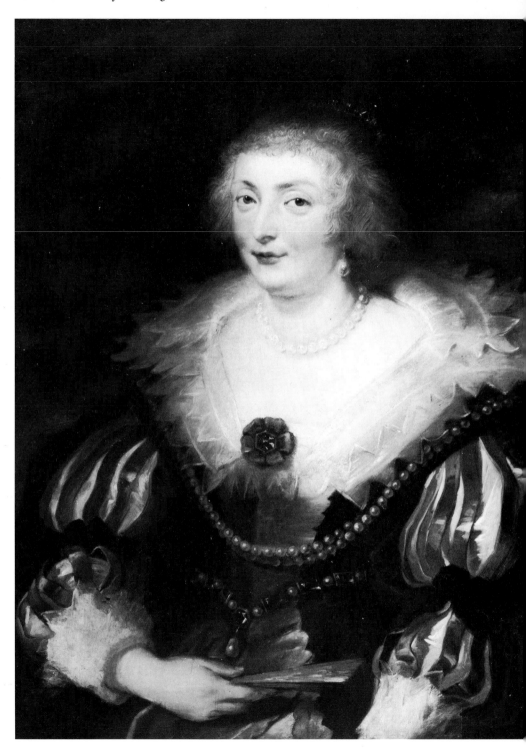

Catherine Manners, Duchess of
Buckingham, by Rubens

from other examples, such as the portrait bust of the
Englishman Thomas Baker executed about the same
time.

In distinguishing the Van Dyck of Antwerp and Genoa
from the Van Dyck of Blackfriars, a tendency to
understatement, which may be equated with refinement
as distinct from dramatic assertion, is to be taken into
account. How far from Rubens he became has an instance
in his portrait of Catherine Manners, when she was the
widow of the Duke of Buckingham, compared with the
earlier portrait of her as Duchess by Rubens. Rubens,
who may not have had his model before him, had recourse
to the general idea of an opulent type of womanhood
which his brush almost automatically created. In strong
contrast is the reticence of style of Van Dyck's picture,
and the unobtrusive reference to the Duchess's wi-
dowhood in the black bow on her bosom enclosing the
miniature likeness of her late husband. Van Dyck was
able to adapt motifs from others without losing the
personal quality inherent in both his refinement of
technique and sense of colour, and his sensitive response
to the character of those he painted. The great equestrian
portrait of the King attended by M. de St Antoine was no
less original for being close in design to Rubens's
equestrian portrait of the Duke of Lerma. The process of
creative borrowing produced a number of memories—
and transformations—of Titian. The pose of the Earl of
Strafford in armour with a background scene of battle is
one such reminiscence, but how distinct are the resolute
features of Strafford as he appeared in 1636 when
answering to the King for his administration in Ireland.

Originality had its secure foundation in the study of
nature as well as the devices of composition that belonged
to art. Careful drawings of detail preceded the finished
works. His excellence in portraying children resulted
from the patient effort with which he observed a
momentary movement or transient expression.
Animals—the horses and dogs of his patrons—were
studied with equal attention. He was as thorough as
Rubens in rendering anatomical structure. Dogs, always a
portrait-painter's resource in adding a feeling of intimacy
and affection, were a well-considered feature, like the

*Overleaf: Left* – Rubens's portrait of the
Duke of Lerma, which influenced the
composition of Van Dyck's equestrian
portrait of King Charles I
*Right:* Thomas Wentworth, Earl of
Strafford, by Van Dyck

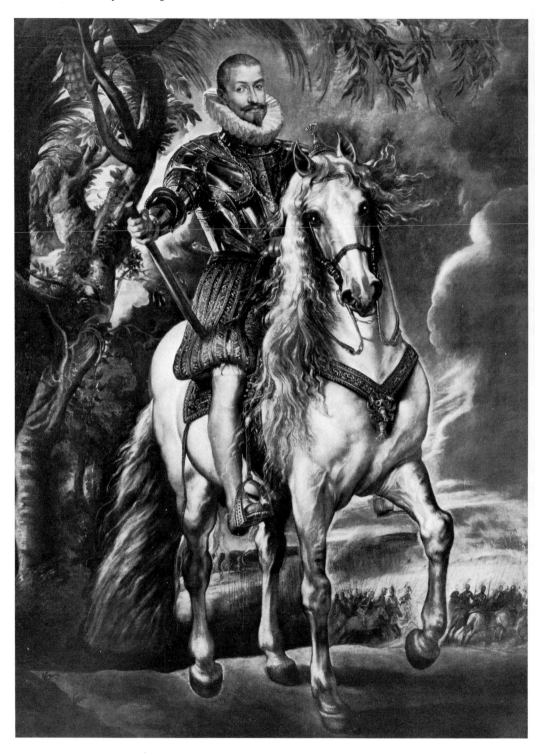

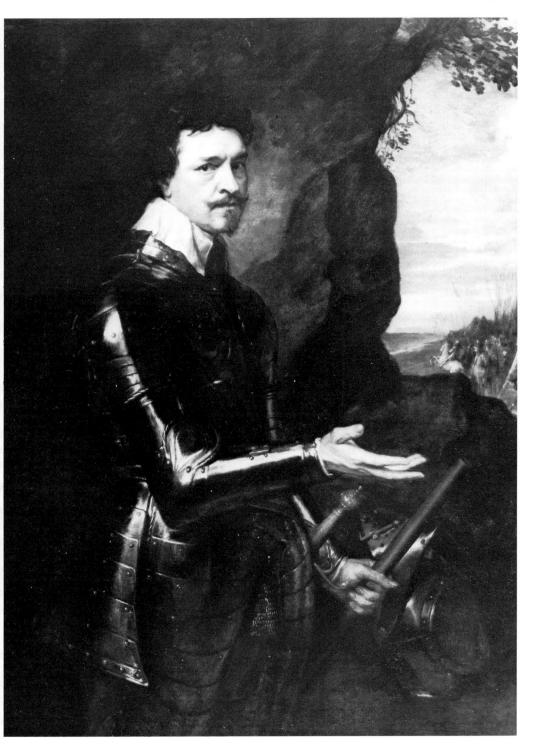

mastiff and spaniel in the group of 'The Five Eldest Children of Charles I' (facing page 83). Nature, in the form of landscape, provided material for backgrounds of a type that was to remain a popular convention in English portraits set against a vista of parkland. Detailed drawings of wayside weeds provided such foreground incident as appears in the Louvre painting of the King in the open air. Watercolours of English country lanes were executed in a medium as yet little used for its own sake, with a freshness and freedom not to be found again until the beginning of the nineteenth century.

In several ways Van Dyck seemed to herald the future. The weight of baroque allegory dwindled; playful touches anticipate rococo charm. The flutter of *amorini* crowning Venetia Lady Digby as Prudence, in the picture that Sir Kenelm Digby commissioned after her death at the age of thirty-three, dispelled excess of mourning gloom. A late work, 'Cupid and Psyche', perhaps designed as part of the decoration of the Queen's House at Greenwich, was a poetical composition recalling those Titian had painted for Philip II but with a delicate rhythm that relates it to the graceful mythologies of a Boucher in the century to follow. Above all, as the portrayer of an aristocratic stratum of society, Van Dyck, in his superlatively well-bred manner, opened the way to the later achievements of the distinctively English school.

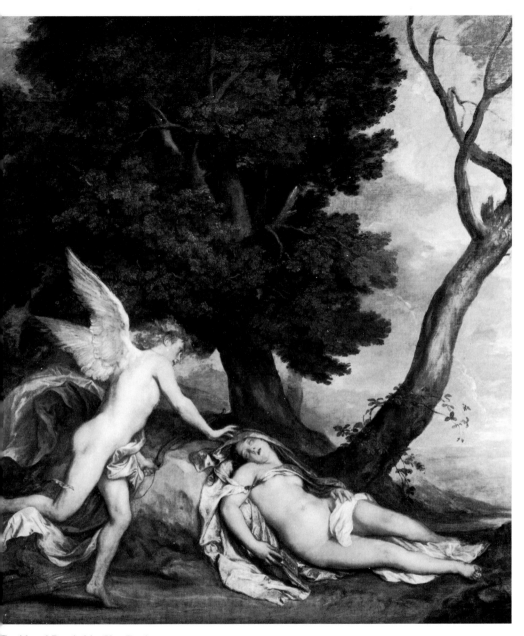

'Cupid and Psyche' by Van Dyck,
perhaps designed as part of the Queen's
House at Greenwich

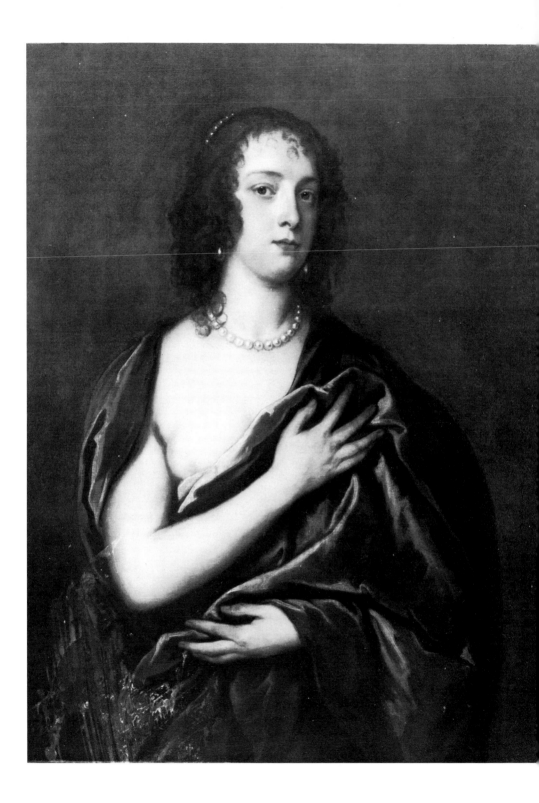

## Chapter 7
## Court painting in a troublous time

It was in 1639, towards the end of Van Dyck's career, that he married Lady Mary Ruthven. The year and the event mark the severance of his relations with his fiery mistress, Margaret Lemon, reputedly the model for his 'Psyche', who is said to have bitten his thumb in an access of jealous rage. His painting of her in a similar pose to that of Titian's 'Girl in a Fur Wrap' was left unfinished in his studio at the time of his death.

1639 also marks a crisis in the affairs of state, the breaking of the political storm that had long been brewing. The invasion of England by a Scottish army in Presbyterian protest against the decrees of Laud, forced the King at last to summon the Parliament he so detested and thus set in train the sequence of events that produced the final explosion of civil war.

It is possible to write of the war and the events that led up to it without reference to painting, just as it is possible to consider the developments of Court painting and art-collecting as activities mercifully insulated from such matters as the levy of Ship Money, constitutional rights as opposed to absolute rule, and the religious divisions that embroiled England, Scotland and Ireland alike. Yet even indirectly art was concerned in the complex history of conflict.

Art was one of the expenses that angered those who had no such enthusiasm for painting and sculpture as King and Court displayed. 'Costly furniture', a term including pictures, as well as 'sumptuous feasting and magnificent building' were described by Sir John Eliot, in his fierce indictment of Buckingham at the time of the latter's impeachment by Parliament, as 'the visible evidence of the express exhausting of the State'.

The philistine burgess could only regard the purchase of the great collection of the Dukes of Mantua as an idle indulgence, though the sum of £18,280 12s 8d for this unique assembly of masterpieces, painfully raised in

an Dyck's portrait of Margaret
emon, his fiery mistress who was
id to be the model for Psyche
revious page)

instalments and after much demur on the part of Burlamachi, the Rothschild of the age, seems trifling in imagined comparison with the millions they would fetch in an auction of the present day. The cost was little enough compared to the enormous sums squandered by James I on his favourites to no obvious purpose whatever. But part of the reluctance to grant the King money was due to the idea that it might be spent on aesthetic luxuries. One argument against Ship Money was the fear that it would not be used for ships.

The constant suspicion of a *coup* that would tie England to Catholic Europe extended to the works of art that came from Continental sources or had similar religious associations. The philistine Puritan had an equal dislike of the beautiful baroque porch of St Mary the Virgin at Oxford and the altarpieces of Continental masters. Both were interpreted as the insidious weapons of propaganda. In the ominous year 1640, Van Dyck went away for a while to Antwerp and Paris, though he returned to London in the following year to paint a final royal portrait commission, the marriage portrait— children though they were—of William II, Prince of Orange, aged fifteen and Mary Princess Royal, aged ten.

The picture, characteristic in its portrayal of youthful charm, was painted in Van Dyck's studio under his supervision at least, if not entirely by his own hand. He was by then an ailing man, who died in the same year at his house at Blackfriars, aged only forty-two. 1641 was also the year in which Strafford, whose determined features he had portrayed, was given over to a merciless Parliament and executed; when Archbishop Laud was committed to the Tower to await his eventual execution; when civil war could no longer be put off.

Evidently Van Dyck contemplated a return to Antwerp. Rubens had died in 1640, leaving unfinished the series of paintings for Philip IV's hunting-lodge. It was tempting to Van Dyck to think that he might add a painting of his own to the series. There was a possibility of adding to the decorations of the royal palace in Paris. But Van Dyck's death put an end to these projects, and leaves also as a matter of speculation how he would have acted in the ensuing period of open hostilities in England between

The marriage portrait of William II, Prince of Orange, aged fifteen, and Mary, Princess Royal, aged ten, by Van Dyck

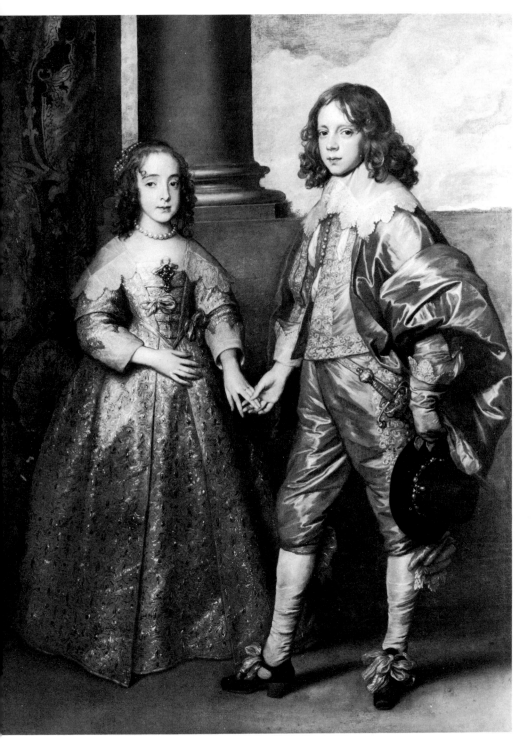

the King's party and the Commons. How a Court painter might fare in this precarious situation is to be followed in the life and work of the one English artist who stands out individually in immediate succession to Van Dyck— William Dobson.

There is scanty record of Dobson's early life and training. He was baptized in 1611 at St Andrew's, Holborn, his father being described in the records as a 'gentleman'. William Dobson senior, 'a St Alban's man' in the words of the lively memoirist John Aubrey, was employed by Francis Bacon and assisted him in the decoration of his house on the estate at Gorhambury, near St Albans. According to Aubrey, the senior Dobson wasted his fortune in high living. The fall of his patron in 1621, charged as Viscount St Albans and Lord Chancellor before the House of Lords with bribery and corruption, was no doubt a factor in the Dobson family's straitened circumstances.

It seems likely, as stated by the Royalist and antiquary Richard Symonds in his memoranda, that the young William Dobson, put early to work as a painter, was the pupil of the German designer of Mortlake tapestries Francis Cleyn, 'who taught him his art'. Evidence of this has been derived from the motifs both made use of. There is some likeness between the sculptured busts and reliefs that Dobson introduced into his portrait canvases, and the classical and allegorical figures of Cleyn's decorative designs. At one time he was assumed to have been the pupil of Van Dyck, though neither style nor authentic record lend much support to the assumption. Venetian painting was a perceptible influence in the development of his rich colour. Either through Cleyn or the royal archivist Abraham van der Doort, he may have gained and profited by access to the Venetian masterpieces in the royal collection, an education in themselves. He was not untouched by the force of Caravaggio as it was transmitted northwards by followers in the Netherlands and so at a remove conveyed to England. Dobson's history painting, 'The Executioner giving the Head of St John the Baptist to Salome', was the copy of a work by the Dutch artist Matthias Stomer, with all those dramatic effects of light and darkness that Caravaggio had inspired.

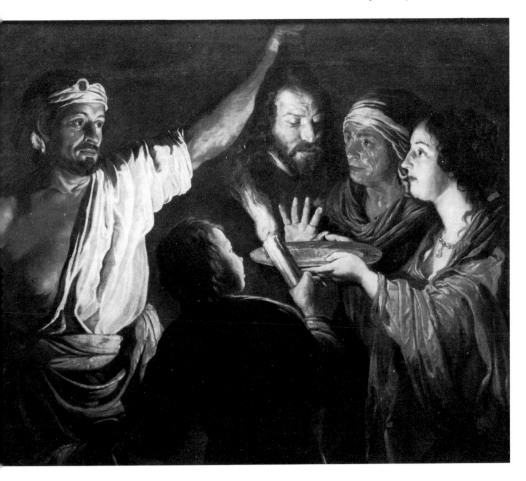

William Dobson succeeded Van Dyck as Court painter to Charles I. His 'Executioner giving the Head of St John the Baptist to Salome' was a copy of a work by Matthias Stomer

It is possible that Van Dyck recommended Dobson to the King, but, little being known of Dobson's work up to the age of thirty-one, he then appears with an effect of suddenness at the Court established after various manoeuvres and misfortunes at Oxford. Whether or no he had an official title as Court painter—it was scarcely a time for such ceremonial appointments—he became the painter of the royal family and entourage in the grim years between 1642 and 1646, until the Parliamentary forces entered Oxford in triumph. Prior to that event, the Court was an improvisation with the character of an armed camp, its members in warlike array, its atmosphere full of tensions, inevitably in contrast with that of the luxurious years of peace.

Dobson, virtually a war artist, had no lack of

employment in these circumstances. His place in the Court circle was made the more assured by his friendship with Sir Charles Cotterell, Charles I's Master of the Ceremonies, knighted in 1644. Cotterell collaborated with William Aylesbury, erstwhile tutor to the Duke of Buckingham, in the translation of D'Avila's *History of The Civil Wars of France*, made at the King's request — perhaps to provide some clue to the solution of his own problems. Dobson designed an allegorical frontispiece. But portraiture was still a main requirement, even in wartime conditions, all the more from a close-knit circle which was subject to intervals of inactivity and boredom. Dobson was fully occupied in painting the likenesses of the Royalist officers and adherents. His masculine style was well suited to convey the typical character of a roughened period when airs and graces were no longer in place. To the outward likeness his realism added some suggestion of the psychological undercurrents of the time.

One of the most distinguished of William Dobson's portraits of the Royalists – Sir James Compton, third Earl of Northampton

Dobson's sitters included seasoned professional soldiers who had seen much active service in the Netherlands and in the earlier battles of the war at home: men such as Baron Byron and Sir Charles Lucas. There were 'unknown gentlemen', temporary officers they might be, putting on a determined front as loyal supporters of the King. There were those who had found it a painful choice to make between the opposing sides, their reluctance leaving its mark. The full-length portrait of Henry Mordaunt Earl of Peterborough, who changed over from the Parliamentary to the Royalist side, suggests his difficulty in making up his mind even by the unsettled nature of the composition. There was the aristocratic youth firm in loyal conviction, such as Sir James Compton, third Earl of Northampton, as he appears in dignified calm against a stormy background in one of Dobson's most distinguished portraits. Finally there were those sick of the whole business and inclined to throw in their hand. A group supposed to represent Prince Rupert and Colonel Murray trying to persuade Colonel John Russell not to resign his commission, tells a story of this sort almost in the manner of a Dutch genre-painting.

An altered light illuminated many of those whom Van

ndymion Porter by William Dobson,
ainted at the King's improvised Court
t Oxford during the Civil War

Dyck had formerly portrayed; partly because they were older and in a world grown menacing, partly because it was not Dobson's habit to idealize. The gulf of years and experience separates the Prince Rupert whom Van Dyck had painted as a boy of fourteen at ease in stately surroundings, from the brooding man resentful of defeat in the portrait Dobson left unfinished in 1645. Endymion Porter, long the King's ally in the quest for pictures, the patron of letters and friend of Donne, Herrick and D'Avenant, takes on the air of a country squire in the portrait that is Dobson's most celebrated work. Gone was the elegance of aspect with which Van Dyck had invested him in the group portrait of Endymion with his wife Olivia and their children; gone the jovial look of the Endymion painted a decade earlier together with Van Dyck (page 95). It was a graver man of some fifty-six years whom Dobson painted in a sporting interlude during Endymion Porter's attendance on Charles I in his rooms

115

in Christ Church. Rich in colour and precise in detail, the portrait indicates that he has just shot a hare with the wheel-lock sporting gun he holds. The hare may well have been a welcome addition to the larder when provisions were in short supply. The gun was painted with all the exactitude that makes it of an immediately recognizable German type to the eye of the modern expert.

Dobson in other portraits applied the same precision to the variety of weapons with which members of the martial court were furnished. The bust of Apollo and the frieze with its symbolic figures of painting and sculpture were probably introduced in reference to Endymion's record as a patron of the arts. Similar sculptural details in other paintings may have furnished either some similar incidental comment on the sitter's career, or a general remark on the cultivated milieu placed at risk by war. In its composition, Dobson's portrait of Endymion Porter followed Titian, being adapted from the pose of Vespasian in the Venetian master's series of paintings of the Caesars. This was appropriate enough, as Endymion had played his part, together with the dealer Daniel Nys, in securing the Titians for the King, along with the many other works from the great Gonzaga collection. An engraving no doubt refreshed memory for the artist, when at Oxford, of the original hanging at Whitehall.

Equally a masterpiece in richness of colour and design was Dobson's portrait of Charles II as Prince of Wales (facing page 131). The Prince whom Van Dyck had portrayed as a chubby little boy of five was thirteen in 1643, old enough to have been present at the battle of Edgehill; his induction into the arena of conflict made evident by his armour, the helmet brought him by his attendant and the distant view of battle. The head of Medusa, overthrown amid debris and contrasting with the stately column and magnificence of tapestry behind the Prince, suggest the hope aroused by an indecisive victory. That the hope proved transient does not impair the quality of the painting.

One group of three, portraying the artist himself, his friend Sir Charles Cotterell, and an elderly man, has left a question as to the identity of the third party, long

Triple portrait by William Dobson – from the right, the artist, Sir Charles Cotterell, and a man who may be Balthasar Gerbier

assumed, though without certainty, to represent the friend of Rubens and agent of Charles I at Brussels, Sir Balthasar Gerbier. If it were in fact Gerbier, his presence would account for the gestures of aversion with which the others seem to turn away from him. The master of devious dealing was now the object of suspicion on every side. He had injured the King's cause by announcing that Lord Cottington, leader of the pro-Spanish party, had betrayed state secrets to Spain—which many supposed Gerbier to have done himself. A pariah at Court, he was hated by the masses as a plotter of foreign invasion, a belief that led to an attack on his house at the then village of Bethnal Green by an angry mob.

Dobson painted at Oxford until about 1644. At about that time he could still produce such impressive works as his portrait of Inigo Jones, recognizably the man whom Van Dyck had drawn but no longer showing the same

alertness of feature, become weary-looking with the pressure of years and events; and the likeness of Sir James Compton, so well conveying aristocratic dignity (page 114). But the tide of the Civil War was inexorably turning. Charles's crushing defeat by Cromwell's New Model army at Naseby in 1645 made the semblance of a Court and military headquarters a pathetic fiction. As its members drifted away, it is not surprising that a number of Dobson's portraits were left unfinished, or that his painting should bear signs of haste and some lack of his earlier vigour. With the departure of the King and his following from Oxford in April 1646, Dobson's career as a Court painter came to an end, though his record of the participants in the strange drama of history which he witnessed was to be of lasting value, and the quality of his art the rediscovery of a later age.

Inigo Jones by William Dobson

## Chapter 8
# A Court in dissolution
## and the after-effects on painting

A mournful chapter in the history of art in England
followed Charles I's surrender. The fate of many gifted
individuals was sad or tragic. William Dobson, who had
spent carelessly and without thought of the morrow, went
back to London where, his living gone, he was imprisoned
for debt. A well-disposed official in the Exchequer
secured his release, but his day was over. He died in
poverty in a house in the artists' quarter of St Martin's
Lane in October, 1646. His burial in the church of St
Martin-in-the-Fields passed without particular remark
or notice of regret. He was only thirty-five when he died.

Nothing was left but ignominy for the great architect of
royal houses, the brilliant designer of court masques,
Inigo Jones. At the age of seventy-two he was taken
prisoner when Cromwell's Ironsides stormed and
destroyed Basing House. Treated with contempt as 'the
Contriver of Scenes for the Queen's Dancing Barne', he
was hauled out of the smoking ruins in a blanket. Though
his property was given back to him in the following year,
with the deduction of a large fine, he ended his life in
obscurity. When he died at Somerset House in 1652, his
will showed that he had retained moderate wealth. There
was provision for his tomb in St Benet's Church, a
sarcophagus flanked by obelisks with reliefs at either
end—of the Banqueting Hall and the porch he designed
for old St Paul's—and a portrait bust above. The tomb
was demolished when the church was rebuilt; the bust
may have survived to give a model to Michael Rysbrack,
whom the third Earl of Burlington, Inigo Jones's great
admirer, commissioned early in the eighteenth century to
produce a similar marble bust for his Palladian villa at
Chiswick. The books and drawings that Jones left to his
architect assistant, John Webb, coming finally after
various dispersals into the collections at Chatsworth,
Worcester College, Oxford and the Royal Institute of

British Architects in London, fortunately survive as graphic testimony to his fertile invention and influential ideas.

The collectors of works of art, who had always been viewed with hostility as such, as well as from their close relation with the King, were precariously placed as rebellion turned into a victorious new order. Thomas Howard Earl of Arundel, was one who could neither tolerate nor be tolerated by the triumphant Commons. Not only a connoisseur, he was a general in the Royalist forces, the escort of Henrietta Maria to the Continent in 1642 to raise money and support for the Royalist cause. He and his wife impoverished themselves by contributing £54,000 from their private fortune. In 1644, unable to do more, they left England to settle in Padua, in the northern region of Italy dear to them by many associations. A large part of the Arundel collection went with them. Parliament meanwhile confiscated their jewellery and plate. John Evelyn, who had breakfast with Arundel at Padua in 1646, records leaving 'that great and excellent man in tears' at 'the undutifulness of his grandson Philip's turning Dominican Friar', and 'the misery of his country now embroiled in civil war'. Arundel died in the same year at the age of sixty.

Endymion Porter fared badly. Well appreciated in the Court circle as a man of intelligence and pleasant humour with a natural flair for both painting and letters, he was bitterly hated by the rebellious faction as the adherent of Buckingham and Charles I. An intellectual entrapped by his loyalties in the mesh of politics and religion, he was suspect on account of his Spanish connections, the Catholicism of his wife, and, it may be, his love of the arts. Loyalty impelled him to follow the King from place to place in the shifting manoeuvres and fortunes of war, arriving eventually at Oxford where Dobson painted his portrait. He was given the rank of colonel in an infantry regiment, though equipped neither by age or training to take part in any actual fighting. Meanwhile the House of Commons, of which he had been a member, decreed his expulsion and seized his property.

He rode out of Oxford with the King in 1645, and in that year was sent to France with messages from Charles I

for Henrietta Maria. The Queen cold-shouldered him; Porter and his family were left stranded in France. Without resources they took refuge in Brussels where there were old friends to give some measure of help. He was allowed to return to England in 1649, but in that fateful year of the King's execution, Endymion Porter also died. The return of some possessions was conceded to his family. It was an irony that the print after his portrait, made by the engraver William Faithorne, was later issued with an altered moustache, by another engraver, as the portrait of the Earl of Essex, leader of the Parliamentary forces.

Nicholas Lanier, agent of the King though he had been, survived the changes of regime to be reinstated as Master of the King's Music after the Restoration. Sir Balthasar Gerbier, suspect to every side but adroit in attaching himself to any, was able to profess loyalty to Cromwell and to discover a plot against him in profession of loyalty, as he had previously discovered plots against the monarchy. He is credited with a malicious and anonymous pamphlet against the King entitled *The None-such Charles, his Character*; though at the Restoration it was he who designed the triumphal arches welcoming Charles II's return. Far removed from his friendship with Rubens, his picture-dealing and his miniature portraits, were his curious ventures meantime. The universal academy of which he was professor at Bethnal Green, teaching everything from astronomy to polite conversation, was treated with ridicule.

Fantastic was his expedition to Guiana in quest of a gold mine, accompanied by a number of his daughters. That the crew mutinied and shots were fired, one of his daughters being killed and another wounded; that three of them afterwards took refuge in a nunnery, gave occasion for much comment. He wrote lengthy pamphlets as a result, describing himself as the victim of endless conspiracies. He was finally employed in some architectural capacity by the old Royalist, the Earl of Craven, at his house at Hempstead Marshall, where Gerbier died in 1667 aged seventy-six.

Painters who had ties with the Netherlands had some inducement to go back there, employment at the English

Court having come to an end. This was so with Cornelius Johnson who, though born in London, was the son of refugee immigrants from Antwerp. Long established as one of the King's 'picture drawers', though his unassuming style had been no rival to that of Van Dyck, he was still in Charles I's service in the early days of the Civil War. In 1645, when the royal cause was obviously lost, Johnson was allowed a Parliamentary pass to leave the country and 'to carry with him such pictures and colours, bedding, household stuff, pewter and brass as belongs unto himself'. Thus uprooted he settled at Amsterdam, the English connection being still of use in bringing commissions for portraits from Royalist exiles.

One of the most moving portraits of the time had yet to be painted, that of Charles I at his trial, by Edward Bower. Little is known of the artist, reputed to have been an assistant of Van Dyck though no trace of that master's elegance appears in Bower's way of painting. In this instance his capacity for realistic statement was an advantage. The portrait was apparently a commission from the Parliamentary party as a document of the trial. The artist was allowed to be present and make his sketch while the proceedings were going on in Westminster Hall. He was thus a 'court painter' in an ironically altered sense—for the High Court of Justice, which was appointed, with no legal basis of authority, by the unconstitutional 'Rump' Parliament from which any members at all favourable to the King were excluded.

Those who expected the portrait to show him in an unfavourable light were due for disappointment. Charles I seemed never to have looked more calmly assured and majestic than as Bower painted him, seated on the red velvet-covered chair placed for him before the tribunal, and in dark clothes the plainness of which brought his Star of the Order of the Garter proudly into view. It may be doubted if the greater powers of Rubens or Van Dyck would have better conveyed the essence of the unique occasion than Bower with his objective accuracy. It is not surprising that the portrait, in its several versions, became for the Royalists an emblem of the King's fortitude and the unfailing dignity with which he came in 1649 to the final 'memorable scene' on the scaffold erected before

One of the most moving portraits of the Civil War – Edward Bower's painting of Charles I at his trial

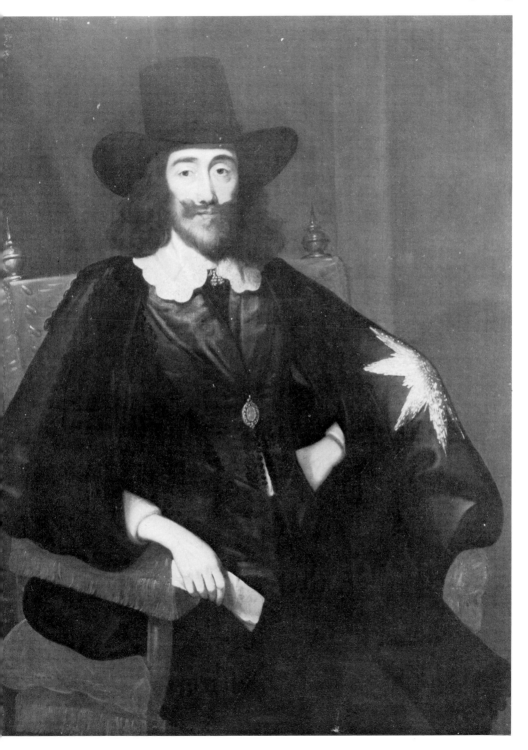

Inigo Jones's Banqueting Hall, part of the great new palace never to be completed.

The subsequent dispersal of the royal art collections at Whitehall, Hampton Court, and Greenwich, was an act of revenge, a means of raising money and, as it can be seen in the perspective of time, a national calamity. The European princes, who had felt as much chagrin as the inhabitants of Mantua at the sale to Charles I of the unrivalled collection of the Gonzagas, took advantage of the unique auction ordered by the English Parliament. Their agents and the picture-dealers gathered like vultures round the works of Correggio, Michelangelo, Titian, Tintoretto, Andrea del Sarto, Giulio Romano, Guido Reni and many masters more. The great paintings, stamped with the crown and initials C.R., which went to enrich the collections of France, Spain and Imperial Russia, if kept in their entirety together and not frittered away, might in the fullness of time have become the most splendid of National Galleries. Some works were sold for little enough. Nicholas Lanier was able to buy his portrait by Van Dyck for £10. It was to Cromwell's credit that he halted the dispersal before the ruin of the collection was complete, specifically reserving the Cartoons of Raphael and the Triumph of Caesar by Mantegna. Yet, so far as the collections of works of the past was concerned, there was reason for Horace Walpole's remark that: 'The arts were in a manner expelled with the royal family from Britain.' The proviso could be made that many artists, little disturbed by political upheaval, worked quietly and impartially on, for the Court circle of Charles I, for the dominant figures of the Commonwealth, and, with no difficulty in readjustment, for the revived Court of Charles II. The miniature-painters give a special instance of the artist's capacity for surviving in all weathers, and continuing or altering a tradition without hindrance.

## Chapter 9
# The survival of the miniature

The miniature blossomed afresh in the seventeenth century, though with a marked difference from its earlier ethos. The joyous outburst of colour and poetic feeling in the Elizabethan miniature faded away. Traces of the style of Nicholas Hilliard and Isaac Oliver lingered in the work of their sons, and others old enough to keep something of the sixteenth-century outlook. But the signs of change were already present in more sober colouring and the greater realism to be obtained by light and shade, equivalent to the effect of three dimensions. These are qualities that appear in the work of Lawrence Hilliard, who followed his father as Royal Limner, Peter Oliver, much employed at the court of Charles I, and Edward Norgate, heraldic draughtsman who painted miniatures and, like Nicholas Hilliard, wrote a treatise on the art of limning.

The factors that had earlier given the miniature Court favour were still operative. The intimate portrait kept its value as a personal ornament, a gift token of regard, a counter in diplomatic exchange. Another use was that of serving as a reminder on a small scale of large compositions, in much the same way as the modern colour reproduction. Charles I had many copies made in miniature of the cherished masterpieces distributed in the royal palaces. He could muse on Raphael or Titian in the small versions kept in his cabinet or (portable as they were) take them with him when he travelled. Peter Oliver and others produced a number of such copies, often after Van Dyck. This was one reason why the miniaturists were so much conditioned to working in his manner. They adopted something of Van Dyck's approach when they came to make original portraits of their own.

In the time of Nicholas Hilliard the miniature had been the avant-garde of painting to the extent of influencing the large-scale portrait in design and colour. The position was now reversed; the miniaturists followed the oil-

painter in realistic aim. They were not on that account necessarily inferior in quality. They included excellent artists, chief among them Samuel Cooper, who was able to bequeath an invaluable record of character and fashion in his time. An often-quoted term of praise describes him as 'a Van Dyck in little', which could be misleading if taken to imply that he was a minor follower of Van Dyck, or that 'little' ambiguously referred to his stature as an artist as well as the size of his productions.

There was a largeness in Cooper's way of painting that was independent of size. A poster accompanying the exhibition held at the National Portrait Gallery in 1974, *Samuel Cooper and his Contemporaries*, showed how well one of his miniatures stood up to the test of enlargement. It was a demonstration of the point made by Horace Walpole: 'If a glass could expand Cooper's pictures to the size of Vandyck's, they would appear to have been painted for that proportion.' Walpole, pursuing comparison, thought it would be 'an amusing trial to balance' Cooper's Oliver Cromwell and Van Dyck's Lord Strafford. It is hard to imagine what Van Dyck would have made of Cromwell, arch-enemy of his courtly world; it is doubtful whether even Van Dyck would have rivalled Cooper in bringing the Protector powerfully to life.

Cooper owed a good deal to his uncle and teacher John Hoskins, who has been overshadowed as an artist by the fame of his principal pupil and has received less notice than he merits from the little that is known of him as a person. Hoskins, born about 1595, was, according to the writer on art, De Piles, 'bred a face painter in oil'; though evidently he turned to miniature painting while still a young man. He was well established at the Court of Charles I in the 1630s and painted masterly miniatures of Charles and Henrietta Maria from life, besides copying their portraits by Van Dyck. He was appointed King's Limner in 1640 with an annuity of £200, though in the circumstances then prevailing it is not surprising that payment soon fell into arrears.

A self-portrait in profile showing him with strongly marked features and prominent nose has a reminiscence of Isaac Oliver, but Hoskins quickly mastered the later developments of pose and lighting that made for greater

realism. Samuel Cooper so far profited by his example that some of Hoskins's works have been attributed to him. Hoskins and his wife Sarah had a son who also became a miniaturist, though next to nothing is known of John Hoskins Junior and his work. That he had a son who died as a baby is recalled by the drawing of a dead child Samuel Cooper made, with the inscription, 'Ye son of Old Mr Hoskins' son'. The family ties were evidently close for a time. Samuel Cooper and his brother Alexander were brought up in the Hoskins household, and there are drawings of Sarah Hoskins by Samuel, while the junior Hoskins is taken to be the young man portrayed on the reverse of the poignant drawing of the dead child.

It was natural enough that they should part company, whether or no Hoskins senior was jealous of his nephew's rapid progress as an artist, as Richard Graham stated in his appendix to Du Fresnoy's *The Art of Painting*. Established in independence, Samuel Cooper was employed and acclaimed a master in the successive regimes of Charles I, the Cromwell Protectorate, and the restored monarchy of Charles II, unaffected either by political change or the rivalry of numerous followers of his style. He spent some time abroad, it may be surmised during the critical period of the Civil War, when according to Richard Graham he was 'personally acquainted with the greatest Men of France and Holland', and by his portraits Cooper was, according to his eulogist, 'more universally known in all parts of *Christendom*'.

That he had an international reputation is certainly suggested by the visit of Cosimo de' Medici to London in 1669. He had heard of Cooper's fame and sat to him for his portrait. The Grand Duke of Tuscany, as Cosimo was to become, left a vivid vignette of the artist as 'a tiny man all wit and courtesy, as well housed as Lely, with his table covered with velvet'.

Alexander Cooper did not risk competition with his younger brother as an artist in London. He went abroad as a young man and stayed out of England, becoming a successful miniature-painter at the courts of Sweden and Denmark, though with less than his brother's exceptional gifts. Samuel Cooper was already mature and distinct in style in his twenties when, about 1635, he painted

Margaret Lemon, Van Dyck's mistress, in masquerade costume as a young cavalier. The long subsequent series of women's portraits show how well he was able to convey individuality and to avoid falling back on some preconceived type of feminine beauty. An intimate and living quality singles them out, whether he was portraying Charles II's Portuguese Queen, Catherine of Braganza, the attractive features of his (Cooper's) own wife, or the aristocratic ladies of the Court and the beauties of Charles II's reign, on whom the King showered titles and favours. Barbara Villiers, whom the King made Countess of Castlemaine and Duchess of Cleveland, *la belle Stuart* Duchess of Richmond and Lennox (by whom, Pepys disapprovingly remarked, Charles II was 'besotted'), incited the miniaturist's best efforts.

The many portraits Cooper produced during a long stretch of time trace the changes of fashion according to the standard set by the Court circle: the variation of feminine coiffure, the corkscrew curls allowed to dangle on either side of the head, the gradual lowering of the neckline with voluptuous suggestion. A change in male fashion was the disappearance of the pointed beard and spreading moustache so characteristic of Charles I and his Court. It became the habit instead to go clean-shaven or with a pencil-line of moustache. 'The loathsomeness of long hair' condemned by the Puritan was not entirely abandoned by Cromwell, though return to an ample luxuriance of locks came with the Restoration and finally had its artificial extension in the wig.

The record of fashion was incidental to the record of personality. Cooper's grasp of character was more than the ability to depict physical features with accuracy. He shared with Holbein the gift of fixing an unmistakable likeness that was the essence of personality and not a surface resemblance merely. His portraits of leading figures in the Civil War and after, give emphatic illustration. In the miniature of John Pym there is all the iron determination of the enemy of Buckingham, the leader in Strafford's impeachment and every following crisis, making him in Clarendon's sour judgement, 'the most popular man and the most able to do hurt that hath lived in any time'.

Samuel Cooper painted a brilliant series of portraits of the women at Charles II's Court. *Right:* Catherine of Braganza, Charles II's Queen. *Far right:* Barbara Villiers, Duchess of Cleveland. *Below:* Frances Stuart, Duchess of Richmond and Lennox

His George Monck had the aura of reasonable compromise, of one ready to go with the tide that turned in the Stuarts' favour after Cromwell's death. In portraying Cromwell himself Cooper achieved a major triumph. The unfinished miniature, the model for a number of other versions, gave even on a small scale, a feeling of bigness, of the formidable power behind the frowning brow and the resolute set of the mouth, its firmness intensified by the tuft of chin beard beneath.

Equally revealing, though dramatically in contrast, were Cooper's portraits of Charles II, superbly represented by the version in the Mauritshuis at The Hague (page 150). The King's features, always strongly marked from boyhood when William Dobson had painted him, now deeply scored by experience, tell without words the whole history of exile and return, and the cynicism and humour that were their product.

The portraits of Oliver Cromwell and Charles II are masterpieces of characterization worthy to rank with Holbein's portrayal of Henry VIII. Yet every face among the many Samuel Cooper painted had its individual stamp. 'One of the best pieces that ever he did', in the view of his friend Aubrey, was the sketch of Thomas Hobbes, also one of Cooper's literary friends. Charles II

*Right:* Oliver Cromwell by Sir Peter Lely (see page 136)

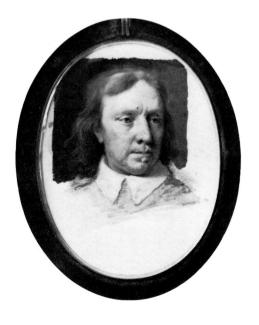

Samuel Cooper's major triumph – the unfinished portrait of Oliver Cromwell

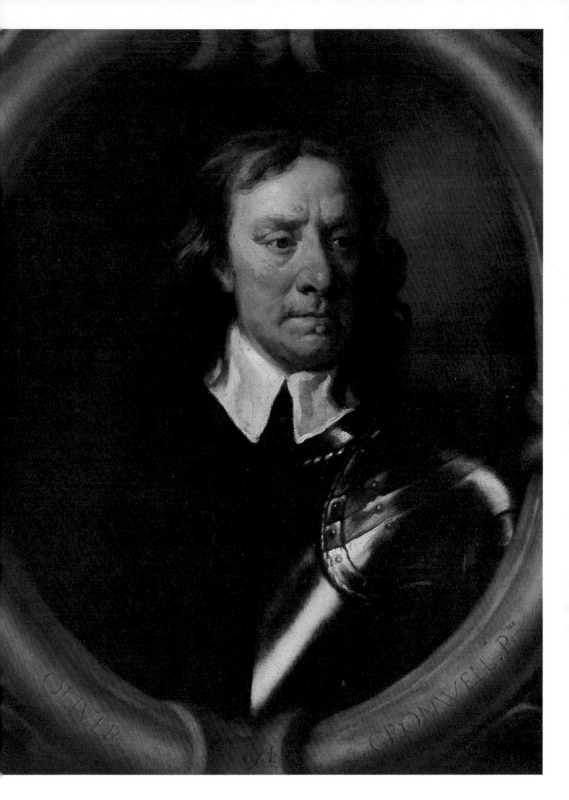

*Left*: William Dobson's portrait of
Charles II as Prince of Wales, at the
battle of Edgehill (see page 116)

bought this miniature of the philosophic advocate of
absolute government, who had been his tutor in
mathematics during the royal exile in Paris. Celebrated as
the author of *Leviathan*, an active controversialist of over
seventy, he seems in the portrait in a mood to enjoy the
Puritan discomfiture and the dispute that still followed
his sarcasms on the subject of liberty. There is a gleam of
the sardonic humour Aubrey spoke of: 'When Hobbes
laughed and was merry one could scarce see his eyes.'

Active until the end of his life, Samuel Cooper, who
died in Bedford Street, London in 1672 aged sixty-three,
was then aptly styled by the painter Charles Beale 'the
most famous limner of the world for a face'. He stands out
clearly among the many miniature painters who flou-
rished in his time, able though most of them were—his
follower, Thomas Flatman being a distinguished exam-
ple. It might almost be said that the art of the miniature
died with him, or at all events with the period in which he
lived. As a form of painting largely supported by the
Court and its adherents, the miniature did not outlast the
seventeenth century. A reason for its disappearance
might be found in a growing preference for painting on a
decorative scale, 'decorative', that is, in relation to some
architectural setting. The large-scale portraiture that
existed alongside the miniature gave its separate evidence
of the influence of Van Dyck.

Thomas Hobbes by Samuel Cooper

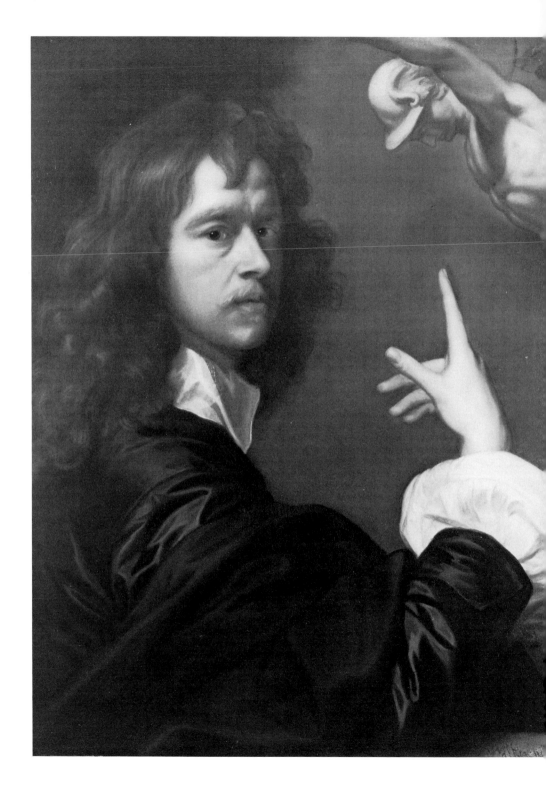

## Chapter 10
# The followers of Van Dyck

It was a feature of the Commonwealth Interregnum that while European master-works from the royal collection were sold off without a twinge of regret, while the statuary, carved decoration and stained glass of the churches were features defaced or destroyed so far as they were deemed to savour of idolatry, the respect for portraiture remained as strong as ever. The rulers of the moment required their likenesses as much as the regime they had ousted. Cromwell, his family and his generals were not only painted in miniature but with all the impressiveness attaching to a larger scale. A painter they favoured was Robert Walker, an artist of not more than moderate capacity but a sedulous imitator of Van Dyck, from whose works he borrowed freely. In the attempt to preserve the flavour of aristocratic refinement he might be termed a Court painter in the absence of a Court. His self-portrait repeats the gesture of the Van Dyck self-portrait in which the artist points to a sunflower as a symbol of the arts, with a graceful implication also of the generous warmth of royal patronage. Walker's forefinger points with similar symbolic intent, though a statuette of Mercury as patron of art is substituted for the sunflower. There was irony in his using the compositions of the King's painter in the portraits of the King's enemies. The portraits of the Puritan and regicide Colonel Hutchinson, and of Oliver Cromwell himself, are examples of this metamorphosis. When Walker came to paint Cromwell victorious after the battle of Naseby, he portrayed him in armour and with baton in hand in the same pose as Van Dyck's Strafford (page 105). A mild presence in the portrait invested with an unsuitable elegance, Walker's version of Cromwell lacked that sense of a formidable power which Cooper's miniature conveyed. No comment by Cromwell is recorded on Walker's flattery. The famous exhortation, delivered with what ferocious humour can be imagined, and obliquely a criticism of

Self-portrait by Robert Walker – a sedulous imitator of Van Dyck

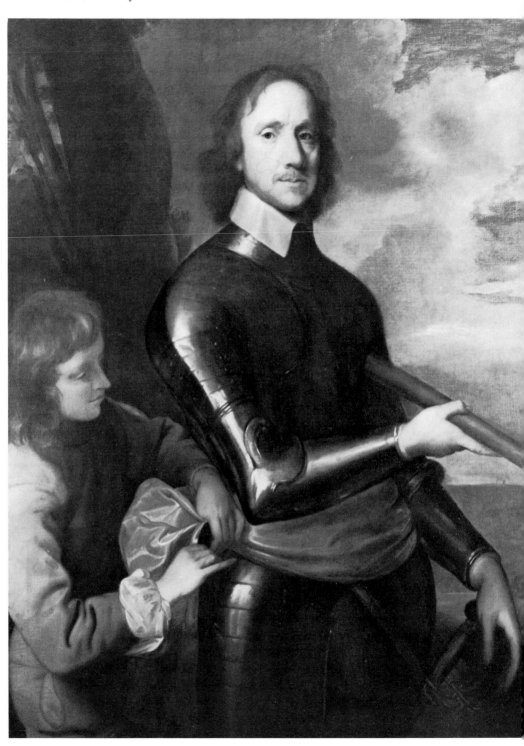

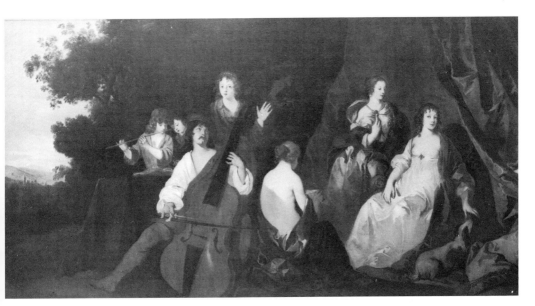

*Above:* 'An Idyll' by Peter Lely, who came to England early in the 1640s

*Left:* Oliver Cromwell victorious after the Battle of Naseby, by Robert Walker

Court airs and graces, 'to remark all these roughnesses, pimples, warts and everything as you see me', was addressed to another painter, Peter Lely (facing page 130). The wart plain to see on the brow in Cooper's miniature (page 130) is absent from Walker's painting.

Robert Walker died in the same year as Cromwell, 1658. Peter Lely, who long outlived him to become the principal Court painter of the restored monarchy, had already made his appearance in England. Originally Pieter van der Faes by name, he was born at Soest, where his father, a Dutch army captain, was stationed. He is said to have adopted the surname Lely from the nickname given to his father who was born at a scent shop, the 'House of the Lily', in The Hague. After learning to paint at Haarlem, Peter Lely came to London early in the 1640s, hoping to find a market for landscapes with small figures, and mythological scenes of the kind with which other Netherlandish artists visiting England had pleased Charles I and the Court circle.

In a similar vein he painted compositions richly combining Dutch realism with a baroque verve of design. The so-called 'An Idyll' brilliantly rendering the spirit of an amateur musical performance, was a composition of this kind. But the time was no longer so propitious as it had been for the fanciful compositions of Cornelis van

Poelenburgh and Frans Wouters. Lely had come to England when war was going on and there was little time or wish for light-hearted pictorial entertainment. He had an early patron in Algernon Percy, tenth Earl of Northumberland, a moderate man who, though driven over to the Parliamentary side by disagreement with the royal policies, still hoped, while it seemed possible, for reconciliation between King and Parliament. He commissioned Lely in 1647 to paint Charles I who was then held a prisoner at Hampton Court, his fate still in the balance, and the royal children who were under Northumberland's care at Syon House but were allowed visits to their father.

The painting which shows the future James II, then Duke of York, a boy of fourteen, handing his father a knife to open a letter addressed *Au Roy*, had all the solemnity the occasion called for, the 'clouded majesty' of Richard Lovelace's poetic description. If there is some awkwardness in the way the figures are placed this may have resulted from hesitation on the painter's part between formal and intimate portraiture, or from the actual awkwardness of the meeting between father and son in the peculiar circumstances. A separate painting of about the same time in which James Duke of York, the Princess Elizabeth, and Henry Duke of Gloucester appear suggests Lely's Haarlem training in its execution. When Cromwell became Lord Protector in 1653 Lely was well enough established to paint his portrait (facing page 130). It is likely that he took heed of Samuel Cooper's miniature. Lely's Cromwell portrait, of which there are several versions, has a similar force.

Lely was forty-two when in 1660 the exiled Charles II landed at Dover and was thereafter acclaimed King, to the general relief of the country and no doubt to the satisfaction of artists who, even if they had not fared too badly during the Commonwealth interlude, looked forward to increased employment in the Restoration. What was to be expected from the tastes and character of Charles II? It was natural that he should wish to restore as far as possible the splendours of his father's Court, though he did not display that whole-hearted devotion to the best in painting that had obsessed Charles I. Nor had

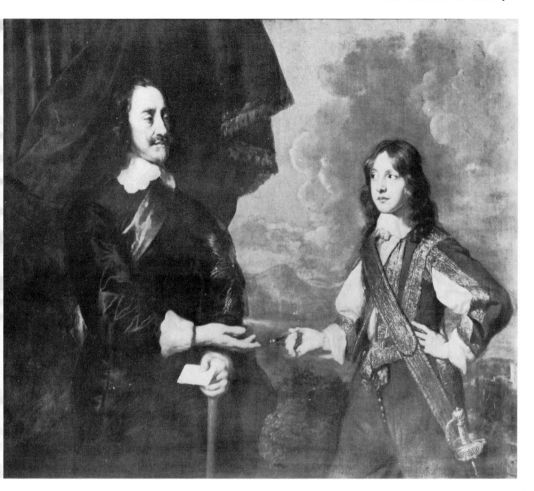

The Duke of York (the future James II) hands his father Charles I a knife to open a letter addressed 'Au Roy', in this painting by Peter Lely

he the will or the resources to create such a disciplined system as united the arts in France and paid tribute to the all-embracing authority of Louis XIV. From that lofty position Louis XIV looked down with contempt on any sign of insular rivalry. When Charles made a minor change in fashion by introducing the waistcoat, the disdain of the Sun King was expressed in providing his footmen with waistcoats, 'an ingenious kind of affront', Samuel Pepys noted with irritation in his diary.

There was not, as in France, any such secondary dictator as Charles Le Brun who could bring painting, sculpture and all forms of decorative design into the overpowering conformity of Versailles. Yet the taste for luxury, on which John Evelyn made critical comment—a

137

reaction against Puritan frugalities and the privations of exile—made for a delight in ornate furniture, tapestry, carved ornament, silver and glass, that went some way towards producing a consistent style of fine craftsmanship.

That in painting Charles II and the Court generally should welcome a return to the spirit of Van Dyck was one aspect of what Evelyn called 'the politer living' introduced by the King. Samuel Cooper, the 'Van Dyck in little', was appointed King's Limner without delay. Charles II sat to Cooper for the likeness on his Inauguration Medal on the same day that he made his public entry into London, according to the recollection of the painter Jonathan Richardson. A note to that effect written by Richardson's son accompanies the chalk drawing of Charles II in the royal collection, one of the remaining testimonies to the excellence of Cooper's draughtsmanship. For a medal or a coin a different emphasis was needed from the surface modelling of the painted miniature. This explains the entry in Evelyn's diary that records his holding up a candle 'when Mr. Cooper, ye rare limner, was crayoning of the King's face and head, to make the stamps for the new mill'd money now contriving'. Candlelight served to accentuate shadow and denote the effect of relief.

Peter Lely, who had come under the spell of Van Dyck during his earlier years in England, was the natural successor to the official post of Principal Painter, with an annual allowance of £200. There were other painters who could claim a privileged position at the Court. A Scot by origin, though born in London, John Michael Wright, who had spent a long time at Rome, described himself as *Pictor Regius* which if not an official title could be justified on general grounds by the fact that he painted portraits of both Charles II and James II. His portrait of Charles II in ceremonial robes and with the new regalia that replaced the old, destroyed in the Interregnum, was evidently painted soon after the coronation and more as a symbol of monarchy revived than as a personal likeness or reference to a specific event. The rigid frontal pose of the King holding orb and sceptre is that of ancient tradition, a convention oddly medieval in a work of the seventeenth century.

Chalk drawing of the head of Charles II, made by Samuel Cooper for the new coins of the Restoration

Without being deeply involved in aesthetic matters, Charles II had a wide range of interests in the arts, as also in science. He seems to have borne in mind the precept of the Marquess of Newcastle, his tutor when he was Prince of Wales: 'For the arts I would have you know them as far as they are of use . . .' Architecture concerned him as the wedding of use to grandeur such as Louis XIV fostered in France. Great buildings that had their beginning in his reign owed something to his initiative. His plan for a new palace at Greenwich to replace the decayed Placentia of the Tudors gave at least a start to what was later to become the Royal Hospital. He provided the means of building the Royal Hospital on the site of the earlier Chelsea College.

The wave of new building in the second half of the seventeenth century, with Sir Christopher Wren and his brilliant followers playing their magnificent part, called for decoration in its various forms and widened the painters' scope. While portraiture remained a Court necessity, it was not now the one and only form of

139

painting encouraged. Subjects with the profusion of allegory and story which belonged to the baroque style were approved as appropriate to surroundings otherwise luxurious. John Michael Wright could turn from portraits to an 'Allegory of the Restoration' that hung in Whitehall. Lost sight of in the early eighteenth century, the painting surprisingly reappeared in an attic in Nottingham in 1952. It represented Astraea, the fabled Goddess of Justice—the Virgin of the Signs of the Zodiac also—who points with her sceptre to the portrait of the King borne by *putti* with the emblems of Plenty and Wisdom.

The facility of Italian painters in such forms of decorative painting gave them a special place among the artist immigrants of the time. The prolific Neapolitan Antonio Verrio was so far approved by Charles II that he was appointed 'our first and chief painter' in succession to Lely. Born at Lecce on the southern tip of Italy, Verrio worked at Naples and afterwards in France, before coming to England where he was much employed and handsomely rewarded by both Charles and James II. George Vertue copied a memorandum of sums received by Verrio for decorative works at Windsor in 1676 which totted up to more than £5,000.

An early example of the riotous medley of gods, goddesses and allegorical figures with which he was later to cover vast walls was the 'Sea Triumph of Charles II' (facing page 146), painted for the King and originally placed in the Privy Lodgings at Whitehall. Neptune and his seahorses draw the royal chariot, Fame, Time, Peace and Love hover in attendance, Envy is struck by lightning, Minerva and Venus float above the British Fleet. Bombast could go no farther.

As a Catholic, Verrio commended himself to the royal brothers. He was also pro-French in sympathy. When the 'Revolution' of 1688 brought William of Orange to the throne as a strong Protestant and a decided enemy of France, Verrio on both counts refused to serve him. He was with difficulty persuaded to complete the decoration of the great staircase at Hampton Court towards the end of William III's reign. He did it, said Horace Walpole with the contempt he expressed for all Verrio's works, 'as

'An Allegory of the Restoration' by J. M. Wright, which originally hung in the palace of Whitehall

ill as if he had spoiled it out of principle'.

Benedetto Gennari, the nephew of Il Guercino, was another Italian protégé of the Court who worked for Louis XIV and in England for both Charles II and James II, painting portraits and, for Charles, a 'Danae' which was hung in the King's apartments at Whitehall. The pervasiveness of baroque symbolism carried to an extravagant extreme is seen in the works of the Flemish painter Jacob Huysmans, who several times portrayed Charles II's consort, Catherine of Braganza, as St Catherine (on whose feast day the Queen was born) and in other roles. The portrait depicting her as a shepherdess, though in a cumbrous load of finery, with a lamb beside her and a winged cherub bearing fruits, compares by no means favourably with the simplicity and essential humanity of the miniature of her by Samuel Cooper (page 129), achieved without resort to such accessory devices.

The interests of Charles II extended to topography, which had a decidedly personal reference in the picture he commissioned from Robert Streeter c. 1670 of Boscobel House and Whiteladies, scene of Charles's escape and hiding after the Royalist defeat by Cromwell at the battle of Worcester in 1651. Streeter's painting of the two houses—Whiteladies with its adjoining ruins of an old Cistercian monastery and the hunting-lodge, Boscobel House—separated by the woods in which Charles hid, gives no more than a hint of the drama of escape, though the King in reminiscence was well able to fill in the details. He could provide his own vivid picture of sheltering in Spring Coppice on a night of heavy rain in September, and afterwards of clambering up into the great oak in Boscobel Wood, of being sustained by bread and cheese and small beer while the baffled Parliamentarian soldiery prowled in search beneath the thick foliage of the famous (though long since vanished) 'Royal Oak'.

Streeter was employed as Sergeant-Painter, which implied a variety of decorative tasks. His ceiling for the Sheldonian Theatre at Oxford, the building completed to Wren's design in 1669, was an essay in the grand allegorical manner which gave him a high reputation in his own time. Samuel Pepys records being taken 'to Mr Streeter's, the famous history painter', whom he

Catherine of Braganza, portrayed by the Flemish painter Jacob Huysmans as a shepherdess

described as 'a very civil little man and lame but lives very handsomely'. Pepys found him in company 'with Dr Wren and several virtuosos to look at the paintings for the new Theatre at Oxford'. The virtuosos pronounced them better than Rubens, but Pepys was less impressed by the array of figures representing Religion surrounded by Geometry, Law, Justice, Music, Drama, Astronomy and Architecture, with, for good measure, the downfall of Envy, Hatred and Malice. As to Streeter's being better than Rubens, he sensibly remarked: 'I do not fully think so.'

Interest in topography as one of the useful arts made Charles II well aware of the valuable work done by the draughtsman and etcher, Wenceslaus Hollar. A Czech by birth, he had been introduced to England by the Earl of Arundel. They first met at Cologne, when the Earl, en route on a diplomatic mission to the Emperor Ferdinand II, took Hollar with him to record the journey. He

Charles II commissioned from Robert Streeter this painting of Boscobel House and Whiteladies, scene of Charles's escape and hiding after the Battle of Worcester

appointed the artist his engraver, and on return to London in 1636 installed him at Arundel House. Hollar married an Englishwoman, a lady-in-waiting to the Countess of Arundel, in 1641 and with the exception of the Civil War years when he retired to Antwerp, he made England his home for the rest of his life. In his thousands of prints that included landscapes, portraits, copies of paintings, details of costume, and studies of natural form such as his series of shells, his views of cities had a particular value as documents. What London looked like before the Great Fire of 1666 can best be gleaned from Hollar's views of its medieval intricacy of peaked gables and half-timbering, and its Gothic cathedral, old St Paul's (with the new portico designed by Inigo Jones).

Charles II had earlier shown his sense of the value of such panoramic views in his appeal to the Lord Mayor of London in 1660 to raise a subscription for a map of the city to be executed by Hollar. It was in the year of the Fire that the King included him among the Court artists, with the title *Scenographus regius*, though this did not carry with it any regular allowance. The £50 granted on his appeal for support as 'a voluntary present and royal reward' seems meagre indeed compared with the lavish subsidies to Verrio. Hollar accompanied Lord Henry Howard's expedition to Tangier as official artist in 1688, surviving the attack by pirates on the return journey, but the prints and drawings that resulted evidently brought no great return. This 'very honest, simple, well-meaning man', as Evelyn described him, author of a unique record of the buildings, events, fashions and everyday life of his time, died poor and was buried in the churchyard of St Margaret's, Westminster in 1677.

The Court painter who stood out beyond the rest was Sir Peter Lely, knighted in 1680. He set his stamp on the age of Charles II as Van Dyck had done on the age of Charles I. This was not because Lely was exceptionally favoured by the King as is clear enough from the variety of the royal interests. It was left to Samuel Cooper to paint the best, the unsurpassed, likeness of Charles himself. Lely had a more enthusiastic patron in Anne Hyde, eldest daughter of Edward Hyde, Earl of Clarendon, privately married to James II while he was

still Duke of York, in 1660. At her instance Lely carried out what is still considered his most characteristic work, the portraits of 'the most beautiful women at Court'. That the 'Windsor Beauties', as they came collectively to be known, included a number of the King's mistresses has heightened the impression of a harem and to some extent has complicated views of the portraits as paintings. In a cross-grained and puritanical mood, William Hazlitt deemed the Windsor Beauties 'a set of kept-mistresses, painted, tawdry, showing off their theatrical or meretricious airs and graces without one touch of real elegance or refinement . . .' While this severe indictment was levelled against the sitters, the critic's adjectives seem to cast an unfair reflection on the work of the painter. There was nothing tawdry in Lely's sense of colour. With the example of Van Dyck before him he took pains to be elegant in style, if with less of poetic feeling. It was the fashion of the time to be slightly theatrical in allegorical allusions and accessories, which offered scope for decorative treatment. Lely is no more to be criticized for painting the beautiful Elizabeth Hamilton, who became the wife of the Comte de Grammont, as St Catherine with a palm branch in her hand than Van Dyck for painting the Duke of Buckingham's daughter, Lady Mary Villiers, as St Agnes with a lamb beside her and a palm branch in her hand also. It can hardly be held against Barbara Villiers, Duchess of Cleveland, who bore the King six children, that Lely chose to paint her as Minerva with plumed helmet and spear; or that *la belle Stuart*, Duchess of Richmond and Lennox, whose attraction for the King was so much deplored by Pepys, looks anything but charming as portrayed holding a bow, against a wooded landscape background.

Lely did not convey as much of individual character as Samuel Cooper partly because of the haste required by the great number of his commissions. Pepys, who was very interested in 'Mr Lilly, the great painter' and paid him several visits, noted in his diary the occasion when Lely, believing his visitor had come to bespeak a picture, at once announced that he was booked up for weeks ahead. Pepys had recourse for the portraits of himself and his wife to a lesser follower of Van Dyck, John Hayls. The

The Neapolitan Antonio Verrio painted the 'Sea Triumph of Charles II' for the Privy Lodgings at Whitehall (see page 140)

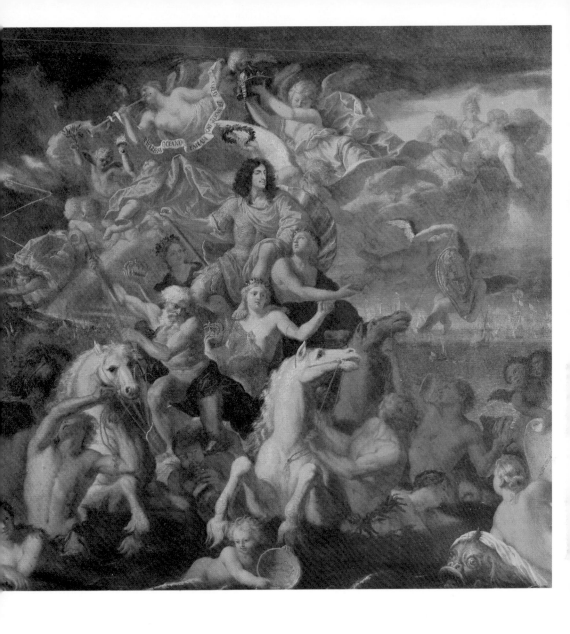

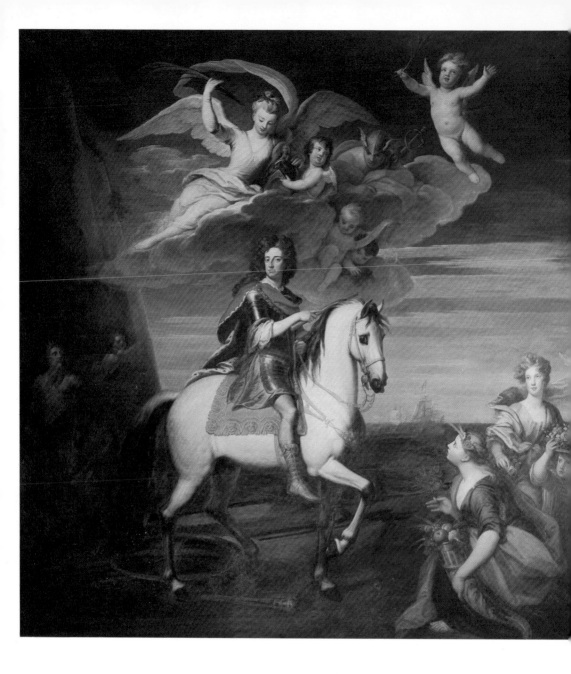

ir Godfrey Kneller's 'William III on orseback' places the King amid the mblems of triumph (see page 165)

portrait of Mrs Pepys (that has since disappeared, though an engraving remains) for which the diarist paid £14 (and 25 shillings for the frame) was so far in the Court mode as to depict her in the role of St Catherine with the palm branch gracefully held in the way Van Dyck and Lely prescribed. 'I almost broke my neck looking over my shoulder', said Pepys of his own sitting, though the required pose did not prevent him from making numerous comments and suggestions as the painting progressed. With the finished work he was 'well content'.

The number of Lely's commissions made not only for swift execution but for the use of assistants who finished many of the works that came from his studio. They were not all as gifted as the young Frenchman Nicolas de Largillière, who was employed by Lely for a time on details of dress and background before returning to Paris to achieve a success of his own in portraits of a sparkling facility.

It might be supposed that the long procession of female sitters in time became merged for Lely into a composite image of Woman. It has never, for instance, been easy to identify among the products of his studio the likeness of Nell Gwyn, though the romantic legend of the Drury Lane orange-girl who became popular on the stage as a comedy actress and was always a favourite with the King, has attached her name to many a canvas. Long considered to represent her was the portrait in the National Portrait Gallery which has since been identified as that of Catherine Sedley, Countess of Dorchester, the mistress not of Charles but of his brother James when Duke of York.

A painting could scarcely suggest the wit with which Catherine Sedley remarked of his attentions: 'It cannot be my beauty for I have none; and it cannot be my wit, for he has not enough to know I have any.' It would be hard to distinguish her features from those of other young women painted either by Lely or an assistant in his studio, such as Willem Wissing who came from Amsterdam to London and was one of Lely's principal pupils and followers. Wissing, as a Dutch painter, was attracted to the English Court by the Protestant alliance with the House of Orange. Other artist immigrants reflected the

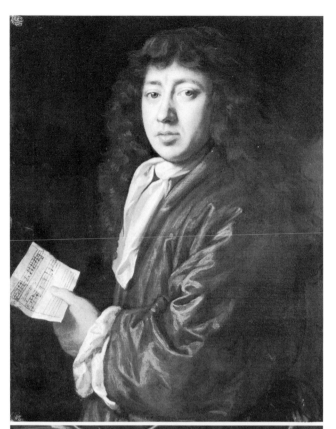

Samuel Pepys by John Hayls: 'I almost broke my neck looking over my shoulder,' said Pepys of his sitting

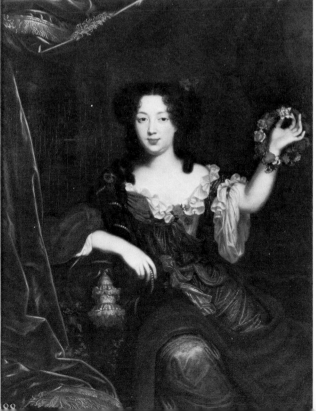

Louise de Kéroualle, Duchess of Portsmouth, by the French artist Philippe Vignon

opposite royal leaning towards France. Philippe Vignon and Henri Gascars were two French artists patronized by the later Stuarts, whose affectations of style more deserved Hazlitt's epithet, 'tawdry', than the paintings of Lely. Vignon's portrait of Louise Renée de Penancourt de Kéroualle, Duchess of Portsmouth, is a dainty example. The 'Madame Carwell' of insular dislike as the centre of French influence at Court, poses archly with a wreath of flowers, in the painting made for Charles II on whom her hold was suspect alike to the moralist and the xenophobe. When the King stayed at Lord Arlington's Suffolk mansion, Evelyn observed her presence with disfavour, 'for the most part in her undress all day', and was shocked 'that there was fondness and toying with that young wanton'. At the same time she was so much a spy of a sort as to receive a message of congratulation from Louis XIV on her efforts to keep Charles in thrall and pass on useful information.

Lely painted so many of the Court ladies that the popular impression was left of this being his one accomplishment. In disproof there are the portraits that show his ability to convey masculine character. His 'Cromwell' is a massive partner to the likeness painted by Samuel Cooper. He was at his best in the series of thirteen portraits of the 'Flaggmen', the Duke of York's flag-officers in the naval victory over the Dutch, the battle of Lowestoft in 1665. They were painted for James II while Duke of York and Lord High Admiral, and were hung at Windsor until George IV presented eleven of them to Greenwich Hospital. The portrait of Prince Rupert, one of the two that remained at Windsor, has all the spirited and reckless look of the 'mad cavalier' of many a headlong cavalry charge, who was no less impetuous in boarding enemy vessels at sea (page 152).

When Lely came to portray the second George Villiers, Duke of Buckingham, the son of James I's and Charles I's favourite, he made a trenchant study of character of another kind. Nonetheless mercilessly because it might have been without intention, he depicted the bloated features, the malevolent eye of one as unprincipled and spendthrift as his father had been. To recall the painting by Van Dyck of George Villiers as a boy (page 155),

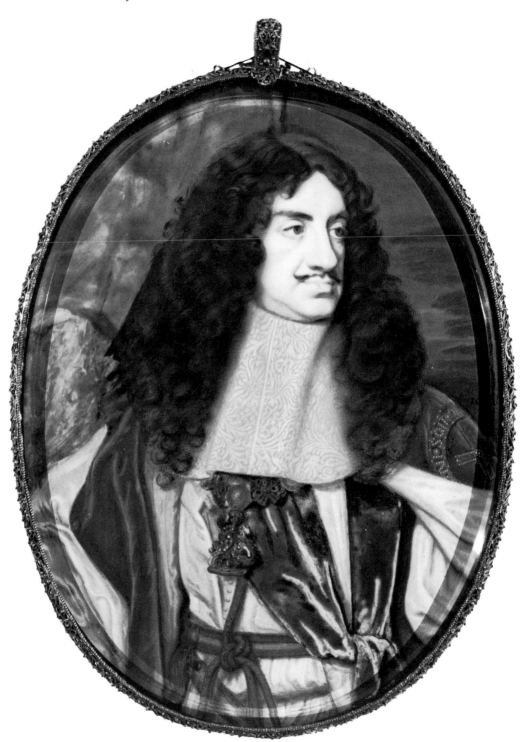

Charles II – a revealing study by
Samuel Cooper

together with his brother Francis, brought up after their
father's assassination with Charles I's own children, is to
wonder at the gulf between the child and the politician, the
member of the sinister Cabal, the libertine, the cynical wit,
the author of 'ten thousand freaks that died in thinking', as
vivid in Lely's portrait as in Dryden's description of him as
Zimri in *Absolom and Achitophel*.

The Dutch painters brought with them specializations
other than portraiture. Simon Pietersz Verelst, who came
to London from The Hague in 1669, was expert in the
flower-piece, so much a development of the Netherlands
in the seventeenth century. He was encouraged by the
second Duke of Buckingham and admired by Louise de
Kéroualle, who furthered his interest at Court. Pepys,
who was taken to see a flower-piece by Verelst, was
fascinated by the *trompe-l'oeil* effect of the drops of dew
hanging on the leaves, 'so I was forced again and again to
put my finger to it to feel whether my eyes were deceived
or no'. It was something new to England, and in Pepys's
opinion 'worth going twenty miles to see'.

Confidence in his ability in every genre, and the
suggestion of the Duke of Buckingham, led Verelst to
paint portraits also, these including a portrait of Charles
II. He introduced a profusion of flowers into his portraits
of women, and is said to have proclaimed himself 'God of
Flowers' and 'King of Painters', symptoms of a mania
that confined him to an asylum for a while. A different
specialization, with a more decided influence on painting
in England, was the maritime genre in which Holland had
also led the way. As a record and a form of national
propaganda, paintings of warships and naval actions had a
new importance in view of the growing expansion of the
West overseas, and the resulting clashes of interest in
trade and colonial settlement. Two Dutch painters who
established themselves in England, the Van de Veldes
father and son, laid the foundations for the later growth of
an English school of marine painting.

The tacit recognition of an artist's independence of
politics that made Lely as acceptable to Charles II as to
Cromwell, allowed the two Willem van de Veldes free
admittance to London even though England was
constantly at war with their native country. The ease with

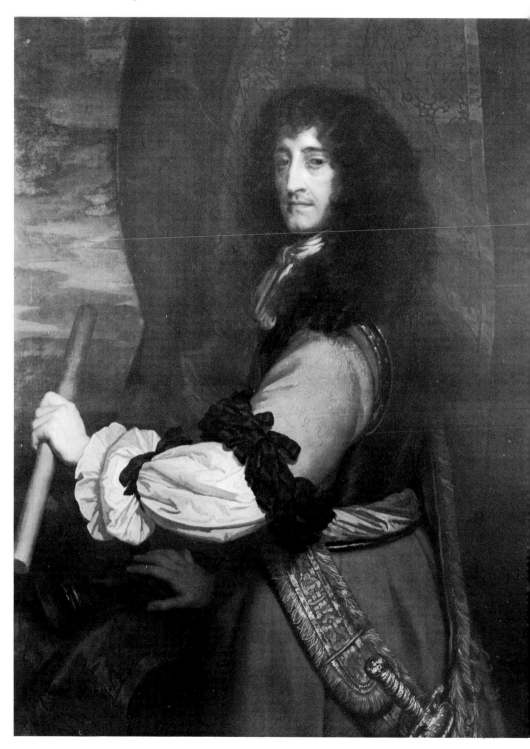

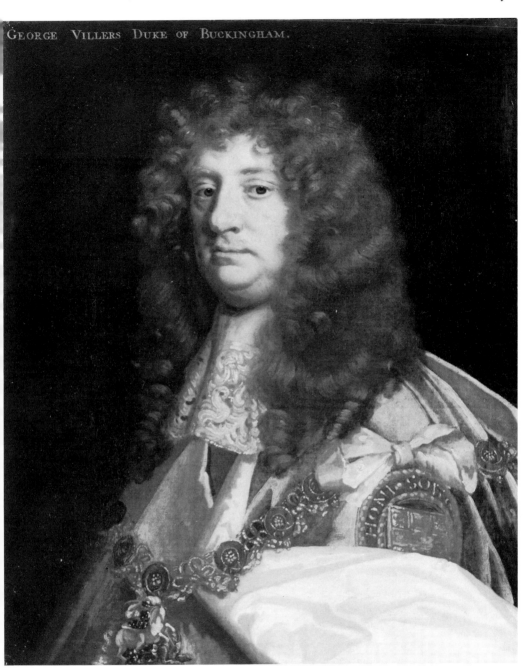

GEORGE VILLERS DUKE OF BUCKINGHAM.

*Above:* George Villiers, second Duke of
Buckingham, by Lely – a merciless
study of an unprincipled man

*Left:* Prince Rupert by Peter Lely

which they changed sides implied that a painter then worked wherever he could make a living. They had recorded Dutch victories at sea when they worked at Amsterdam, until their sources of revenue dwindled and a move was called for. From 1672 on they painted English ships and victories with the same expertise as before.

They were Court painters by virtue of Charles II's allowance of a salary to each of £100 a year. It was the elder's function to make 'draughts' of sea-fights, he being more used to working as a draughtsman in black and white than as a colourist. The younger had 'the like salary for putting the said draughts into colours for our particular use', in the wording of the Royal Warrant. A mark of official status, they were assigned apartments in the Queen's House at Greenwich. The building had remained empty since Henrietta Maria had ended her last visit to the scene of former splendours in 1665. The Van de Veldes painted industriously there, until plans for completing the Royal Hospital took active shape, when they moved to Westminster.

For Charles II Willem the Younger painted *The Royal Escape*, the name given to the Brightelmstone coal-brig owned by Nicholas Tattersall, who in 1651 had taken the royal fugitive over to France from Shoreham for a payment of £60. The picture passed into the collection of James II, who was interested not only in this event in his brother's career but in ships and the sea generally. As Lord High Admiral he had twice commanded the English fleet in the wars with the Dutch. He set an example, followed by others who had taken part in naval engagements, by commissioning a series of paintings of sea-fights from the two Van de Veldes in collaboration.

At a later date Horace Walpole spoke with respect of Willem Van de Velde the Younger as 'the greatest man that has appeared in this branch of painting; the palm is not less disputed with Raphael for history than with Vandervelde for sea pieces . . .' By that time his influence was plain to see in the work of Samuel Scott, Charles Brooking and others. Yet surprisingly the notes of such assiduous followers of the arts as Evelyn and Pepys make no mention of him. Pepys, active Secretary to the Admiralty as he was, might have been expected to refer to

George Villiers, second Duke of Buckingham, with his brother Lord Francis Villiers, by Van Dyck

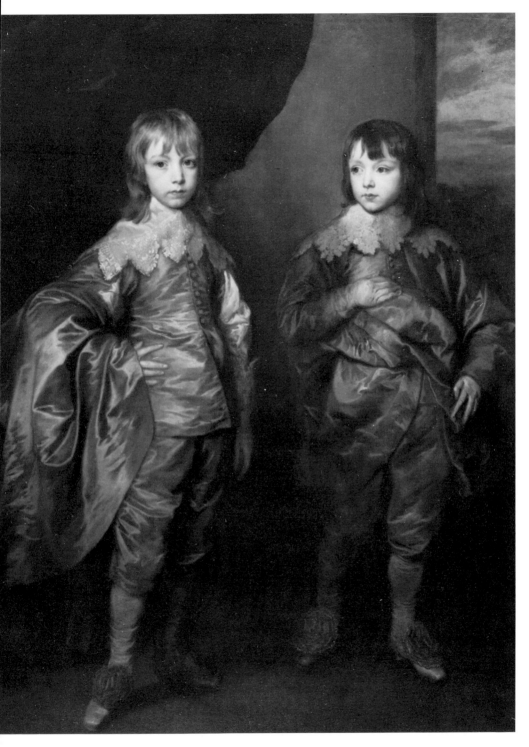

the painter of ships. Evelyn was more inclined to dilate on his 'discovery' of 'that incomparable young man' Grinling Gibbons, whom he introduced to the King as a master, until then unknown, of wood-carving and sculpture.

The portrait painter still had the advantage over those with specializations of a less personal kind. In holding a mirror to the uppermost level of society he became essentially of the Court, reflecting something of its glamour in his own person and mode of living. Lely was eminent not only as one generally spoken of and admired as 'the great painter' but as an ornament of society. He lived in magnificent style, was married 'to a beautiful English woman of family', though of her little else is recorded, had a country property at Kew as well as a town house, and entertained lavishly. A wealthy connoisseur, he bought paintings and drawings by the great masters as Van Dyck had done, a number of them coming from Van Dyck's own collection, from that of the Earl of Arundel, and from what was left of the first Duke of Buckingham's collection disposed of by his son. He was knighted by Charles II in 1679, and died the following year at the age of fifty-two. That the Court painter should be a grandee had been a consequence and condition of success. Van Dyck and Lely had established a tradition which left the place of honour open for a new occupant. Godfrey Kneller stepped into it with confidence and a measure of success equal to that of his predecessors.

'The Royal Escape', the coal-brig which took the fugitive Charles II across to France, painted by Willem Van de Velde the Younger after the Restoration

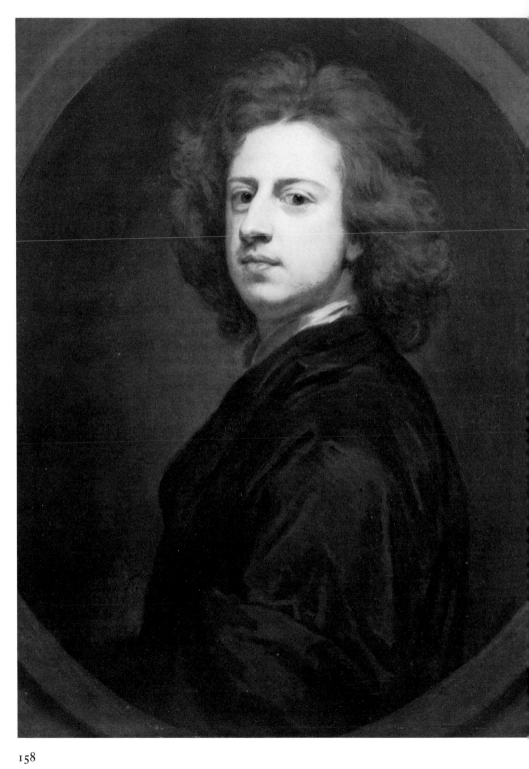

## Chapter 11
# Kneller – Court painter in five reigns

Godfrey Kneller was active as Court painter during five reigns. The period of time was not so long as it might sound, as the reigns were short after that of Charles II, but it was long enough for him to remain active as a painter until he was well over seventy. Through the several quick changes of rulers he worked on, prosperous and secure; through the few years of James II's reign, the new orientation of William of Orange, the 'Augustan Age' of Queen Anne, and the beginning of the Hanoverian regime. In his own time — in England at all events, though there were foreign critics who sneered — he was considered superior to Van Dyck. Later was another story. From the eighteenth century his reputation as a painter declined. He was criticized, as Lely was, for the mass-production of portraits dashed off in haste and given a mechanical finish by assistants. Horace Walpole's dictum on Kneller, that 'where he offered one picture to fame he sacrificed twenty to lucre', has often been approvingly quoted, though his best works were considerable in both quality and number, and the great age of English portraiture still to come derived much from him.

Kneller, born Gottfried Kniller, third son of Zachary Kniller, the chief surveyor of the city of Lübeck, came to England when he was about thirty years of age. He was already a mature artist, trained at Amsterdam with Ferdinand Bol, the pupil of Rembrandt. How far Kneller profited by his lessons in light and shade and dramatic gesture can be seen in his 'Elijah and the Angel' of 1672. He completed his education in art at Rome and Venice, and in 1676 found lodgings in London with his first patron there, a German business man, John Banckes.

A social climb was thereafter easy for the able and self-confident young man. James Vernon, secretary to the Duke of Monmouth, admired Kneller's portrait of Banckes sufficiently to require him to paint his portrait also and to introduce him to the Duke. Monmouth,

Sir Godfrey Kneller: self-portrait

portrayed in the stock martial attitude with armour and baton, which was originally derived from Titian, was in turn pleased enough with his likeness to introduce the artist to Charles II. Kneller was by then established, as he wrote to his brother, 'in one of those new streets on the left hand side before you get to the statue of the old king in bronze' (Le Sueur's 'Charles I' at Charing Cross). In 1679, the year after the Monmouth portrait, Charles II sat to him at the same time as to Lely.

George Vertue's account of the occasion laid stress on the rapidity of execution that was one of Kneller's special faculties (as well as a temptation to be too facile). The lookers-on, who included the King's brother James, Monmouth, then high in royal favour, and other familiars of the Court, were astonished to see that Kneller had almost finished his picture at the first sitting whereas Lely had only got as far as laying in the ground. The same account suggests that Lely was generously minded enough to feel no envy, and warmly praised the newcomer's work to the King.

Kneller's portrait of Charles II, beautifully engraved by Robert White, was clearly a good likeness, though by that time the King had shaved off the thin pencil-line of moustache that had previously added an extra touch of cynical humour to his expression. The painting was the first of several portraits of the King, who thought so highly of Kneller that towards the end of his life he sent the artist to France to paint the portrait of Louis XIV. As the story goes, when the Sun King asked what personal reward Kneller might wish for, he made the courtly answer that he would like only a quarter of an hour of the King's time in which to draw his head. This may well be the chalk study inscribed in the artist's own hand: 'Drawn by the Life at Versallis in the year 1684 by G. Kneller.'

The death of Lely in 1680 left Kneller with no great amount of competition to face and with a growing demand for his portraiture following his success with Charles II. Willem Wissing was not a formidable rival, though as the pupil of Lely he still had royal commissions. He painted Charles II in his later years, James II, William of Orange and Prince George of Denmark, who was to

'Elijah and the Angel' by Kneller shows how the young artist profited by his lessons from Rembrandt's pupil, Ferdinand Bol

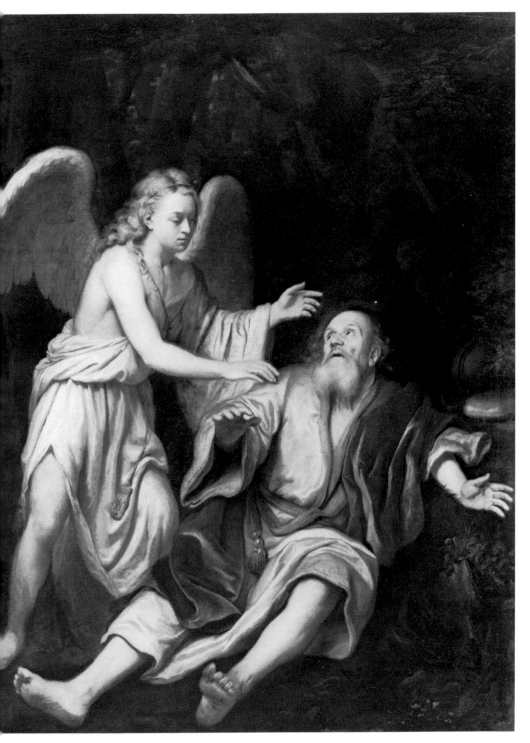

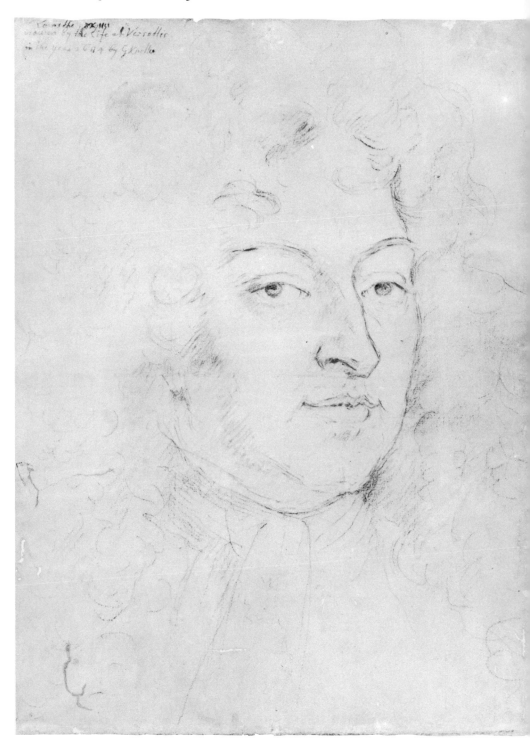

Chalk study of Louis XIV, inscribed in the artist's hand: 'Drawen by the Life at Versallis in the year 1684 by G. Kneller'

become the consort of Queen Anne. But Wissing died in 1687. The English painter John Riley, though a painter of merit, was not well equipped by character to compete with a bold and bustling foreigner such as Kneller. He is said to have been quite hurt by Charles II's quip when Riley was painting his portrait: 'Is this like me? Then Odd's fish I'm an ugly fellow!' He would perhaps have been happier with humbler subjects. There is, in fact, a remarkable departure from Court grandeur in his picture of one of the domestics of the royal household, Bridget Holmes, with apron and broom. That the picture was painted for the royal family may be assumed from its having been hung at Windsor Castle. Why it should have been required is possibly explained by the fact that Bridget Holmes was an old retainer, ninety-six when the picture was painted (1686); she lived to be a hundred.

Another descent from the heights of Court life was Riley's distinguished portrait of Katherine Elliot painted in collaboration with Johan Baptist Closterman, the German immigrant who was Riley's 'drapery painter'. Mrs Elliot had been nurse to James II when he was a child, and was later Dresser and Woman of the Bedchamber to Anne Hyde, his first wife, and after her death to his second wife Mary of Modena.

The recurrence of religious and political upheaval due to James II's attempts to restore absolutism and re-establish Catholicism, put an end to the special favour accorded to French and Italian artists. Largillière went back to France. When William of Orange superseded James II in 1688, Verrio ceased to be Principal Painter to the King, though not banished from the royal service. Riley and Kneller were jointly appointed in his stead. When Riley died in 1691, Kneller became the sole Principal Painter, a position he retained until his death. Years of prolific production lay ahead.

Like other masters of foreign origin, Kneller had altered in style on coming to England. Little remained of his Rembrandtesque beginnings. He had discreetly accommodated himself to the tradition established by Van Dyck and Lely, though in a personal fashion. The pomp of baroque left its trace on his work and he essayed allegorical compositions that looked better in the first oil

*Left:* Bridget Holmes, one of the domestic servants of the royal household, was painted by John Riley when she was ninety-six

*Right:* Katherine Elliot, nurse to James II and dresser to both his wives, painted by J. Riley and J. B. Closterman

sketches than in a highly finished form. His 'William III on Horseback' (facing page 147) placed the King incongruously amid the boastful emblems of triumph. The gods and goddesses seemed the more fulsomely artificial in contrast with his unpretentious being. Where Kneller excelled was in the directness and simplicity that went with his swift way of painting.

The 6,000 portraits attributed to him or his studio are evidently to be whittled down to the much smaller number that represent him at his personal best. It remains an heroic achievement that he painted practically everyone of note in his time; royalty from Charles II to George II (when he was Prince of Wales); visiting potentates and celebrities including Peter the Great, portrayed for William III on the Tsar's visit to England in 1698; the lords and ladies of the Court; the military and

naval commanders; the diplomats and politicians; and the men of learning, literature and science.

His portraits of women had more dignity, if less charm, than those of Lely. Even his painting of Louise de Kéroualle had a certain stateliness due in part to her long robe, and without the coyness of Vignon's portrait. This may be the picture of 'the late Duchess of Portsmouth' that Defoe spoke of in his *Tour through England and Wales* as 'a noble piece', and which Charles II described as 'the finest Painting of the finest woman in Christendom'—a view hardly likely to have commanded enthusiastic agreement from English ladies at Court. The series of 'Hampton Court Beauties' which Kneller was commissioned to paint by Mary II invites comparison with Lely's Windsor Beauties, though more decorous than that voluptuous assembly in representing 'the principal Ladies attending upon her Majesty, or who were frequently in her Retinue'. The idea of a beauty competition did not please everyone. Lady Dorchester pointed out to the Queen the invidious nature of the choice: 'Madam, if the King were to ask for portraits of all the wits in his court, would not the rest think he called them all fools?' Yet Kneller's eight Beauties, with the advantage in dignity of full-length proportion, more classical in effect than Lely's three-quarter lengths, were generally admired, were popular in engravings and gave example to portraitists such as Allan Ramsay in the century following.

The fourteen portraits of admirals, painted for Queen Anne or Prince George of Denmark, a commission shared by Kneller with the Swedish painter settled in London, Michael Dahl, again suggests comparison with Lely, in his 'Flaggmen' series—though differences were manifest. As William Dobson had done in his 'Endymion Porter', Kneller took ideas of composition from the portraits of Roman Emperors by Titian that had come to Charles I with the Duke of Mantua's collection. The Titian originals were bought for Philip IV of Spain when Charles I's collection was sold in 1652, and hung in the Alcazar, but engravings and copies remained available to the English painter. Titian's 'Caligula' provided the striking pose for Kneller's 'Admiral Sir Charles Wager'.

*Above:* Louise de Kéroualle, Duchess of Portsmouth, by Kneller

*Right:* Admiral Sir Charles Wager, painted by Kneller

Kneller is particularly associated with the 'Augustan Age' roughly coinciding with the reign of Queen Anne. Almost a court in itself was the Kit-cat Club, an epitome of politics and the arts, to which Kneller belonged, his portraits of its members being one of his principal *tours de force*. A society of a convivial kind was very much to his taste. He had belonged to one such club, the 'Honourable Order of Little Bedlam' founded by the fifth Earl of Exeter, the members of which had animal nicknames and totems that appeared in their portraits. Kneller's self-portrait, *circa* 1689, featured a unicorn in the background.

The Kit-cat Club, founded some years later, was also a meeting-ground for convivial eating and drinking. The mutton-pies of Christopher Cat, keeper of the tavern where meetings were first held, are said to have given the club its name. The consumption of wines was large; but the club was also a constellation of power and brilliance, of the Whig statesmen (principal among them Robert Walpole), of literary culture of Addison, Steele and Congreve. Kneller's portraits of forty of the members now preserved in the National Portrait Gallery were simple in essence. A canvas of the special size that came to be known as 'Kit-cat' enabled him to concentrate on head and hands. Without recourse to other detail, he varied his formula with consummate skill.

There is every reason to think that Kneller hugely enjoyed himself in these early years of the eighteenth century. He had everything that a Court painter could materially wish for. The demand for his work was so great that he left hundreds of unfinished canvases when he died. Eulogy ministered to his self-esteem, the Augustan poets sang his praises. The Emperor Leopold I made him a Knight of the Holy Roman Empire in 1700; George I bestowed a baronetcy on him in 1715. He was rich enough to have a country mansion built at Whitton, Twickenham in 1709, designed after the style of Wren with spacious formal gardens and a deer park. The interior was decorated by Antonio Verrio and by Kneller himself. Here he lived in state with his wife, the widowed Susanna Grave, daughter of Rev John Crawley, Archdeacon of London, was thence conveyed to his London house in Great Queen Street ('the first regular street in London')

Shen Fu-Tsung, the 'Chinese convert' painted by Godfrey Kneller

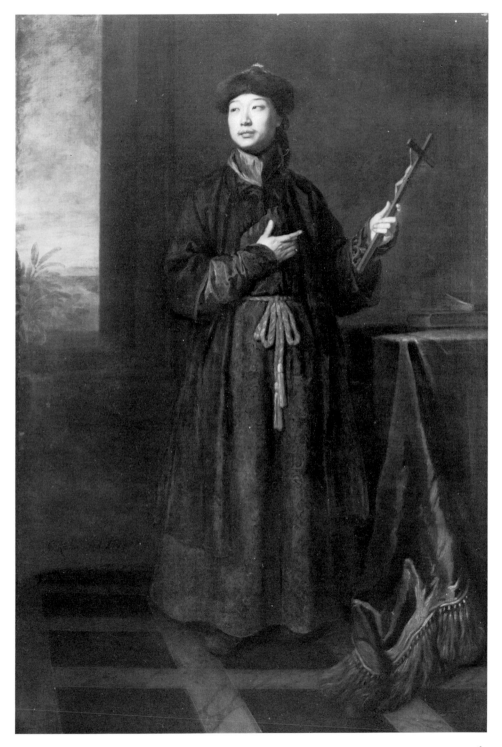

in the splendour of a coach drawn by a team of six horses. There was a naïve sadness in his expressed wish that when he died God would let him stay at Whitton 'instead of sending him to Heaven'.

Kneller had an influence on the age that followed in more ways than one. His simplicity and directness were absorbed in the moving current of painting style. Paintings such as his portrait of Shen Fu-Tsung the 'Chinese Convert', the 'little blinking fellow' in James II's description, who helped to catalogue the Chinese MSS in the Bodleian; and of Jacob Tonson, the publisher and Kit-cat secretary, give a foretaste in their sense of character of what Hogarth and Reynolds would achieve in portraiture.

He was not so entirely immersed in his own efforts as to disregard wider issues. He was responsible for the opening of the academy of painting and drawing in 1711 near his house in Great Queen Street, and was its Governor until 1718. His initiative was to result in the foundation of the Royal Academy in 1768.

## Chapter 12
## The Hanoverian age

The auspices for Court painting in England were far from promising at the beginning of the eighteenth century. Sir Godfrey Kneller had provided an imposing façade, the disappearance of which when he died in 1723 exposed to view the barrenness of the ground. As one who had collaborated with Kneller not uncreditably, the Swedish painter Michael Dahl had some reason to expect the appointment of Principal Painter to the King, but he was passed over in favour of Charles Jervas, an Irish painter. He had the prestige of ten years spent in Italy where he was known as Carlo Jervasi and made copies of Italian paintings. On his return, according to Vertue, 'by his talk and boasting he had a great run of business . . . but it would not do, what he did answered not expectation'. His want of success 'in painting their Majesties pictures' naturally enough lost him 'much the favour and interest at Court'. He is remembered more as the friend of Alexander Pope, to whom he gave drawing lessons, and of Swift, whose portrait he painted, than as a painter of royalty. He is said to have gone back to Italy in later life to collect pictures for the royal family and, according to Pope, in hopes 'of some repreive from Asthma'.

For several reasons the Court had lost its old pre-eminence in the encouragement of art, as in the conduct of national affairs. A link with tradition disappeared when the rambling collection of public and private offices and apartments that had constituted Whitehall Palace was destroyed by fire in 1698. No impulse was left to bring to completion the great new palace Inigo Jones had planned. With its classical beauty and mournful memories, the Banqueting Hall remained in splendid isolation. The Court moved from place to place. St James's Palace, built by Henry VIII on the site of a nunnery as an alternative residence, became, with the alterations made by Sir Christopher Wren, the official Court ('of St James's'). But William III's liability to bronchial ailments caused

him to seek fresher air outside London, and to convert the house he bought at Kensington into Kensington Palace. It was not until 1762 that George III found a congenial London establishment in the Buckingham House he bought from Sir Charles Sheffield, later redesigned as Buckingham Palace.

In these circumstances a splendour comparable with that of Versailles could hardly be expected. In France the nature of the Court as the central organism of the State took visible shape in a style. As clearly as might be, the baroque weight of decoration expressed the despotic authority of Louis XIV; the rococo in lighter vein the relief of his successors when the burden was lifted. The monarchy in England had no such decided direction to give. William III, preoccupied with his campaigns against the French, had little time for the arts. A leaning towards the mildly decorative inclined Queen Anne to acquire works by the Hungarian painter of birds, Jakob Bogdani, follower of the Dutch birdpainter, Melchior d'Hondecouter, who had portrayed specimens in William III's aviary in Holland. The Queen's interest in decoration also led her to patronize the French painter of flower-pieces, Jean-Baptiste Monnoyer, one of the talented designers who worked for Le Brun at Versailles and were brought to London by the Duke of Montagu to decorate his Bloomsbury mansion. Monnoyer, whose portrait was painted by Kneller, found London congenial enough to spend the rest of his life there.

Another of the Versailles artists was the painter of classical perspectives and ruins, Jacques Rousseau, whose subjects make a modest decorative addition to Hampton Court. Of the first two Hanoverians, George I and George II, it seems fair to say that they had no feeling for art whatever. 'We are now arrived at the period in which the arts were sunk to the lowest ebb in Britain', observed Horace Walpole of the opening Hanoverian years, an assertion coloured by his bias against Kneller in painting and Vanbrugh in architecture. Yet the late seventeenth and early eighteenth century was a great period of architecture in England, exemplified by the magnificent succession of Wren, Vanbrugh, Hawksmoor and Gibbs. Their splendour of design gave room for the craft of such

a master of carved decoration as Grinling Gibbons, John Evelyn's 'discovery'; of the elegant metalwork of the French smith Jean Tijou, who came to England in the train of the Princess of Orange in 1689. There was room also for painting on the grand scale in the new public buildings, St Paul's Cathedral, Greenwich Hospital and in the country mansions to which an aristocracy, no longer entirely dependent for place and preferment on the Court in London, showed an increasing attachment.

The tradition of decorative painting on a large scale was not native to England. The Neapolitan Verrio had found favour with Charles II and James II as a Roman Catholic and an adept in the grandiose mural style of France. He had a royal patronage to the end. Queen Anne granted him a life pension of £200 a year when his faculties were failing. He died in 1707 at Hampton Court at the age of seventy-three. His associate, the Frenchman Louis Laguerre, born at Versailles (Louis XIV himself being his godfather) and trained under the aegis of Le Brun, was lodged at Hampton Court and continued in a similar manner to that of Verrio to cover large areas of wall and ceiling there, and at Marlborough House, at Blenheim, and at other aristocratic mansions, until his death in 1721.

Verrio and Laguerre, linked together for all time in Pope's derisive reference to their sprawling saints, were the advance guard of the influx of decorative painters into England which was a marked feature of the first half of the eighteenth century, and was one aspect of a European phenomenon. This was a migration from the cities of Italy, Venice in particular, to Austria, Spain, France, and the many local kingdoms and princedoms into which Germany was divided. Painters expert in mural decoration were made welcome at every European court with pretensions to grandeur. Though George I and George II had little to do with their coming to England, they were invited by a nobility desirous of adding a princely magnificence to mansions in town and country.

The Venetian artists brought with them, and widely distributed, the charm of style that was beginning to replace baroque heaviness. Giovanni Antonio Pellegrini spent some years in England before leaving in 1721 to

work for the Elector Palatine, the freshness of his colour being well exemplified in his staircase at Kimbolton Castle. A seasoned artist-traveller, Sebastiano Ricci, who had lately been painting a ceiling for the palace of Schönbrunn in Vienna, came to London in 1712 together with his nephew and pupil, Marco Ricci, whose decorative talent for landscape was complementary to his uncle's ability in figure composition. They stayed for four years with great success and financial profit. Sebastiano's scheme of decoration for the connoisseur Earl of Burlington in part remains, and adds its elegance to the reconstructed Burlington House. His 'Resurrection', a commission he may have owed to the Duke of Shrewsbury for the Chapel of the Chelsea College, is an impressive survival. Jacopo Amigoni was another Venetian visitor who spent ten years in England, 1729–39, after working in Germany and before finally settling in Spain; his activities divided in England between the mythologies of Moor Park and portraits of the royal family.

It might have seemed a foregone conclusion that one or other of these visiting celebrities would be chosen to decorate such great new public buildings as St Paul's and Greenwich Hospital. It was thought that Sebastiano Ricci's cherished ambition was to paint the dome of St Paul's, and that the reason for his leaving the country, together with his nephew in 1716, was that he was passed

*Above:* 'The Resurrection' by Sebastiano Ricci

*Top right:* 'St Paul before Agrippa' – sketch by James Thornhill for a grisaille painting in the dome of St Paul's

*Centre right:* George I and Frederick, Prince of Wales, from James Thornhill's masterpiece, the Painted Hall at Greenwich

*Below right:* The Princesses Amelia, Caroline and Anne representing Painting, Poetry and Music, from the Painted Hall at Greenwich

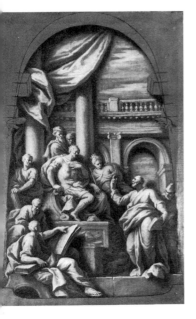

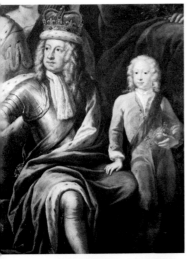

over. Louis Laguerre was a first choice but the commission was finally given to James Thornhill, an English artist favoured by Queen Anne. It was equally remarkable that he should make headway against so much formidable competition and that he should paint in the baroque manner on the largest scale with as masterly assurance as any.

Thornhill, the first of English-born artists to be knighted for his work, was a country gentleman by origin and inclination, member of an anciently established but impoverished family in Dorset (his commissions made him wealthy enough to buy back the family seat at Thornhill when he was forty-five). In youth he was the pupil of Thomas Highmore, a follower of Kneller and Sergeant-Painter to William III. Though he never went to Italy, he profited by study of the brilliant illusions of space and depth in engravings after the works of such Italian masters of the baroque ceiling as Pietro da Cortona and Andrea Pozzo. He was a successor to Verrio at Hampton Court, his Queen's Bedroom ceiling showing Leucothoë restraining Apollo from entering his chariot. His most important undertakings, overlapping in date, were the monochrome grisaille paintings in the dome of St Paul's of scenes from the life of St Paul (1715–17) and his masterpiece, the Painted Hall at Greenwich, which occupied him for nineteen years (1708–27). As much the celebration of royal triumph as Rubens's ceiling for the Banqueting Hall, it gave the baroque drama and authority of style a different direction.

The theme, methodically worked out in the 30,000 feet of wall and ceiling paintings, was no longer the assertion of a divinely appointed absolutism but the defeat of tyranny encompassed in the reign of William and Mary, the epic achievements of the navy, the advent of Peace and Prosperity in Queen Anne's time, and the prospect of a new Golden Age under the unobtrusive auspices of the House of Hanover. The happy accordance of the paintings with the architectural setting completed by Nicholas Hawksmoor after Wren's design, was part of their magnificence of effect. Well might George Vertue acclaim Thornhill as 'the greatest History painter this Kingdom has produced'.

Though Thornhill was knighted and appointed Sergeant-Painter in 1720, the indifference to art of George I gave no assurance of royal commissions. It was left open to the influential men of title to promote the interest of their protégés. A signal example is that of Richard Boyle, third Earl of Burlington, who, after Sebastiano Ricci, had left the country in a huff, transferred the weight of his support to William Kent, man of many talents and unlimited self-confidence. Burlington was apparently determined that Thornhill should not repeat the successes he had gained in preference to Ricci at Hampton Court and St Paul's. When the project of decorating the interior of Kensington Palace was being discussed, Burlington, according to George Vertue, 'forwarded Mr Kent's interest as much as layd in his power at Court & strenuously oppos'd Sr James'.

Kent can be admired on various grounds, as architect, landscape gardener, designer of numerous ornamental objects from a state barge to a royal baby carriage, but he was no painter, strenuously though he tried to be and clever as he was in obtaining commissions. As Sergeant-Painter, Sir James Thornhill might reasonably have expected to decorate Kensington Palace, but the lower estimate Kent provided, coupled with his patron's influence, won the day. Between 1721 and 1725 he produced the pretentious figure painting of the King's Staircase and the decoration of the Cube Room which Vertue described as 'a terrible glaring show'.

The indifference of George I and George II to art was offset to some extent by the interest Caroline of Anspach, George II's Queen, took in assembling royal portraits in historical sequence, a work helpful to George Vertue in his inquiries into the history of art in England by throwing light on the little-studied annals of Court portraiture. It was she who brought out of some long-unopened drawer the drawings by Holbein that are now a splendour of the royal collection. She was responsible for the purchase of Holbein's portrait of Sir Henry Guildford, Comptroller of the Household to Henry VIII, one of whose duties it had been to settle the bills for work done of 'Master Hans'.

The opposite of George II in many respects, his son Frederick Prince of Wales was unlike him in an enthusiasm for painting, especially for Italian and French works, though with more inclination to portraits than anything else. Jacopo Amigoni was one of the Prince's favoured painters. Though his preferred subjects were such mythological compositions as he furnished for Moor Park, Rickmansworth, he was drawn inevitably into the more profitable pursuit of making likenesses of Frederick and the Princess of Wales, and other members of the royal family, during his ten years' stay in England.

Frederick was impressed by the coming of the French painter Jean-Baptiste Van Loo in 1737. Van Loo was the very model of the Court painter of international celebrity, confident in the renown he had gained by his equestrian portrait of Louis XIV, expert in the formulas for accessory detail that were in themselves homage to his sitters. He shared a European reputation with his brother Carle Van Loo, was much sought after in England for portraits, though sourly regarded by the native practitioners who saw him building up a virtual monopoly, to their detriment. The *style Louis Quatorze* as represented by Van Loo was much to Frederick's taste, the artist producing portraits of the Prince, the Princess Augusta and their large family before the gout caused him to retire to Provence after five years' stay.

Prince Frederick's patronage extended to Philip Mercier, member of a French Huguenot family that had settled in Berlin. Mercier came to London about 1716, after years spent in Paris during which he engraved prints after Watteau whom he imitated in his own paintings. Frederick was sufficiently attracted by the French flavour of Mercier's work to appoint him his Principal Painter in 1729, as well as his Librarian. Frederick was reputed fickle by nature, a sign of this being the number of times he was painted by different hands. Mercier was replaced after eight years, the Prince perhaps tiring of a delicacy of portraiture that verged on timidity. It would be hard to reconcile the contemporary description of the Princess Anne as 'fat, short and disfigured by smallpox' with the slender figure of Mercier's portrait.

A lessening of Court formality is to be seen in his

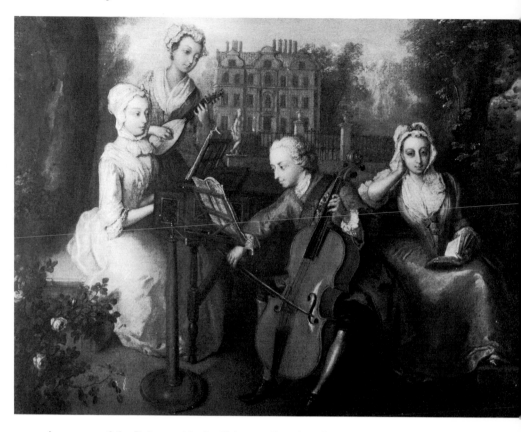

portrait groups of the Prince with the Princess Royal and his sisters, Caroline and Amelia, in a music party. Frederick plays the violoncello, the Princess Royal sits at the harpsichord, Caroline plays the mandora, while Amelia is engrossed in her copy of Milton. In two of the versions the party is set in the open air at Kew, with the 'Dutch House' in the background—one of the royal properties that provided a refuge from the oppressive atmosphere of George II's favourite country retreat, Richmond Lodge, a mile away. Frederick had a refuge of his own, in the White House nearby, from the outbursts of wrath that regularly followed his meetings with his father and his refusal to do as he was told.

That the painting was satirically or humorously intended is surmised from the fact that about that time (*circa* 1733) Frederick was not on good terms with his sisters or with the King himself. He had opposed the King's support of Handel and the Italian opera he

'The Music Party' by Philip Mercier – a portrait group of the Prince of Wales with his sisters

brought to England. His sisters were not supposed to speak to him. 'The Music Party' may have been a kind of defiance.

While Prince Frederick was as liberal in patronage as George II's reluctant allowance of funds made possible, he did not bring together a circle of unusual ability. In several ways painting was moving away from the Court. The career of Mercier illustrates some of the ways in which this came about. The upper level of society was no longer held together by the magnet of a single metropolitan centre. There were rival attractions in other centres of fashion and in the simpler routines of country life. The royal families enjoyed refuge in the 'nurseries' of royalty, the modest houses at Kew in their rural surroundings. Fashion was drawn to cities other than London: to York, Bath, Dublin, essentially metropolitan also in their sophisticated pursuits, brilliant gatherings and splendour of architecture.

Mercier prospered at York, with its much patronized racing season, its glittering receptions and balls in the 1730s at the Grand Assembly Rooms designed in the Palladian style by the Earl of Burlington himself. In addition to portraits of Yorkshire notabilities, Mercier, the ex-Court painter, developed a middle-class type of theme, essentially domestic in character and inspired by the paintings of a superior bourgeoisie by Chardin rather than the idealized aristocracy of Watteau.

The conversation-piece, and the 'fancy' picture so popular in the first half of the eighteenth century had, as Mercier shows, small connection with the Court. His royal music party was more jest than earnest. The domestic element was considered to lower the standard of dignity. Commenting on the vogue for small figure groups and 'conversations' by Charles Philips, one of the numerous competing practitioners, Vertue remarked on the encouragement he met with even from some of the royal family; 'even' suggesting that this form of royal patronage was unusual. For William Hogarth, the conversation-piece was a charter of freedom, a step towards that comprehensive view of social life in which he had complete independence of expression.

Yet the competitive nature of the profession, especially

as regards portraiture, still made the royal commission a prize to be contended for. There were painters who contrived to give the impression of being officially received at Court even when this was not so, by making unsanctioned drawings of royal personages and working them up with the aid of paintings by others. Vertue singled out Joseph Highmore for severe criticism in this respect. A shrewd and able young man, Highmore had early success as a portrait painter after giving up the study of law. His drawings for the series of engravings by John Pine celebrating the revival of the Order of the Bath and its ceremonies, in 1725, brought him commissions from Knights of the Order, including the portrait of Prince William, Duke of Cumberland. As he did not get sittings from the King and Queen he resorted to the device that Vertue deprecated—'did by stealth draw them first on paper at Several Views and afterwards by Memory in some parts & copying those pictures before painted by Sr G. Kneller . . .' The portraits produced in this fashion earned Highmore some commendation for his ability 'to take a likeness by memory'.

Even the independent Hogarth at one time hoped to find a place in the Court circle, but in the art of manoeuvre he was no match for William Kent, who contrived to frustrate his efforts. Through Kent, evidently, he was debarred from making his studies of the decor and ceremony attending the marriage of the Princess Royal to William Prince of Orange. Though the Queen had given Hogarth permission to paint the scene, Kent was successful in obstruction—and again in putting a stop to Hogarth's projected group portrait of the family of George II. It was made clear to Hogarth that he had no place in the charmed circle of favourites in the 1730s; that his true metier lay elsewhere. It was a belated gesture of recognition, of a merely honorary kind, that made him, at the age of sixty, Sergeant-Painter to the King. It was conveniently forgotten in 1757 that some years before George II had refused the dedication of 'The March to Finchley' in engraving, with the remark that he hated 'bainting and boetry'—and any inclination to laugh at his guardsmen; and that the artist had in consequence defiantly dedicated the print to the King of Prussia.

## Chapter 13
## The Georgian heyday

A general impression that the arts had been having a poor time of it was tinctured with new hope when the young George III succeeded his grandfather George II as King in 1760. It was expected that as patron he would follow his father Frederick Prince of Wales, who had died untimely as the result of an injury from a tennis-ball in 1751. Up to the time when his eyesight and reason became clouded, George III showed a good deal of interest in art, science and craftsmanship. The purchase of Buckingham House in 1764 entailed elaborate plans for the interiors in furniture, ceramics and paintings; some objects being especially designed, in addition to those brought from other royal properties. A library was built up from nothing. The young King had a scholarly concern with architecture and music, and gave proof of his regard for pictures in the bold gesture of paying £20,000 for the works of art acquired by Joseph Smith, the former British Consul in Venice. They included the fifty paintings and 140 drawings by Canaletto that are still a magnificent feature of the royal collection. He had definite views as to who should paint the royal portraits, and he was discriminating enough to favour Allan Ramsay and Thomas Gainsborough, though on some personal ground he could not tolerate Joshua Reynolds—an allergy shared by his consort, Queen Charlotte. His dislike for the first President of the Royal Academy did not prevent him from giving all support to the Academy itself, and providing rooms for its early exhibitions in Somerset House.

Apart from portraiture, George III favoured Neo-Classicism, not as a new movement in art but from a conservative attachment to the classical past. He took approving notice of the classical compositions that the American painter Benjamin West had learned to paint in Rome, and later appointed West the King's Historical Painter. The King's attitude to painting and painters

became increasingly erratic as time went on and symptoms of his derangement began to appear, but with all his shortcomings as a patron, what a writer in the *London Chronicle* in 1764 termed his 'propensity to grant his royal protection to whatever can embellish human life' retrieved the Court from the sluggish level to which it had fallen, and revived the status and importance of the painter in that connection.

Allan Ramsay, a great favourite with George III, was in many ways well suited for the role of Court painter. He had an early acquaintance with the celebrities of literature and fashion who frequented the Edinburgh bookshop of his father. Allan Ramsay senior was a prosperous man of business and a poet with a considerable reputation derived from his dramatic pastoral, *The Gentle Shepherd*. His friendship with the Lord Provost of Edinburgh secured a subsidy for his son to study art in Rome. In Europe the young Ramsay acquired a courtly elegance of style, first derived from Italian sources and later much influenced by French example—the incisive characterization of Quentin de La Tour, the pastel charm of Jean-Baptiste Perronneau. Settling in London in 1738, he had an immediate success, 'putting to flight' as he said, such foreign competitors as the Florentine Andrea Soldi and even the formidable Van Loo. An unusual ability enabled him to give strength to his male portraits and gain equal admiration for his portraits of women—'delicate and genteel' as Vertue found them, 'his flesh tender, his silks and satins, etc. shining beautiful and clean'.

A Scot, and like many other Scots, Ramsay commended himself to the Earl of Bute, the tutor and mentor of George III from the time when he was Prince of Wales onwards. In 1757 Ramsay was summoned to Kew to paint the Prince's portrait, a full-length that was well received as combining individual character with royal dignity. Even more impressive in this respect were the companion portraits of the King and Queen Charlotte in coronation robes, painted soon after their marriage in 1761. The crown jewels were sent to Ramsay's studio in Soho Square for their portrayal, a weighty responsibility that caused the artist to insist on guards being on duty day and night.

The successful state portraits, as well as Ramsay's ability to talk German with the King and Queen and to converse intelligently on a number of subjects, not excluding politics, clearly destined him for the appointment of Principal Painter. The post had become so far a matter of indifference in George II's time that a painter of no particular note, John Shackleton, had held the office and was reappointed in a routine fashion by the Lord Chamberlain's department in the new reign. Many commissions however were diverted to Ramsay, and his place was assured when Shackleton died in 1767. By then Joshua Reynolds was a strong rival, but the King had his own say in the matter. His refusal to sit for Reynolds when Lord Eglinton suggested it was sharply worded: 'Mr Ramsay is my painter, my Lord.'

Ramsay for a long time had almost a monopoly of royal portraiture in oils; though the talented painter and pastellist Francis Cotes never lacked royal employment as a 'crayon painter'. His pastel of Queen Charlotte with the infant Princess Royal led Horace Walpole to compare it with the work of Guido Reni. It was Ramsay to whom Laurence Sterne addressed his witticism: 'You paint only the Court cards, the King, Queen and Knave'—the Knave being understood to be the unpopular minister, Bute. British expansion abroad produced a great demand for replicas of Ramsay's portraits of the King and Queen in robes of state; for embassies and consulates and the residences of colonial governors as well as for public buildings in Britain. The painter's studio in Soho Square was filled with reproductions of the royal image at various stages of completion.

It is a comment on this success that he ceased to be a painter. The work of assistants producing endless replicas of his royal portraits provided him with a large income. His portraits of women, of which the portrait of his second wife, Margaret Lindsay (facing page 194), is an exquisite example, became fewer as he prospered. With fame enough, he did not seek more by exhibiting at the newly-established Royal Academy, and by about 1770 he had disappeared into respected obscurity as a minor man of letters. He wrote on political subjects, sought the company of philosophers, Hume, Voltaire, Diderot and

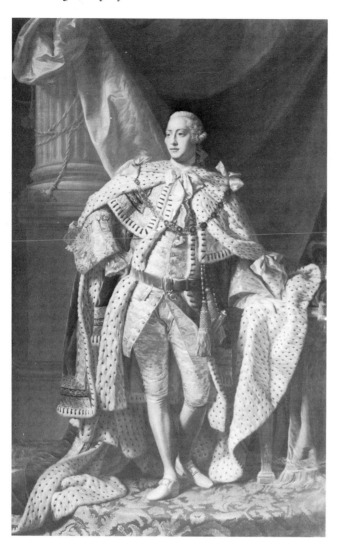

Rousseau, and delighted Dr Johnson with his con-
versation. His later visits to Italy occupied him with such
dilettante inquiries as the whereabouts of Horace's
Sabine villa. So effectively did he conceal the abilities that
bring him into comparison with Reynolds and Gains-
borough, that when he died in 1784 he was remembered
mainly for his literary talent.

Another painter's Court career curiously halted was
that of Johan Zoffany, the German painter who came to
England in the year of George III's accession. In the early
expansive period of the King and Queen's patronage he

George III in his coronation robes, by
Allan Ramsay. The success of this
portrait ensured him the post of
Principal Painter to the King

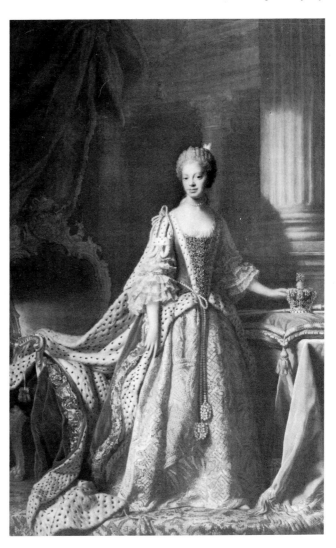

Queen Charlotte in her coronation robes, by Allan Ramsay. The companion portraits were painted soon after the royal marriage in 1761

added a genre to Court painting in the form of the royal conversation-piece. Born near Frankfurt, the son of a cabinet-maker and architect, Zoffany studied in Italy and acquired a command of the rococo style that he applied in the 1750s to the decoration of the Elector of Trier's palaces at Trier and Coblenz. His wife, the daughter of a Court official, accompanied him to England in 1760 but did not stay. A struggle to learn English, which he is said to have always spoken with a German accent, and the other difficulties of making his way in a crowded profession, were overcome with the help of David

Garrick, his first English patron.

Essays in the conversation-piece were his paintings of Garrick and his family and friends idyllically at leisure on the shore of the Thames at Hampton. To paint Garrick on stage in some of his celebrated roles was a further development of the genre. It remained to bring this highly adaptable portrait form into the upper sphere of society and fashion where it had previously been less favoured. The Earl of Bute commissioned group portraits of his sons and daughters which pictured them at play in a lively and informal style. It was natural enough that Bute, well satisfied with the exactness of portraiture and the atmosphere suggested of a happy family, should introduce the painter to the King. The several royal portraits that followed included, in 1764, the two remarkable groups that gave a new prestige to the conversation-piece.

One of them portrayed George Prince of Wales and Frederick, later Duke of York, as children playing with a spaniel in a drawing-room at Buckingham House, an interior depicted with an astonishing minuteness, exactly reproducing two portrait groups by Van Dyck which hung on the wall, the rococo mirror, the marble fireplace and the decorative screen. The other painting, no less detailed but more interesting as a composition, portrayed the Queen at her dressing table in one of the newly-decorated apartments overlooking the garden at Buckingham House, together with her two small sons in the fancy-dress that was a theatrical whim of the time. The gilt toilet service, the richly embroidered lace of the dressing table, the French long-case clock (a recent purchase by the young King) attributed to the Parisian *ébéniste*, Charles Cressent and still in the royal collection, added to a unique blend of document and virtuosity.

Both George III and Queen Charlotte liked the idea of the pictorial document executed with such consummate skill. 'The Academicians of the Royal Academy' showing the artists gathered together in the Life Room at Somerset House and evidently painted for George III, was the most popular picture of the year when exhibited at the Academy in 1772. The Queen looked forward at the same time to the record she commissioned Zoffany to

George, Prince of Wales, and Frederick, later Duke of York, in a drawing-room in Buckingham House, by Johan Zoffany

Queen Charlotte at her dressing-table, with her two eldest sons in fancy-dress, by Johan Zoffany

make of masterpieces in the Uffizi Gallery at Florence. His painting of the sixteenth-century room, the *Tribuna* and the great works of art there assembled, was a brilliant *tour de force*, and was unfortunately also the cause of Zoffany's loss of royal favour. A stay of six years in Italy, which gave him time enough to carry out commissions at the Courts of Pietro Leopoldo, Grand Duke of Tuscany, and of Duke Ferdinand of Parma, seemed longer than was

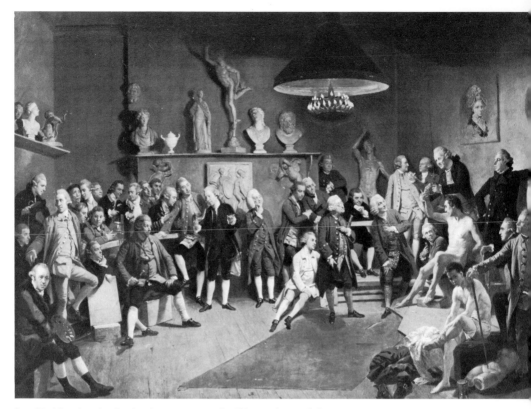

justifiable. A principal grievance was the liberty he took in introducing a crowd of tourists and dilettanti into his painting of the *Tribuna*, and in distributing the works of art to his own liking with something of the effect of an auction room. The presence of the 'travelling boys', as the English Grand Tourists were described with some distaste, was irritating to George III. His vexation grew as he became increasingly fitful in temper. The point was reached when he could not bear to have the painting on the wall.

There were no more works by Zoffany for the royal family. As brilliant as ever was his painting of Charles Towneley in his library in Park Street together with fellow connoisseurs, surrounded by the classical sculptures of his famous collection; but this was not exhibited until 1790. A dwindling number of commissions led Zoffany to seek better fortune in India under the auspices of the East India Company and the Governor-General Warren Hastings, 1783–89. His pictures of Anglo-Indian

'The Academicians of the Royal Academy' by Johan Zoffany, shows the artists in the Life Room at Somerset House

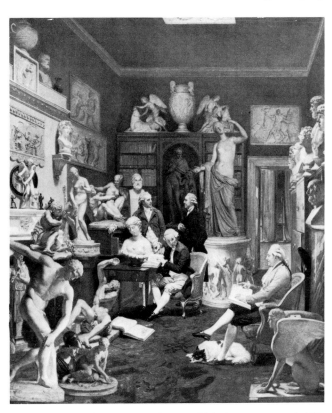

Charles Towneley by Zoffany, painted in his library with the classical sculptures of his famous collection

society, the principal products of his later years vividly evoked the exotic mingling of Court and colonial life. On his return to England in 1789, the conservatism of the Court painter appeared in his satirical works denouncing the excesses of the French Revolution.

Court painting reached its Georgian height when Thomas Gainsborough came into a close connection with the royal family. George III and Queen Charlotte took as great a liking to the temperamental, music-loving Gainsborough as they seem to have felt aversion for the bland Joshua Reynolds. Gainsborough was a man of middle age, married and with the two daughters of whom he painted exquisite portraits when he finally settled in London in 1774. He was inclined to deplore the fate that had made him a fashionable portrait painter, had taken him away from the rural life and landscape of Suffolk to the aristocratic urban society of Bath, and had made a move to London inevitable as the greater fount of commissions.

Yet the restlessness and dissatisfaction involved in adapting himself to these changes of condition were also a spur to his abilities. How Van Dyck had invested the Court of Charles I with an elegance that derived from the painter's art was an inspiring precedent. The mature Gainsborough was a second Van Dyck in sensitivity of style and the graceful translation of his sitters into the characters of an idyllic world—though fully in agreement with the King and Queen that it was essentially the portrait painter's business to obtain a likeness. If George III's taste was dubious in his commissions to Benjamin West, including besides 'history' pictures a whole series of mediocre royal portraits, it had its vindication in his regard for Gainsborough's genius, which was repeated with even better understanding in the admiration of George, Prince of Wales.

When Allan Ramsay died in 1784 it was disappointing to Gainsborough that he did not succeed Ramsay as Principal Painter to the King. His remark that he 'was very near being King's Painter only Reynolds' friends stood in the way' conveys as much. The title could be thought of as a formal honour due to the President of the Royal Academy by virtue of his office, even though Reynolds as an individual was an object of royal dislike. To Reynolds, creator of an historical gallery of the greatest and most famous personalities of his time, the appointment was of no particular profit. Gainsborough was 'the Apollo of the Palace', already well established as royalty's chosen painter, if without official status. The portraits of the King and Queen exhibited at the Royal Academy in 1781 were greeted with much approval, and that of Queen Charlotte certainly is one of Gainsborough's masterpieces. Charlotte Sophia, the German princess, niece of the Duke of Mecklenburg-Strelitz, whom George III had married in 1761, the year after his coronation, had been painted and was to be painted by a number of artists. Short in stature and plain of features, she had a naturalness that appealed to them. Allan Ramsay turned this engaging simplicity to account in contrast with robes of ceremony and heaviness of architectural background (page 185). Zoffany and Cotes gave their more intimate picture of the young mother and

her children. With his magic of touch and without flattery, Gainsborough excelled the others in the creation of a gracious presence, realized with what the painter James Northcote aptly called the 'light airy facility' that belonged to Gainsborough alone.

Queen Charlotte had fifteen children, twelve of whom survived the danger period of infancy. Gainsborough was the royal choice to paint the whole family. The series of portraits painted at Windsor in 1782 was taken from life with two exceptions: Prince William, then a midshipman at sea, and Prince Alfred, who died just before Gainsborough's visit. William was portrayed from an earlier likeness, Alfred from memory. All the pleasure Gainsborough took in painting young people appears in his portraits of the royal children, together with a perception of the shared family image sometimes plain to be seen, sometimes an elusive presence. Gainsborough's work for George III and Queen Charlotte ended with this remarkable study of hereditary features. The King seems to have looked with little comprehension at the painting in which Gainsborough's imagination found an outlet, the rural fancies of 'The Woodman' and the 'Cottage Children'. The Prince of Wales, later to be George IV, continued the interest in family portraiture though bringing a wider range of understanding to bear on art of quite another kind.

There was small reason for George III to wish for portraits of his younger brother, Henry Frederick Duke of Cumberland, and his wife Anne, incensed as the King was by Henry Frederick's involvement in the suit brought by Lord Grosvenor against his wife for adultery; and further by the Duke's clandestine marriage to the widowed Mrs Horton. Gainsborough, however painted brilliant portraits of each, and of the two together in the 1780s with the Duchess's sister, Lady Elizabeth Luttrell (reputed a heavy gambler) making the third of the somewhat notorious group. The Duke did not take up his option to buy this distinguished work, which remained unsold in Gainsborough's studio until, after his death, it was acquired by the Prince of Wales.

George IV, while still Prince of Wales, commissioned the handsome group of the three eldest Princesses—

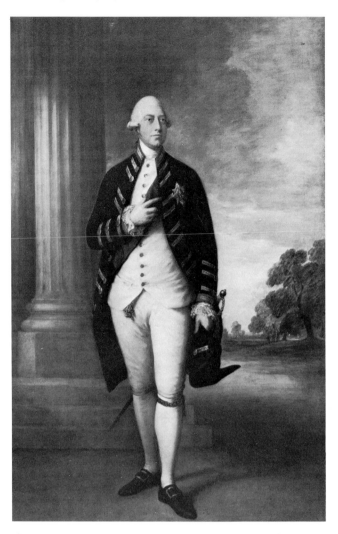

Charlotte Princess Royal, Augusta and Elizabeth—to hang in the Saloon at Carlton House (page 196), the separate establishment designed by Henry Holland for the Prince when he came of age in 1783. The favourites of his amorous youth had to be portrayed also. One of Gainsborough's masterpieces is his portrait of Mrs Robinson (facing page 195), the actress with whom the Prince had fallen in love after seeing her in the role of Perdita in *The Winter's Tale* at Drury Lane. This passing fancy cost George III £5,000 for the return of compromising letters from his son, and cost the latter an allowance of £500 a year after he deserted her in 1782. But

George III by Gainsborough. Though not the official painter to the King, Gainsborough was nevertheless a favourite at Court

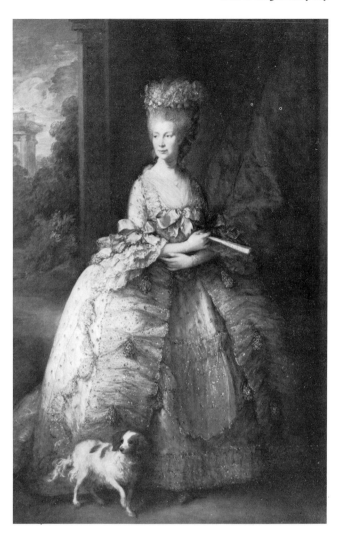

Queen Charlotte by Gainsborough – one of his masterpieces, displaying the Queen's regality without flattery or heaviness

these materialistic details of 'Perdita's' later misfortune are remote from the idyllic vision of the young woman in park-like setting with a miniature of the Prince in her hand and one of the dogs that Gainsborough painted so beautifully beside her.

That George IV admired what Gainsborough termed his 'Fancy pictures' appears from his purchase of 'Diana and Actaeon' (page 197) from the sale after the artist's death. Often accused of wild extravagance, George IV could scarcely be so criticized in this instance. The price paid at auction for this enchanting version of a subject always popular with the masters since the Renaissance,

among the works remaining in Schomberg House in 1788, was £2 3s.

Margaret Lindsay, by Allan Ramsay (see page 183)

That George IV spent enormously on gambling, horses and other forms of extravagance is a matter of record and has often been the subject of censure. For the puritanically minded, good taste was a grievance. Criticism on this score was levelled against him as it had been against Charles I. The acquisition of works of art was correspondingly seen as a ruinous outlay. Yet it was not unreasonable that he should acquire many sumptuous pieces of furniture and porcelain representing the peak of French craftsmanship of the old regime to contribute to the splendour of Carlton House. This was a work of salvage after the lootings and dispersals resulting from the French Revolution. The Peace of Amiens in 1802 gave the opportunity to buy cabinets, candelabra, clocks, bronzes, Sèvres porcelain and all the rich debris of an overturned social order. Further purchases of the kind were possible after the end of the Napoleonic wars in 1815.

George IV's sporting tastes coincided happily with the growth of a school of sporting painters. Many of his favourite horses were portrayed in the 1790s by the able devotee of the racecourse, Benjamin Marshall. Royal patronage in the same period not only enabled the unworldly George Stubbs to tide over monetary difficulties but to make great works of art from the subjects assigned to him. He painted George IV when Prince of Wales in 1791 —sprucely dandified and not as yet overweight, riding by the Serpentine (facing page 210). George IV's interest in military uniforms, and especially that of the regiment of which he was Colonel, called for the painting of 'Soldiers of the 10th Light Dragoons', Stubbs's only military subject. In this he made a remarkable design out of the ritual of mounting or changing guard. The royal phaeton with its black horses, red-coated coachmen, leaping dog 'Fino' and attendant 'tiger-boy', gave material for a magnificent composition. A recent replenishment of the royal herds of deer in 1792 enabled Stubbs to show that his understanding of animal form was not confined only to racehorses.

Some distinction may be called for between the painter

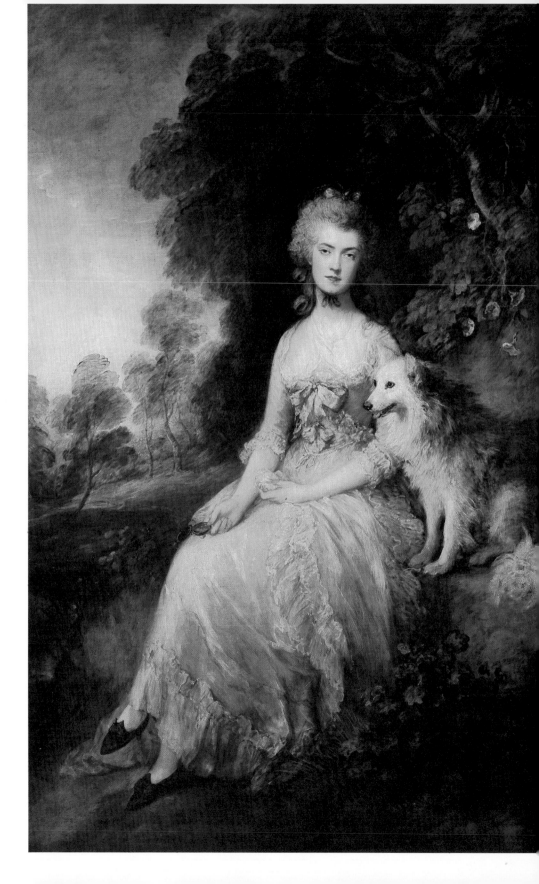

'Perdita' – the actress Mrs Robinson, painted by Gainsborough. She holds a miniature of the Prince of Wales, who loved her (see page 192)

habitually concerned with the ceremonies and personalities of the Court, and those called in for a time or a particular occasion to satisfy some interest or hobby of the ruler as an individual. The proper milieu for Ben Marshall was Newmarket rather than the palace. The Hunters' laboratory of natural history specimens was where Stubbs worked for choice. It is not likely that they were worried by the suggestion of inferior status to that of the 'history' or portrait painter, though an artist of unsatisfied ambition such as James Ward was susceptible in this way. When Ward, as a skilled animal artist, was appointed Painter and Engraver in Mezzotint to the Prince in 1794 he was conscious of a minor role in having to work in the royal stables. It was a disappointment not to be assigned a room in Buckingham House, a distinction that the portrait painter Thomas Lawrence was readily accorded.

If some uncertainty might be felt as to the place of a sporting painter at Court, that of Sir Thomas Lawrence was assured beyond dispute. His appearance and manners were all that could be wished. Of handsome presence with a noble brow, the more impressive in his mature years from a frontal baldness, he had a winning personality and a courtesy towards women that conveyed so much of personal attention as from time to time to be mistaken for a declaration of love. Without intent on his part he disappointed such devoted admirers as the daughters of Mrs Siddons, Maria and Sally, whose portraits he painted as well as that of their famous actress-mother. A similar courtly attention drew him embarrassingly into the 'Delicate Investigation' of the conduct of Caroline of Brunswick, who was married to the Prince Regent in 1795 but parted from him almost immediately after the birth of their daughter. Lawrence stayed a few nights at Montague House, Blackheath, where the sittings were held for his portrait of Caroline and her daughter, in order to be ready for them when they arrived from neighbouring Shooter's Hill, but a suggestion of intimacy between the Princess and the painter was dismissed as being without foundation.

Lawrence's rise to the peak of his profession as portrait painter was phenomenal. A natural gift had steadily

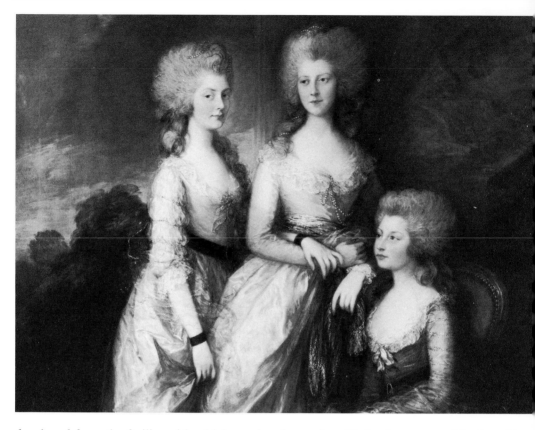

developed from the facility with which as a boy he made chalk drawings of the patrons of the Black Bear Inn at Devizes, where his father was landlord. A growing repute afterwards marked his success as a portraitist at Oxford and Bath before he came to London in 1786, a youth eager to make himself into another Sir Joshua Reynolds. An early contribution to the Royal Academy in 1789 brought him a recommendation to Queen Charlotte, whose portrait he painted in the autumn of that year. It is still astonishing that the young man of twenty could produce a portrait to vie with Gainsborough's picture of the Queen. The picture was in a different key from those of Gainsborough and Reynolds. In some way the period of dramatic events, of revolution in France and impending war, transmitted its fever to the work of sensitive artists, Lawrence among them. The Queen was a placid subject enough. Sitting passively and reluctantly, with the burden of George III's attacks of insanity on her mind,

The handsome group of the three eldest Princesses, Charlotte, Augusta and Elizabeth, was commissioned from Gainsborough by George IV while Prince of Wales

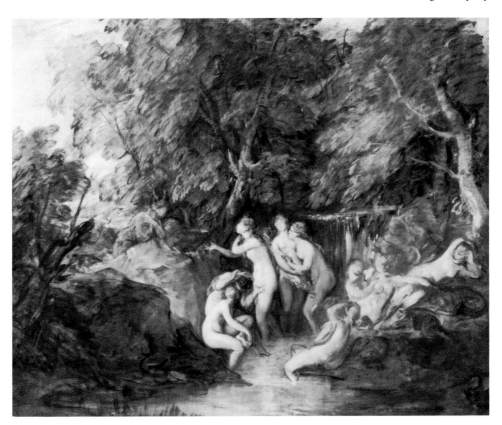

'Diana and Actaeon' by Gainsborough: George IV paid only £2 3s for it at auction after the artist's death

she gave no incitement to vivacious expression. But the energy of Lawrence's painting, the bold contrasts of light and dark, gave a startling force to her image. This dramatic effect, vivid now as ever when the painting is seen from a distance down the aisle of the National Gallery, was too startling for the King and Queen. The painting remained on the painter's hands, though much admired when exhibited at the Royal Academy in 1790. They preferred the milder talent of William Beechey, knighted in 1798 after he had painted his huge composition 'George III at a Review'. The King approved the martial vigour with which he was credited as evidence of faculties unimpaired. Yet when Sir Joshua Reynolds died in 1792, Lawrence, then only twenty-two, was his successor as Principal Portrait-Painter-in-Ordinary.

Beechey was no match for him, even if the Queen had more regard for his homely portrait of her than for Lawrence's brilliance. John Hoppner was another rival

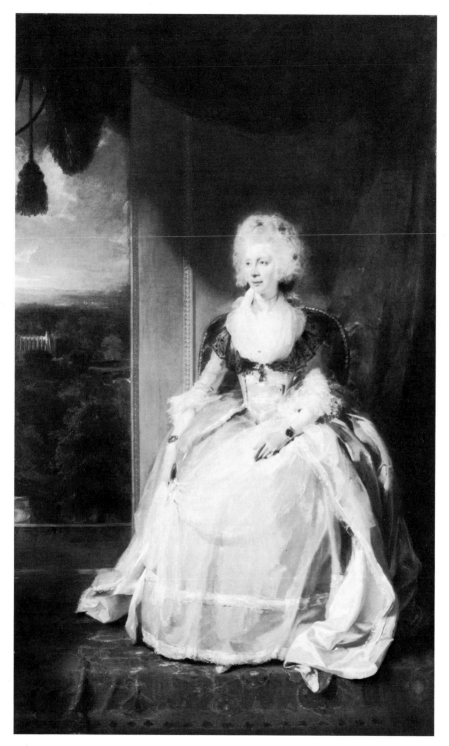

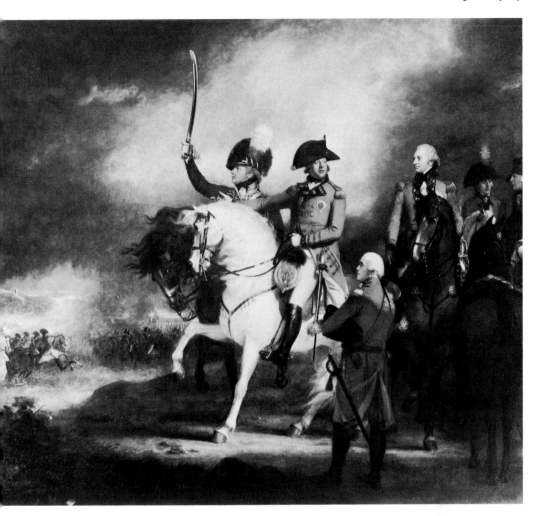

*Above:* 'George III at Review' by William Beechey, who was knighted by the King after painting it

*Left:* This painting of Queen Charlotte, by Thomas Lawrence, is a work of astonishing brilliance by a young man of twenty

who, until his death in 1810, was George IV's officially appointed portrait painter. Thereafter Sir Thomas Lawrence, knighted in 1815, was unchallenged in eminence. He painted George IV many times, seeming to distil the dandified character of the time and the person in what Lawrence considered his most successful royal portrait—that of the King in private dress in 1822. The cheerful floridness of the sitter was engagingly conveyed, even though John Constable, little inclined by the independent direction of his thought to admire Court portraiture, was sarcastic about what he considered a 'blustering pomposity'.

Lawrence's supreme triumph came with the suc-

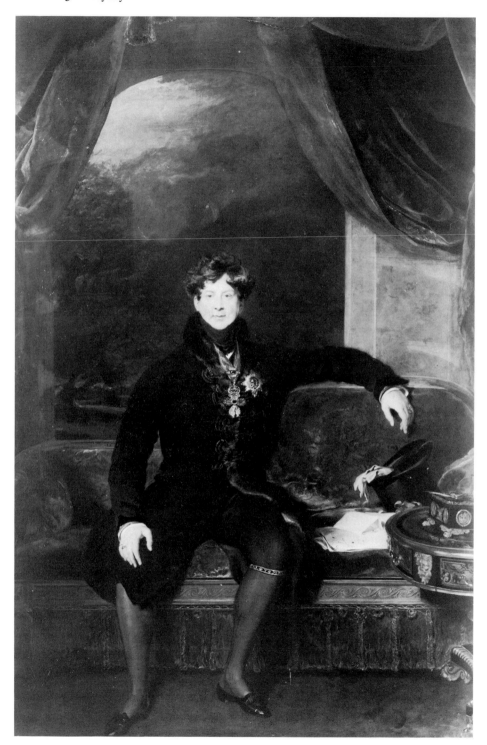

George IV by Thomas Lawrence: the artist considered this his most successful royal portrait

cession of historic events that brought about the fall of Napoleon in 1814 and his final defeat at Waterloo in the following year. It fell to Lawrence to portray the princes, statesmen and warriors who gathered in mutual allied congratulation after victory, first in London, later at Aix-la-Chapelle and Vienna, where they assembled (in the words of Lawrence's first biographer), 'to prevent the recurrence of war for ever'. That he should be chosen to depict the allied leaders was almost inevitable. There was no other English artist adequately equipped for the task — or indeed any Continental artist who seemed suited to it. The Duke of Wellington was sure he would 'convince even the vain Parisians of the superiority of an English artist'.

As it turned out he made an impression on the rulers of Europe without parallel since the day of Titian and Rubens. The Emperor of Russia stooped to affix the pegs of his easel and help him place his canvas in position — reminding the painter of the occasion when Charles V bent down to pick up Titian's brush. His fine manners and distinguished appearance, as well as his art, caused him to be greeted everywhere with the greatest respect. Honours were showered on him, entertainments were lavish. The banquets, the fêtes, the balls (where three sovereigns might be seen at one time dancing the polonaise), which celebrated victory, accompanied his progress from place to place with a continued brilliance in which he was an essential participant. The English Court painter in these triumphant years was the painter of every European court.

The memorable series of portraits began in 1814 with the coming to London of the military commanders. Field-Marshal Gebhardt von Blücher arrived at the painter's house in Russell Square in the small hours, after travelling all night from Plymouth, and evidently, it was said, 'half-seas over'. Lawrence painted him as on the battlefield, with a look of that abundant energy on which Wellington made the dry comment that Blücher was always ready and eager to fight — 'if anything too eager'. In the same season he painted the Cossack General, Count Platov, much bemedalled and with the Asiatic features that caused him to be curiously regarded in

London as a barbaric phenomenon. The convenient moment to paint not only generals but all the allied dignitaries concerned was still to come with the opening of the Conference at Aix-la Chapelle in 1818.

The pre-fabricated studio designed in London for Lawrence's European journey was not finished in time, but nowhere was handsome accommodation lacking. He was sumptuously housed in a huge gallery in the Hôtel de Ville at Aix; in Vienna in the great Salon of the Imperial Chancery; in Rome in a specially furnished suite in the Quirinal. Places en route, as well as the panorama of glittering social life, fostered his romantic mood. The poetry he had recited as a boy came back to his mind with fresh meaning. The 'gorgeous' ruins of Heidelberg Castle made him think of Byron and Scott; Tivoli, of Turner as the only painter who could do justice to its sublimity. But no sight-seeing diverted him from his study of all that was individually characteristic in the kings, dukes, princes, soldiers, statesmen, and churchmen who sat for him. By a dramatic employment of light and shade he was able to surround them with an aura of excitement and exultation, suggesting the mood that followed conflict lately over, hard-fought and won.

The result was the superb gallery of portraits preserved in the Waterloo Chamber at Windsor. How well Lawrence rendered the typical posture of Alexander I of Russia, a portrait so like as to make his aides-de-camp jump in excited recognition when they saw it. How characteristic was the shrewd sidelong glance of Prince Metternich; the commanding gesture of Prince Schwarzenberg, the Austrian leader in the campaign of 1812. The profusion of orders and medals worn was painted with a zest that added to the general magnificence of effect.

As a study of character, perhaps the best —as Lawrence himself thought—was the portrait of Pope Pius VII on his throne in the Vatican, an essential addition to the Waterloo series in view of the Pope's defiance and excommunication of Napoleon after the annexation of the Papal States. The least satisfactory was that of the victor of Waterloo himself. The theatrical pose with uplifted Sword of State was scarcely in accord with the nature of

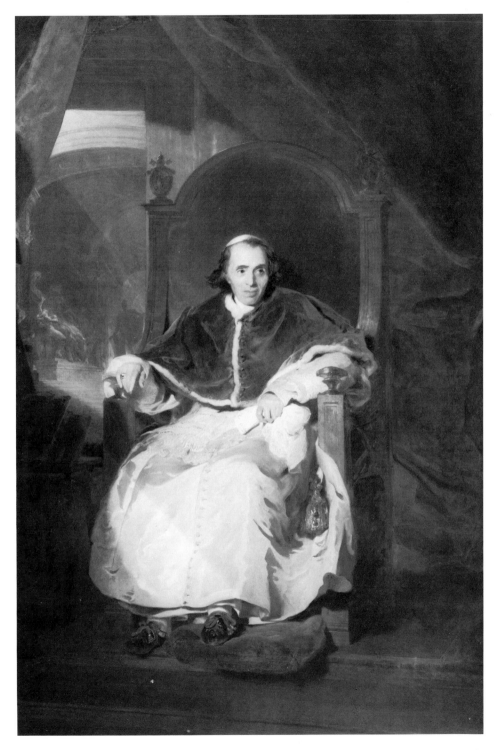

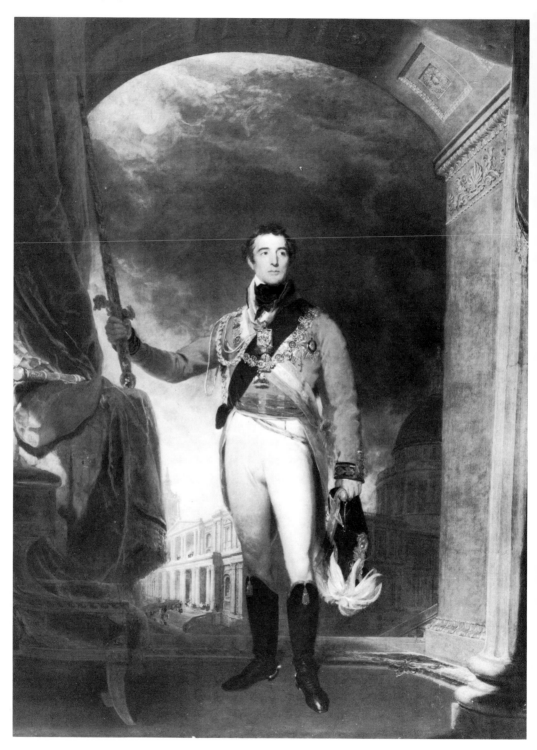

The Duke of Wellington, with uplifted Sword of State, painted by Thomas Lawrence after Napoleon's defeat at Waterloo

one who was so much addicted to understatement. More like the Duke's odd humour was his remark when Lawrence, having painted out the stripes on the sash he was wearing as being discordant notes in the colour scheme, offered to put them back if they had some special importance. 'Never mind', said Wellington. 'They merely constitute me Generalissimo of the Armies of Spain.'

If the history of Court painting in England were to end with Sir Thomas Lawrence, it could be said to arrive at a tremendous finale. He was the last of that illustrious line who were not only the painters of princes but were in themselves princely. He had, like his great predecessors, the refinement of both manners and taste that belonged to the grand seigneur, the perfect gentleman. He shared with Rubens and Van Dyck the noble amiability of disposition that led him to look for and extol what was best in those he met with. He had many things to say in praise of the potentates he portrayed. The weak but would-be despotic Charles X, returned from exile to the throne of France (until once more driven out in 1830), had in Lawrence's view 'a peculiarly benevolent expression'. The Archduke Charles of Austria was 'of dignified pleasing manners with a face of great strength of character'; Cardinal Consalvi had 'a countenance of powerful intellect and great symmetry'. If words became too uniformly suave the brush made its better discrimination.

The way in which he charmed women by attentions that seemed to make each the object of his particular regard became a pictorial idealization such as that of his portrait of the Countess of Blessington. The sparkling eyes, the glossy coiffure, the demure smile, the immaculate bosom as unselfconsciously revealed, were a vision of beauty changing by subtle degrees from Regency classical to early Victorian. Seen from a broader viewpoint, he was a Romantic in temperament even though the nervous vitality of feeling that the term implies was largely canalized within the limits of single portraits. The temperamental quality was clearly recognizable to the young Eugène Delacroix, who visited Lawrence in 1825 and thought his portraits 'in some respects superior to those of Van Dyck himself'.

205

Comparison with Rubens and Van Dyck, bringing into view the full range of their work, would inevitably expose Lawrence's limitations in many respects, especially as a painter of imaginative themes, but he was level with them in the princely habit of collecting works by the masters and in the exercise of admirable judgement. It is a strange paradox that Lawrence acquired a fortune and yet was always poor. His extravagance was a kind of unworldliness in that he kept no account of what sums he received or what he spent. His house in Russell Square was sparsely furnished, his entertaining was limited, but the Old Master drawings of which he assembled an unrivalled collection cost him many thousands of pounds. He was no less an acute judge of classical sculpture than of draughtsmanship. When the *cognoscenti* were baffled as to what they should say about the Parthenon sculptures that Lord Elgin brought to England, and the proposal to buy them for the nation, Lawrence was one of the few who asserted their value and importance to be beyond question. It is thus Rubens might be imagined to have spoken out if a like question should have arisen in his time.

The Countess of Blessington by Thomas Lawrence

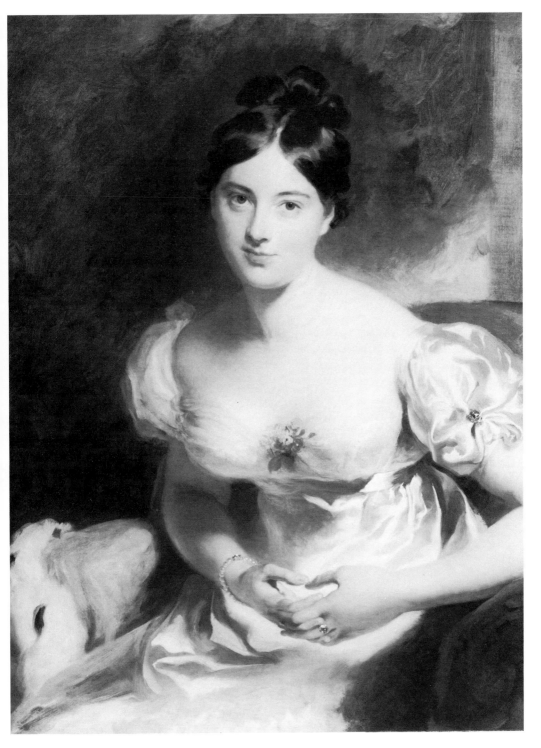

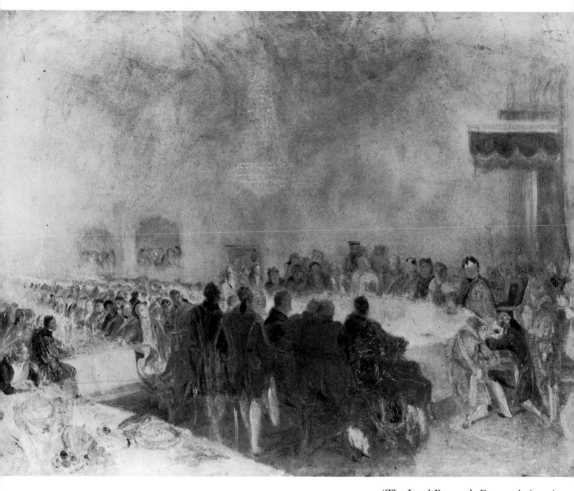

'The Lord Provost's Banquet' given in
Edinburgh for George IV, painted by
Turner

## Chapter 14
## The end of an era

The nineteenth century marks the end of the close relationship between Court and artists persisting during three centuries, and starred with the names of Holbein, Hilliard, Rubens, Van Dyck, Gainsborough and many outstanding painters more. Sir Thomas Lawrence rounds off the story of the great age of English portraiture. George IV, with a perceptive eye for pictures, was not so catholic in taste as to reward the great masters who brought the art of landscape to its height. Far from the Court seem John Constable, distant in temperament and the originality it was left to critics and artists in France to appreciate; and J. M. W. Turner, the solitary traveller roaming Europe but linked with a wide public through the interest in travel his landscapes fostered.

Only one painting by Turner was a royal commission, 'The Battle of Trafalgar', and this was so heavily criticized by naval men as to inaccuracies of sails and rigging and other technicalities unconnected with pictorial quality, as to be consigned from Carlton House to Greenwich Hospital. In search of topographical material in Scotland, Turner made other incidental sketches that included an impression of the Lord Provost's banquet at Edinburgh in George IV's honour. Gorgeous colour gave more prominence to the footmen's livery than the royal presence—the unfinished painting remained in Turner's studio.

A liking for genre-pictures, a contrast in subject with the ceremonial and the grandiose, was an aspect of George IV's taste that interested him in the Dutch and Flemish painters of popular life and such later equivalents as might be found among the living. His fancy was taken by a picture of rustic musicians by Edward Bird, a specialist in village humours, 'The Country Choristers'. George IV, then Prince Regent, asked through Benjamin West (as PRA) for a companion picture from the young Scotsman, David Wilkie, already of mark by his

contributions to the Royal Academy after the manner of Teniers and Ostade.

The Regent was delighted with the result, 'Blind-Man's Buff', painted in 1812, humorous, highly detailed and spirited in movement. 'The Penny Wedding' that followed depicted a Scottish country marriage, the title referring to the subscriptions contributed by the guests according to a traditional custom. The lively grouping and incident in a barn-like interior repeated his previous success. Ten years later, in 1828, the Regent paid 500 guineas for a further example of humorous genre, 'The Mock Election' by Benjamin Robert Haydon. The purchase of this scene of prison fun witnessed in actuality by Haydon when detained in the King's Bench for debt, raised that unfortunate man's hopes of continued royal patronage. They were to prove ill-founded. His 'Punch or May Day', a companion piece to the 'Election', sent on approval to Windsor, came back to him unsold.

Neither Wilkie nor Haydon corresponds to that serene image of the painter perfectly at ease at Court level presented by a Van Dyck or a Lawrence. Dissatisfied with themselves, they were engrossed, each in his own way, with the struggle to realize a personal aim that lay somewhere beyond their reach; Haydon, maddened by his ill-success in 'high art', the huge classical compositions that elicited no such response as the humours of everyday life; Wilkie overwhelmed on his travels in Italy and Spain and driven to desperate changes of style by the emotions Titian and Velazquez aroused. Wilkie, more fortunate than Haydon, retained the interest of George IV by his pictures of life and war in Spain. When Lawrence died in 1830, he became Painter-in-Ordinary to the King, an appointment confirmed by William IV and after him by Queen Victoria.

To paint State occasions did not come easily to one more at home with peasant frolics. The composition of his 'Entrance of George IV at Holyroodhouse' turned out awkwardly. Candid friends pointed out a lack of tact in painting the King in jackboots that drew attention to his corpulence. The artist encountered the problems of protocol when, after the accession of Queen Victoria, he was required to portray 'The Queen's First Council'.

The sporting painter George Stubbs painted the Prince of Wales – later George IV – riding beside the Serpentine (see page 194)

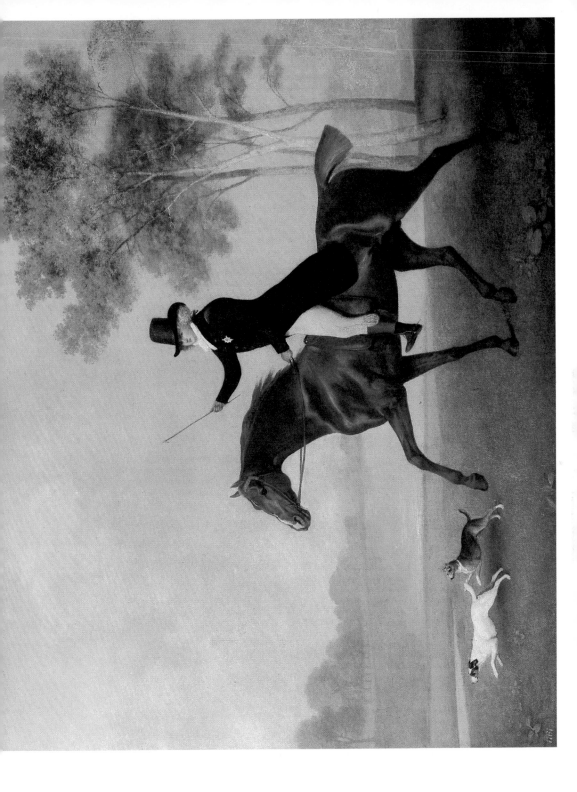

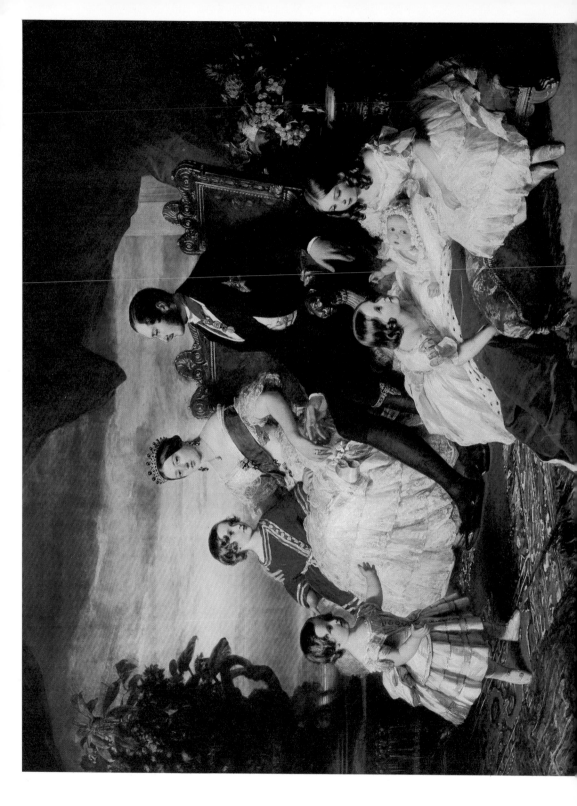

Winterhalter's royal family group of 1846: Queen Victoria and Prince Albert in dignified parenthood with the Prince and Princesses disposed around them (see page 214)

Who should be in front and who behind was hard to decide. The prominence of Melbourne, Palmerston, Grey and Wellington, of George III's son Augustus Frederick, Duke of Sussex, and the Duke of Cumberland, King of Hanover, allowed no dispute as to their placing; but the twenty-seven other participants were, as Wilkie put it 'a considerable plague in adjustment'. A stony assembly, as finally arranged, faced the young Queen; accounting in part, it may be, for the dislike she came to have for the painting. Looking at it again in 1847 she decided it was one of the worst pictures she had ever seen.

It was not Wilkie who was chosen to paint the young Queen receiving the Sacrament in Westminster Abbey on her coronation in 1838, but Charles Robert Leslie, one of the Academicians presented to the Queen when she visited the Royal Academy the year before. Two of his then exhibited works pleased her, his 'Autolycus' and the 'Perdita' which enraptured the critic Tom Taylor as 'one of the sweetest and most graceful creatures ever embodied on canvas'. Something of the prettiness thus eulogized appeared in the picture of the coronation; the flutter of attendant ladies-in-waiting added an attraction missing from the solemn ranks of privy councillors in Wilkie's picture of the year before. Leslie again executed a royal commission in his 'Christening of the Princess Royal at Buckingham Palace' in 1841, the year Wilkie died on shipboard on the way back from his visit to Constantinople and Jerusalem.

Apart from these excursions into ceremony, he illustrated and catered for a middle-class taste. His imagined glimpses of the life and costume of the past, of glamorous characters in classic works of fiction, appealed especially to the self-made men who had made fortunes in industry and commerce. They were now the fount of patronage rather than the Court. 'Almost every day', wrote Leslie in 1851, 'I hear of some man of fortune whose name is unknown to me who is forming a collection of the works of living painters or who have made fortunes in business and retired.' His own pictures were bespoken for ten years ahead by collectors of this order.

The Court painting of Victoria's reign could almost be summed up as the pictorial record of a happy marriage,

'The Country Choristers' by Edward Bird

'Blind-Man's Buff' by David Wilkie

'The Penny Wedding' by David Wilkie

'The Mock Election' by B. R. Haydon

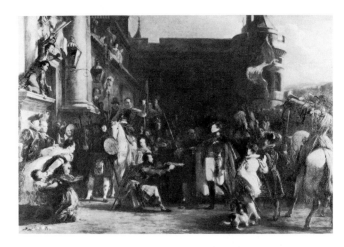

'The Entrance of George IV at
Holyroodhouse' by David Wilkie

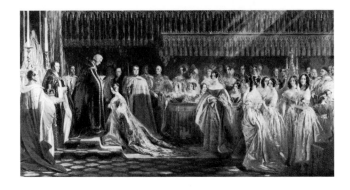

'Queen Victoria receiving the
Sacrament at her Coronation' by
C. R. Leslie

provided mainly by two artists, Franz Xavier Win-
terhalter and Sir Edwin Landseer. Winterhalter, born at
Baden-Baden, had settled in Paris as a young man after
studying art in Munich and Rome. His facility and ability
to invest his subjects with an air of distinction, even if
with a certain waxwork smoothness, made him an
acquisition to the French Court. After being the officially
appointed painter to the 'citizen king', Louis Philippe, he
had a still more congenial role, when the Second Empire
was established, as painter to Napoleon III. To all intents
and purposes he was by then a French artist. The outward
show of pomp and lavish spectacle that made for a
glittering exchange between France and England in the
1850s was such as to give him success on both sides of the
Channel.

Not long after Queen Victoria's marriage to Prince
Albert she was attracted by a Winterhalter she saw in
Paris, 'La Siesta', 'representing 3 lovely Italian girls with
one of them asleep'. She bought the work to hang at
Osborne. The full-length portraits of the Queen and her
Consort which Winterhalter painted in 1842, of which
many replicas were made, were the most popular of the
royal likenesses. In the following year he painted the
informal portrait of the Queen with which she planned to
surprise Prince Albert on his birthday. A model at once of
domesticity and decorum was the royal family group of
1846 (facing page 211), the Queen and Prince sitting in
dignified parenthood with the little Prince of Wales and
Princesses gracefully disposed round them.

The division between the ceremonial record and
paintings with an intimate association, is more strongly
marked in Landseer's work for, and friendship with, the
royal couple. There was little of the Court as a place or an
institution in the many pictures Landseer produced as a
result of his outings in company with the Queen and
Prince Albert—the exploration of the Highlands, the
shooting and sketching parties. They delighted in
Landseer's surpassing ability to portray the many royal
pets, the spaniel Dash ('Dear little Dashy . . so fond of
playing at ball and of barking and jumping'), Islay, Tilco,
Eos and others. But this was not an interest in art; rather,
as Ruskin put it, 'a healthy love of Scotch terriers'.

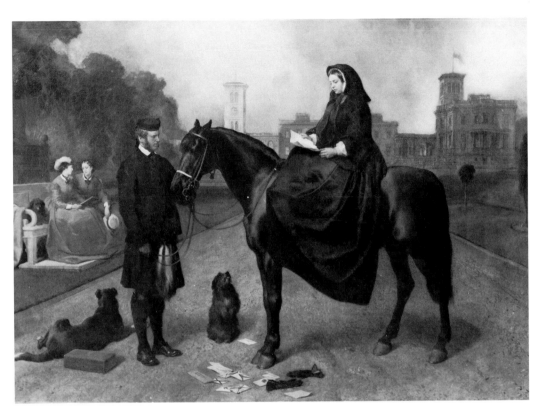

Queen Victoria on a pony held by John Brown, by Sir Edwin Landseer

Apart from these forms of family entertainment were the Prince Consort's plans to revive mural and decorative painting on a large scale. They were not an attempt to create an art exclusively of the Court but to encourage a national effort. The frescoes for the rebuilt Houses of Parliament were a democratic choice from the entries to an open competition. That the scheme was disappointing in the outcome showed how little conditioned painters had become to a scale and technique other than that of the portrait and the easel picture.

The time when painting was the product and souvenir of many happy royal occasions ended with the death of the Prince Consort from typhoid fever in 1861. There was no heart left for subjects such as had enlivened the earlier euphoric years, the Highland picnics, the cheery sketches of frolicsome pets. It was a subdued, a mournful picture that Landseer painted in 1866 of the Queen at Osborne in her black dress, mounted on the docile pony held still by the attendant John Brown.

In the years that followed, the Queen's interest in art waned. The developments of the century that marked a growing independence of aim belonged to a different world. It would be hard to imagine a Dante Gabriel Rossetti among the royal pictures; even harder at a later date to imagine the inclusion of a painting that could be labelled Impressionist. Impressionism in the later Victorian years made obvious — and forbidding — the gulf between the work of artists pursuing purposes of their own and the conservative nature of an established order.

Though little inclined or equipped to carry further her Consort's comprehensive plans for encouraging the arts of design, the Queen had a sense of the value of record that made her one of the pioneer photographers and a patron of the newly-formed Photographic Society in 1853. Going as a royal duty to the Academy in 1854, she saw a picture that satisfied her feeling for fact, 'Life at the Seaside — Ramsgate Sands' by William Powell Frith, near to a photograph in the detail that had occupied the artist for two years. The first of Frith's memorable panoramas of contemporary life, the painting also recommended him to the Queen as one capable of doing justice to a scene of ceremony. 'The Marriage of the Prince of Wales and Princess Alexandra of Denmark', which the Queen commissioned Frith to paint in 1863, was a marvel of patient labour, in the vast number of its portraits, the minutely finished detail of costume and interior — yet strangely characterless as a work of art, and as compared with such another crowded scene of the same period as Frith's 'Railway Station'. The artist was more at ease with the bourgeois incident of the station platform under the iron girders of Paddington than with society on its best behaviour in the Gothic precincts of St George's Chapel, Windsor.

Court painting, splendid and indispensable in the past, was fated to give way to the photograph, though in the later years of Queen Victoria's reign, in spite of her reclusiveness and few public appearances, the royal image was more distinct and widely seen than at any earlier time. To the pictures that portrayed her at the time of the Royal Jubilee in 1887, maternally dominant among the repre-sentatives of European royalty and her children and

grandchildren (fifty-five portraits are counted in the gathering at Windsor painted by a Danish artist, Laurits Tuxen), are to be added the many photographs, prints, stamps, medals, busts and statues that were Imperial symbols in every part of the Empire. The metamorphosis of the Court portrait into a popular art, was completed by the twentieth-century camera equipped with the advantages of colour and movement.

'The Marriage of the Prince of Wales and Princess Alexandra of Denmark', commissioned by Queen Victoria from W. P. Frith

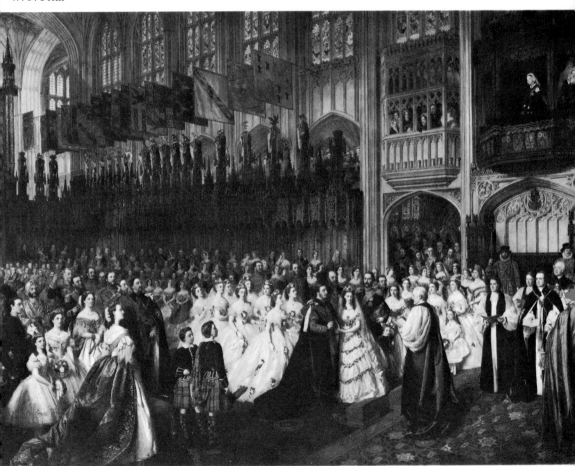

# A short Bibliography

AUERBACH, E., *Nicholas Hilliard*, London 1961

FOSKETT, DAPHNE, *Samuel Cooper 1609–1672*, London, 1974

HERVEY, MARY F. S., *The Life, Correspondence, & Collections of Thomas Howard, Earl of Arundel*, London, 1921

LEVEY, MICHAEL, *Painting at Court*, London, 1971

MILLAR, OLIVER, *The Tudor, Stuart and Early Georgian Pictures in the Collection of Her Majesty the Queen*, 2 vols, London, 1963

—*The Later Georgian Pictures in the Collection of Her Majesty the Queen*, 2 vols, London, 1969

SAINSBURY, W. NOEL, *Original Unpublished Papers Illustrative of the Life of Sir Peter Paul Rubens as an artist and diplomatist preserved in HM State Paper Office*, London, 1859

STRONG, ROY, *Holbein and Henry VIII*, London, 1967

VAUGHAN, WILLIAM, *Endymion Porter & William Dobson*, London, 1970

WEDGWOOD, C. V., *The Political Career of Peter Paul Rubens*, London, 1975

*Exhibition Catalogues*

From the Queen's Gallery, Buckingham Palace:

—*Treasures from the Royal Collection*, 1962

—*Animal Painting: Van Dyck to Nolan*, 1966

—*Van Dyck, Wenceslaus Hollar and the Miniature Painters at the Court of the Early Stuarts*, 1968

—*Gainsborough, Paul Sandby and Miniature Painters in the Service of George III and His Family*, 1970

—*George III, Collector and Patron*, 1974

HARRIS, J., ORGEL, S., and STRONG, ROY, *The King's Arcadia: Inigo Jones and the Stuart Court* (Arts Council of Great Britain exhibition, Banqueting House, Whitehall) London, 1973

MAAS, JEREMY, *'This Brilliant Year': Queen Victoria's Jubilee 1887* (Royal Academy of Arts exhibition) London, 1977

MILLAR, OLIVER, *The Age of Charles I: Painting in England 1620–1649* (Tate Gallery exhibition) London, 1969

STRONG, ROY, *Hans Eworth: A Tudor Artist and his Circle* (exhibition held at City of Leicester Museums & Art Gallery; and National Portrait Gallery, London) Leicester, 1965

—*The Elizabethan Image: Painting in England 1540–1620* (Tate Gallery exhibition) London, 1969

TRAPP, J. B., and SCHULTE HERBRUGGEN, H., *'The King's Good Servant': Sir Thomas More 1477/8–1535* (National Portrait Gallery exhibition) London, 1977

WILTON ELY, JOHN, *Apollo of the Arts: Lord Burlington and his Circle* (Nottingham University Art Gallery exhibition) Nottingham, 1973

# Index

# Index